reading rey chow

This book is part of the Peter Lang Education list.
Every volume is peer reviewed and meets
the highest quality standards for content and production.

PETER LANG
New York • Washington, D.C./Baltimore • Bern
Frankfurt • Berlin • Brussels • Vienna • Oxford

paul bowman

reading rey chow

visuality,

postcoloniality,

ethnicity,

sexuality

PETER LANG
New York • Washington, D.C./Baltimore • Bern
Frankfurt • Berlin • Brussels • Vienna • Oxford

Library of Congress Cataloging-in-Publication Data

Bowman, Paul.
Reading Rey Chow: visuality, postcoloniality,
ethnicity, sexuality / Paul Bowman.
pages cm
Includes bibliographical references and index.
1. Chow, Rey. 2. Culture—Study and teaching—China.
3. Postcolonialism—China. 4. Motion pictures—Social aspects—China.
5. Sex role—China. 6. Group identity—China. I. Title.
HM623.B696 305—dc23 2013003319
ISBN 978-1-4331-1928-6 (hardcover)
ISBN 978-1-4331-1927-9 (paperback)
ISBN 978-1-4539-1089-4 (e-book)

Bibliographic information published by **Die Deutsche Nationalbibliothek**.
Die Deutsche Nationalbibliothek lists this publication in the "Deutsche
Nationalbibliografie"; detailed bibliographic data is available
on the Internet at http://dnb.d-nb.de/.

The paper in this book meets the guidelines for permanence and durability
of the Committee on Production Guidelines for Book Longevity
of the Council of Library Resources.

Contents

Acknowledgements

I owe thanks to a range of people and institutions for helping me in various ways to complete this work. First and foremost, thanks are owed to Professor Chow herself, whose work has transformed and greatly enriched my thought on so many matters. It goes without saying that this book would not have been possible were it not for her! Secondly, I owe thanks to my students, at both BA and PhD level. The reaction of students has often reconfirmed for me both the need for and value of such a book as this—a serious and sustained study that seeks to set out some key coordinates crucial to establishing a thorough understanding and appreciation of the significance and impact of Rey Chow's work. Student reaction regularly takes the form of a familiar sequence: initial statements of confusion and comments about the difficulty of Rey Chow's work, followed quickly—as we work through the texts in seminars, tutorials and conversations—by a palpable kind of delight and even awe at the insights that Chow's work affords. Most importantly, though—and to an extent that I have rarely seen before—I have found that engaging with Chow's work translates directly into the production of more mature, insightful and compelling work on the part of both the students and the researchers with whom I have shared and explored Chow's work.

Several people have directly and indirectly prompted me to keep going in this direction, and to produce this book; most notably Colette Balmain, Floriana Bernardi and Patrizia Calefato. Colette Balmain on several occasions invited me to speak as keynote at the prestigious East Winds international conference and East Asian film symposium, held annually at Coventry University and the University of Warwick. She has always made it clear that these invitations came chiefly because of the fact that Rey Chow's work had infused my thinking on matters of film and culture, and that the work I was developing by way of exploring approaches to film and culture derived from Rey Chow was widely valuable. At the same time, Floriana Bernardi and Patrizia Calefato at the University of Bari in Italy also extended several invaluable invitations to me, enabling me to compose and to present work on (and occasionally in the company of) Rey Chow. These occasions have been of great value to me. Similarly, Matthew Phillips and Bianca Son Suantak kindly invited me to

give a keynote address at an international conference at the School of Oriental and African Studies (SOAS) at the University of London. Like all of the events listed here, this provided an important opportunity and occasion for me to engage with questions and themes that came to have a strong influence on this book. All of these events have enriched and sharpened my appreciation of the importance of Rey Chow's contributions to cultural, film, cross-cultural and postcolonial studies.

For reasons I describe in more detail in the Preface, I also owe thanks to Professors Terry Threadgold, Justin Lewis and Jenny Kitzinger, of the School of Journalism, Media and Cultural Studies (JOMEC) at Cardiff University. As Head of School, Justin Lewis has supported my research endeavors and activities both directly and indirectly—the latter in the form of ensuring a healthy and productive working environment in JOMEC, which fosters research and scholarship as well as collegiality and collaboration.

Others whose collaboration, conversation and collegiality have assisted my research and writing in different ways include Iain Chambers, Samuel Chambers, Hiu M. Chan, Zahid R. Chaudhary, Christopher Connery, Simon During, Maria Rosaria Dagostino, Jeroen de Kloet, Michael Dutton, John Frow, Bernhard Gross, Todor Hristov, Song Hwee Lim, Nasheli Jimenez del Val, Corbett Miteff, David Machin, Kerry Moore, Keiko Nitta, Alexis Nuselovici, Michael O'Rourke, Michael A. Peters, Marinos Pourgouris, John Seed, Richard Stamp, James Steintrager, Ye Weihua and Xin Zhang. Thanks also to Isabelle Gibbons for some close reading. Finally, thanks are owed to Chris Myers and all at Peter Lang in New York for being so supportive of this project; and also, as always, to my wife, Alice.

Preface

On 13 May 2008, Jodi Dean announced on her blog (*I cite*) that Columbia University Press was having a "white sale." I clicked the link, browsed the catalogue, and noticed a book called *The Protestant Ethnic and the Spirit of Capitalism* by Rey Chow. I had heard of Rey Chow. It was a familiar name. I owned at least one book in which an essay of hers—on Chinese literature—was anthologized. However, never having had much reason or inclination to study Chinese literature, I had browsed through this but had never seriously read any of her work. Yet the title of this book appealed to me immensely. This is because I had been involved in studying the ideology critiques of Slavoj Žižek for several years—or rather, I had been involved in an ongoing critique of Slavoj Žižek's approach to ideology critique—at the same time as I was also attempting to make sense of the complex of factors involved in the explosion of "Western" interest in "Eastern" martial arts and Eastern culture, philosophy and religion—an interest that hit and transformed the mainstream of international popular culture in the early 1970s, around the massive popularity of Bruce Lee's kung fu films.

Taking stock of this complex chiasmus or conjuncture demanded an engagement with many factors, including trying to work out the possible reasons for the emergence of a popular Western interest in East Asian philosophy. Žižek had more than once referred to the arguments of Max Weber—the author of *The Protestant Ethic and the Spirit of Capitalism*—in developing his own theory of ideology. In his pronouncements about "capitalist ideology," Žižek frequently referred to Buddhism and Taoism. But he did so in a very dismissive way. So, knowing that Rey Chow was a scholar both of Chinese literature and of cultural studies and film, and being tantalized by the way that her book's title played on Weber's title in such a way as to emphasize ethnicity, I was intrigued to find out what she might have to say about (presumably Chinese) ethnicity and capitalism.

When I opened my copy of *The Protestant Ethnic and the Spirit of Capitalism*, it changed everything. It had a massive impact on my thinking and indeed on

• READING REY CHOW •

my orientation in cultural studies. It introduced me to new perspectives on media, culture, ethnicity, gender, technology, history and identity, and it modified my understanding of many issues that I thought I was more than familiar with. So I immediately ordered the rest of Chow's published books and read them all in rapid succession that summer. I was moved to do so because I was excited by the implications and possible ramifications of Rey Chow's thought, not just for my own projects—specifically my slightly eccentric interests in martial arts and popular culture—but actually for cultural studies and film studies, as well as studies of visual culture, identity, gender and ethnicity much more widely. I began incorporating Chow's arguments and insights into all of my analyses of popular culture, cultural practices and film. But, given the breadth, depth and complexity of her writings, it took a great deal of sustained effort and engagement for me to feel like I had begun to grasp more completely, let alone synthesize and conceptually master her paradigms. The book you are now reading is one result of that effort.

At the time of first encountering Rey Chow's work, I was in the process of completing my third monograph, *Theorizing Bruce Lee*. On encountering Chow's work, I held off from submitting the manuscript of the Bruce Lee book until I could rework it in light of what I had started to be able to see and think anew thanks to the insights and perspectives provided by Chow's work. I also began to initiate other projects, organized by the dual aim of both personally exploring and of publicizing the existence, implications and ramifications of Rey Chow's work for cultural studies—specifically in the UK, where I did not believe Chow was well enough known or read—but also more widely.

Professor Terry Threadgold at Cardiff University agreed with me that it was indeed peculiar that Rey Chow's globally significant and internationally acclaimed work had somehow not more substantially made inroads into British academic and intellectual life in the fields of cultural studies, film studies and postcolonial studies. We reflected on this, and determined that, whatever the reason for it (whether it was perhaps a matter of uneven communication networks between, say, the US and the UK, or whether it reflected Britain's relative provinciality, or whether it was connected to demography or the structure of academic disciplines in the UK, and so on), it was a real problem that there was such a gap and such a significant absence here.

My sense that there was a peculiar situation in which on the one hand Chow's international significance was apparent whilst on the other hand her work apparently had a relative lack of visibility or prominence in UK-based cultural studies demanded interrogation and, I felt, intervention. I wanted to explore the reasons for it and to try to intervene to redress it, because I felt

sure that Chow's approaches could enrich British cultural studies. This remains so even if it is reasonable to propose that there are demographic, ethnographic, sociological and disciplinary reasons for Chow's prominence and recognition in both the USA and all across Asia, on the one hand, and also for her lesser prominence in the UK, on the other. For, put bluntly, it seems merely to reflect the fact that all of the different kinds of Chinese and Asian studies, and the related fields and problematics that currently flourish across the world are, in the UK, either comparatively small fields, or even non- or barely existent. But just because the arrangement, structure and relative weight of the disciplines in the UK does not seem conducive to the kind of cross-disciplinary communication networks, relays, flows and overflows that supervene elsewhere, this does not mean that Rey Chow's writings—even when they are focused on and organized by "China" or "Chinese" themes (which, in actual fact, is not all that frequently)—do not have a far wider currency. Indeed, as this book endeavors to demonstrate, Rey Chow is a lot more and other than a "mere" scholar of China, Chinese film, and/or diasporic Chinese and Asian identity. As each chapter sets out in different ways, her interventions traverse and enrich—even transform—multiple fields.

Before writing this book, as a way to begin to affect an intervention, I asked Professor Chow whether I could compile a collection of her essays into a Reader. She graciously consented, and *The Rey Chow Reader* was the result.

At the same time, Terry Threadgold and Jenny Kitzinger enabled me to set up a seminar series under the aegis of the *Race, Representation and Cultural Politics Research Group* in the School of Journalism, Media and Cultural Studies (JOMEC) at Cardiff University. The Head of School, Justin Lewis, and the Head of Research, Jenny Kitzinger, approved the venture and supported it financially—support that enabled me to run seminars and conferences, often with no charge to delegates, attendees and invited speakers, from 2009 to the present day. I also invited an international and cross-disciplinary group of scholars to participate in an edited collection on her work, and the result was not one but two special issues of the respected international academic journals *Social Semiotics* and *Postcolonial Studies*, each focusing on Rey Chow's work.

The book you are now reading, *Reading Rey Chow*, represents for me what is a logical conclusion to this stage of my intervention: a sustained engagement on my part with Rey Chow's work. I do not see this as the final culmination or the entirety of the intervention. In fact, I (obviously) have no idea what will become of it. But my hope is that it will be read not just by students and scholars of China, Chinese studies, Chinese diaspora, Chinese film studies, Asian identity studies, etc., but also by those working in cultural studies and

postcolonial studies—at least some of whom will hopefully be based, like me, in the UK. I want this because I believe that the approach, the paradigms, the analytical techniques and the overall orientation of Rey Chow's work offers a lot more to cultural studies—when cultural studies is viewed as a historical, institutional, political or politicized project—than many, if not all, of the approaches currently on offer to cultural studies—whether these involve "following" this or that famous "name" (such as Žižek, Deleuze, Rancière, Agamben, Badiou, or whoever else) or following arts, aesthetics, technology or "technicity," or indeed whether travelling more straightforwardly disciplinary forms of practice (such as this or that school of empirical "discourse analysis" like CDA, content analysis, or other "scientific" approaches). Of course, this may seem to be self-contradictory, given that I am pushing "Rey Chow"—i.e., a "name"—onto readers. But hopefully it will become apparent that I am not arguing for any particular type of devotion or fidelity to a figure or to a school. Rather, I want to take forward some of the critical advances of cultural studies and postcolonial studies, advances that I fear are in danger of being lost during the long march through the university institution—whether scattered to the winds like the traces of a diaspora, or washed over, smoothed out and erased like marks in the sand, in the path of a rising tide.

I engage these questions more fully in the following chapters; chapters which each have a unique and different focus, but which are all exercises in *reading* Rey Chow, and doing so with a sustained attention to questions of visuality, postcoloniality, ethnicity, sexuality, discourse and textuality, topics which are recurrent concerns in Rey Chow's work, and fields to which her work makes many important contributions.

Reading Rey Chow: Visuality, Postcoloniality, Ethnicity, Sexuality

Rey Chow completely restructures the problem of ethnicity; all future discussions and debates will have to come to terms with it.

– Fredric Jameson

[Rey Chow] should be read by all who are concerned with the future of human rights, liberalism, multiculturalism, identity politics and feminism.

– Dorothy Ko

Rey Chow is one of the most learned and imaginative left critics writing today.... Elegantly traversing philosophy, literature, history, and politics, Chow refracts our political times through our academic practices in a fashion that is alternately pedagogical, biting, lyrical, and profound.

– Wendy Brown

The epigraphs above go some way to indicating the importance of Rey Chow's work for multiple fields of intellectual, critical, academic and political work. The book you are currently reading is the first single-authored monograph on the work of a thinker whose body of work to date is— as E. Ann Kaplan puts it, in another review—not merely "brilliant" but actually nothing less than "essential for all literary, cinema, and cultural studies scholars" (Chow 2002: cover). There will doubtless be many more studies like this one over time, because Rey Chow's interventions into multiple fields—film, feminism, cultural studies, postcolonialism—have massive importance and implications for these disciplines. To employ one of Rey Chow's own favored

terms, her work will come to *translate* and thereby to transform such fields. One reason for this is because, in the words of one review in the journal *Social Semiotics*, Chow's work is always "methodologically situated in the contentious spaces between critical theory and cultural studies, and always attending to the implications of ethnicity" (Chow 1998: cover). As such, her work "constitutes a unique intervention in contemporary cultural politics." *China Information* puts it like this: Chow always gives us "rich and powerful work that provides both a dazzling synthesis of contemporary cultural theory and at the same time an exemplary critique of Chinese cinema" (Chow 1995: cover). And as indicated in the epigraphs above, Dorothy Ko has asserted that Rey Chow "should be read by all who are concerned with the future of human rights, liberalism, multiculturalism, identity politics and feminism" (Chow 2002: cover). Fredric Jameson argues that Chow's work is not only "wide-ranging, theoretically rich, and provocative," but that it actually "completely restructures the problem of ethnicity"—and to such a profound extent that "all future discussions and debates will have to come to terms with it" (Chow 2002: cover). Wendy Brown calls Rey Chow "one of the most learned and imaginative left critics writing today," with writings that are always "pedagogical, biting, lyrical, and profound" (Chow 2006: cover).

The book that you are reading is the consequence of a four-year period of research and engagement with Rey Chow's work, one that could be regarded not merely as a personal endeavor but also as one moment in the wider processes of coming to terms with the significance and challenge of Rey Chow's work for cultural studies and postcolonial studies in film, ethnicity, identity and visual culture. This is a book about the work of a diversely and diffusely stimulating and important thinker, a book I hope will be of use to students and researchers new to Chow's approach, and a book that sets out some of the significance and consequences of her work's interventions into several disciplinary fields and schools of thought. And both of these are necessary. For Chow's books and articles are always of such range, depth, sophistication and currency that, as *China Information* puts it (in very generous terms), they call out "to be read and re-read." Another way to make this same point (less generously) would be to say that Rey Chow's works are so difficult that they *have* to be read and re-read! This is certainly the kind of comment that I am familiar with, having heard the likes of it from more than one undergraduate, postgraduate student, and professional academic.

This complexity no doubt derives from the fact that, as Wendy Brown expresses it—again in a very generous and supportive way—Rey Chow's works are always interventions that "elegantly travers[e] philosophy, literature, history,

and politics," and which "refract our political times through our academic practices." Again, this observation might be phrased very differently. For, from the point of view of both the neophyte (such as the new student of cultural studies, feminism, film studies or postcolonial studies) and from that of any of many disciplinary (hidebound) positions and perspectives, what Wendy Brown represents as Rey Chow "elegantly traversing" many fields could just as easily be represented as Rey Chow producing convoluted or hugely complex and even impenetrable jumbles of works. This is a risk and a possibility that must be taken seriously, and which this book seeks to "head off at the pass," so to speak. It argues that Rey Chow's work deserves to be read and understood for important critical and political reasons by both new student and established academic, and by both theorist and activist alike. It is true that Chow's work is often complex. But, as I hope will become clear, this is because her work always carries with it a demand of and for rigor and responsibility—a demand of which more students and academics should be made aware and to which they should be challenged to respond. In this demand "there is nothing consolatory," says Eric Hayot: "one is faced simply with the imperative to think harder and better about the problems that face back from the surface of the world" (Chow 2002: cover).

Such a complex and detailed approach to film, ethnicity and culture as Rey Chow's demands an introduction. This book seeks to provide such an introduction, and to act as a critical guide; to be both an orientation into Rey Chow's approach to cultural studies and cultural politics, and to constitute a new intervention into the practices of cultural studies and thinking about approaches to cultural politics in itself. More modestly put, my hope is that the book will be a helpful preliminary or companion read for new readers of Rey Chow, whilst also remaining useful for all who are studying, researching and teaching in the interlocking and overlapping fields of film, visual culture, cultural studies, ethnography, sex and gender, postcolonialism and fields like Asian studies and area studies.

I felt the need for such a book because although it is increasingly acknowledged by more and more of prominent thinkers in the disciplinary realms of postcolonialism, cultural studies, cultural theory, feminism, visual culture, ethnicity, ethnography and film, that Rey Chow is one of the contemporary theorists and critics whose work (as Bill Brown says) "will shape the future" of these fields, it remains the case that no sustained assessment of her intervention yet exists. This book aspires to address this lack. The need for, status and value of such a book becomes apparent when one considers that her work has been translated from English into Japanese, Chinese, Korean, French, Italian,

Spanish, German, and Bulgarian. Her books have received major awards, including the James Russell Lowell Prize (for *Primitive Passions* (1995)), which is the most prestigious book award given by the Modern Language Association in the USA—the first time that award was ever given to a book on an Asian culture topic and on the study of film. Her work is at the cutting edge of many contemporary fields, and has the rare—indeed, arguably unique—feature of always containing both clear and incisive accounts and compelling critiques of the key figures, arguments and movements of these cultural, political and intellectual fields (both of their history and their current contemporary configurations, intellectual figures, arguments, movements and cutting edges) *and* developing her own highly innovative and productive approaches. Her original and incisive critiques of events, texts, discourses, figures, problems and problematics are always matched by positive suggestions for significant new methodological, ethical and political interventions.

Moreover, it is important to note that of the scholars working on modern China, Chow is the only one with a reputation that extends well beyond the confines of China and Asian studies, and whose works have been translated into so many languages. This is surely because Chow, in addition to being a scholar of modern China, is also—if not primarily—a preeminent critic of modern literary and visual culture in the league of prominent figures such as Butler, Hall, Jameson, Kristeva, Spivak, and Žižek. The topics addressed in her work (representation, cultural politics, ethnicity, visuality, and popular lyricism, to name just a few) are consistently of a comparative nature, and their theoretical implications speak to a wide disciplinary and international audience. At the same time, Chow's modes of analysis are distinguished by the juxtaposition of critical concerns that may not at first seem related but that in fact share profound (epistemic) affinities—for example, the nonwhite native and the white man's "symptom"; ethnic mothers and extinct dinosaurs; high theory and area studies; avant-garde film and the politics of ethnicity, and so on. As many people have noted, Chow's writings always challenge our most comfortable assumptions, and while she deconstructs such assumptions, she also surprises us with her original ways of revealing the most unexpected connections among heterologous phenomena. As such, a focused engagement with this oeuvre is clearly both timely and necessary, and will be of enduring importance.

Chow's first book, *Woman and Chinese Modernity* (Chow 1991) was the first book-length study of modern Chinese literature to foreground "modernity" as a problematic rather than just using the adjective "modern" as a given—which was what most scholars did before that book was published. Since then, nu-

merous scholars in the China field have followed suit and adopted "modernity" in their book and essay titles. It would therefore not be an exaggeration to say that Chow's book brought about a conceptual paradigm shift, after which it became no longer sufficient to continue to study modern China from the Cold War perspective. Rather, *Woman and Chinese Modernity* made it necessary to rethink modern Chinese literature and culture in conjunction with a globalized modernity, which is articulated not only to the well-defined aesthetic concerns of (European) modernism but also to the larger contexts of colonialism and postcoloniality.

This first book also helped to broaden and redefine the research agenda on modern Chinese literature and culture in a number of ways: by explicitly focusing on gender and sexuality; by linking the role played by popular/mass literature thriving in an urban context of commodity fetishism dialectically to the "canonical" modern literature of the May Fourth period; by emphasizing the role of film as a way of seeing China, and with it, the status of China as a spectacle on the international scene. In subsequent years, various concepts and projects that are theoretically traceable to Chow's work have appeared in the modern China field: for example, a "repressed modernity" as may be found in late imperial Chinese fiction; an "ethnic spectator" as emerging from popular literature of the Mandarin Duck and Butterfly genre; the translator who does not simply translate but mediates between Chinese and Western mores through the work of translation; the use of Walter Benjamin's study of 19th-century Paris as a comparison with early 20th-century Shanghai and other urban experiences of modern China.

The books *Writing Diaspora* (1993) and *Primitive Passions* (1995) have likewise inspired numerous follow-ups, as can be seen in the many works that have been published on diaspora, cultural politics and Chinese cinema since these titles appeared, or that make use of Chow's logics of argument, usually with but also now sometimes without acknowledgment. Similarly, Chow's subsequent four books—*Ethics after Idealism* (1998), *The Protestant Ethnic and the Spirit of Capitalism* (2002), *The Age of the World Target* (2006), and *Sentimental Fabulations, Contemporary Chinese Films* (2007)—have each opened distinctive possibilities for discussing ethics, ethnicity and capitalism, the globalization of war and academic studies, as well as the tenacity of sentimentalism in contemporary Chinese cinema.

Ethics after Idealism: Theory—Culture—Ethnicity—Reading argues that the necessity of a critique of idealism constitutes an ethics in the postcolonial, postmodern age, by way of readings of theorists from Slavoj Žižek and Gayatri Spivak to Frantz Fanon, from songwriter Luo Dayou to poet Leung Ping-kwan,

and from the film *M. Butterfly* to the films *The Joy Luck Club*, *To Live*, and *Rouge*. The readings she offers involve multiple cultural forms, including fiction, film, popular music, poetry, and critical essays, as well as a range of cultural topics, including pedagogy, multiculturalism, fascism, sexuality, miscegenation, community, fantasy, governance, nostalgia, and postcoloniality.

In the highly celebrated book, *The Protestant Ethnic and the Spirit of Capitalism* (2002), Chow argues that although in late-capitalist Western society, cross-ethnic cultural transactions are an inevitable daily routine, nevertheless, the notion of ethnicity as it is currently used is theoretically ambivalent, confusing, and ultimately self-contradictory. This is because it straddles an uneasy boundary between a universalist rhetoric of inclusion on the one hand, and actual, lived experiences of violence and intolerance on the other. Chow explores the vicissitudes of cross-ethnic representational politics in a diverse range of texts across multiple genres, including the writings of Georg Lukács, Michel Foucault, Max Weber, Jacques Derrida, Fredric Jameson, Etienne Balibar, Charlotte Brontë, Garrett Hongo, John Yau, and Frantz Fanon; the films of Alfred Hitchcock, Marguerite Duras, and Alain Resnais; and the cartoon drawings of Larry Feign. Tracing out hauntingly familiar scenarios from stereotyping and coercive mimeticism to collective narcissistic abjection, the rise of white feminist racial power, and intra-ethnic *ressentiment*, Chow articulates a series of interlocking critical dialogues that challenge readers into hitherto unimagined ways of thinking about an urgent topic. This work has received an enormous amount of critical praise.

Similarly, *The Age of the World Target: Self-Referentiality in War, Theory, and Comparative Work* (2006) has been called "a catalyzing tour-de-force" in which "Chow provides a poignant, persuasive staging of a topic that will shape the future of literary and cultural studies [by reconceptualizing] the role of particular poststructuralist claims within the fields of area studies, identity politics, and comparative literature" (Bill Brown). For, here, Chow argues that in the age of atomic bombs, the world has become a *target*—to be attacked once it is identified, or so global geopolitics, dominated by the United States since the end of the Second World War, seems repeatedly to confirm. Accordingly, Chow enquires into the problem of how to articulate the problematics of knowledge production with this aggressive targeting of the world. Thus, she probes the significance of the chronological proximity of area studies, poststructuralist theory, and comparative literature—fields of inquiry that have each exerted considerable influence but whose mutual implicatedness as post-war U.S. academic phenomena has seldom been theorized.

In her more recent and again highly praised monograph, *Sentimental Fabulations, Contemporary Chinese Films: Attachment in the Age of Global Visibility* (2007), Chow examines nine contemporary Chinese directors (including Wong Kar-wai, Zhang Yimou, and Ang Lee) whose accomplishments have become historic events in world cinema. Approaching these works from multiple perspectives, including nostalgia, feminine "psychic interiority," commodification, biopolitics, migration, homosexuality, kinship, and incest, and concluding with an account of the Chinese films' surprising affinities with *Brokeback Mountain*, Chow demonstrates how the sentimental consistently appears in stories and pictures not of revolution but of compromise, not of radical departure but of moderation, endurance, and accommodation. "Sentimental fabulations," therefore—artifacts of cultural transition exhibiting special conceptual logics of their own—are first and foremost contemporary Chinese cinema's invitations to the pleasures and challenges of cross-cultural thinking.

Chow's most recent monograph, *Entanglements, or Transmedial Thinking About Capture* (2012), is less "placeable" within one or more disciplinary context than her earlier works. This is because it traverses more and more fields, objects and approaches than are commonly tackled together. And it does this because of a commitment to the complexity of textual, discursive and other relations—*entanglements* that respect neither disciplinary nor national borders.

In addition to these critically acclaimed monographs, Chow has often been invited to contribute keynote articles and chapters to often trailblazing journal issues and fundamental texts across these several interlocking fields. Her works are increasingly anthologized and many articles, chapters and sections of chapters have been included in now-canonical texts in the fields of feminism, cultural studies, film studies, visual culture, Chinese studies and postcolonialism. The range, scope and significance of Rey Chow's intervention and impact is indeed immense.

So, to compose a book focusing on the interdisciplinary contribution of the work of Rey Chow to postcolonial studies and other fields in and around cultural studies is likely to make immediate sense both to new and established readers of Rey Chow, who will receive the idea of a sustained engagement with the work of such a subtle and complex thinker to be valid and timely as well as justified in its own right. This is not to say that Chow's work has an easily or clearly defined place within or in relation to the field(s) of cultural studies or postcolonial studies; nor is it to say that Chow's work is simply "understood" as an agreed part of an accepted place of postcolonial cultural studies. As I have already hinted, her work—perhaps precisely because it is so interdisciplinary—offers distinct challenges to many established positions in and around

feminist, ethnic, cultural and postcolonial studies. This is not least because it has such a complex and intimate awareness of and sensitivity to the intricacies of the interlinked problematics of class, feminism, ethnicity, history, translation, comparative work, poststructuralist theory, popular culture, literature, film and technology. It is also because Chow's readings are all informed by a sensitive and responsive awareness of the imbricated genealogies and lines of force that have constituted and structured these fields, and the often subterranean pressures and movements that condition and overdetermine such academic fields and other cultural discourses' distances, relations, encounters, hybridizations, ruptures and consolidations. So it is to the matter of *reading* that we shall now turn.

Rey Chow Reading Postcolonialism and Poststructuralism

A s more than one reader of Rey Chow has observed, the challenges and values of Chow's work arise because it has such a comprehensive and active relationship with the very activity of *reading*. James Steintrager puts it like this:

> [The way that] Chow constructs her analyses...suggests an ongoing passion for close reading and interpretation, albeit mingled with a skepticism about institutional interests, the prestige of literary studies, and the values of close reading. She loves theory in a way that can appear alarmingly irreverent to the disciple because she reads it less for what it is—for what it reveals—as for what it does. (Steintrager 2010: 300)

Steintrager's intermingling of two putative opposites—*reading* (and, what is more, *reading Theory*) and *doing*—is significant. For, these two terms (reading and doing; theorizing and doing) are all too easily opposable, and they frequently acquire the values of passivity to activity and, hence, negative/inferior to positive/superior. The consequences of such oppositions become apparent when faced with the set of questions that are almost begged by the very term "Theory." For what is the *object* of "Theory"? What is the *other* of "Theory"? Or, indeed, what is the *point* of "Theory"? There are certain answers that are almost ineluctably preprogrammed into such questions. These answers include highly valuing terms like *practice, action, doing, reality*, etc.—all of which seek to consign "Theory" to the category of the inferior and the less important.

However, Steintrager's formulation suggests that, in the work of Rey Chow, such putative oppositions are to be regarded not as clear and stable opposites, but rather (following Jacques Derrida's work on this problem) as *reciprocally reinforcing and subverting relations of supplementarity*. In other words, these

are "oppositions" whose stability can easily be destabilized and whose destabilization has consequences for the way we think of "theory" and the way we think of "practice," as well as the ways in which we think of the "point" and the "other" of our intellectual, academic and institutional work. Steintrager is, of course, not alone in following such a line. For instance, in an essay on the work of Rey Chow called "Theory, Thresholds and Beyond," Iain Chambers explores Rey Chow's consistent attention to what he calls the "exteriority" of theoretical work, and to what lies *beyond* the academy and *outside* the West (Chambers 2010). Chambers does so in order to route scholarly work through those non-authorized spaces in which we are required to consider how the rest of the world invariably becomes something more or less like a *target* for Euro-American theory. The purpose of Chambers' essay is to examine how Chow's intellectual enterprise consistently raises the shadows of worldly conditions that interrupt and interrogate the very conditions of academic discourse. Theory is here confronted in a post-colonial world in which the multiplication of perspectives necessarily de-stabilizes "Europe as the grid of intelligibility"—a phrase that Chow takes from Michel Foucault's studies of knowledge (as we will explore in subsequent chapters).

Chow has often clarified the way that certain self-declared "others" or opponents of "Theory" (those hostile to cultural theory and poststructuralism, for instance) may have a distaste for theory because they wish to be "for" reality, practice, or practical engagement, and so on. Yet just because they are "pro" this and "anti" that, they themselves remain just as "merely academic" as the theorists they disparage (and vice versa, of course). Yet, Chow goes on to point out that, whether pro or anti theory and whether pro or anti practice, *all* such academic polemics exist in relations and have consequences that are far from "merely academic." As we will see in the next chapter, Chow has drawn our attention to the fact that area studies, for instance, is a disciplinary field which, in Chow's words, "has long been producing 'specialists' who report to North American political and civil arenas about 'other' civilizations, 'other' regimes, 'other' ways of life, and so forth" (Chow 1998: 6). However, quite unlike the declared aims of fields like cultural studies and postcolonial studies (with their affiliative interests in alterity and in "other cultures"), within area studies, "others" are "defined by way of particular geographical areas and nation states, such as South Asia, the Middle East, East Asia, Latin America, and countries of Africa" and are studied as if they are potential threats, challenges and—hence—ultimately as "information target fields" (Chow 1998: 6).

In a closely related discussion, in an essay called "Hybrid Disciplinarity: Rey Chow and Comparative Studies," John Frow explores Chow's reflections

on comparative literary studies, not only as manifested in her book *The Age of the World Target* (Chow 2006), but also, more generally, throughout her exemplary practice of inter- and cross-disciplinary work. He does so in order to pose the related question of the "comparative." The significance of the question of comparison which Chow focuses through a consideration of the historical field of comparative literature is elucidated once more through its relations with area studies, the field that may be regarded as a kind of monstrous double of postcolonialism and cultural studies. Frow scrutinizes and builds upon Chow's analyses of the intellectual, ethical, aesthetic and paradigm problems of comparison, in an analysis of the constitution of disciplinary objects, disciplinary fields, and "approaches" per se. He argues that Chow's comparative practice is elaborated "not as an exercise performed upon a common ground, but as the drawing together of incommensurable places and objects of knowledge" in a way which works to "to generalise the condition of otherness."

Similarly, Marinos Pourgouris has focused an analysis of Chow through the vexed registers of "theory," in an essay called "Rey Chow and The Hauntological Specters of Poststructuralism" (Pourgouris 2010). This work discusses the perceived gap or "crisis" between postcoloniality as praxis, activism, performativity, counter-hegemony, and so on, on the one hand, and its imbrication in poststructuralist discourse on the other. Pourgouris' overarching affirmation is that at a time when the humanities are feeling the symptoms of a crisis that might be traced, to a large extent, to the "barrier" that is at once the gap between the West and the Rest and also between aesthetics and the praxis of life, a re-examination of Rey Chow's position is not just "illuminating," it is, according to Pourgouris, *necessary*. Of course, "necessity" in academic and intellectual fields is often an easy claim to make but always a hard one to prove. This is no doubt related to the contingencies structuring the conditions of audibility, "hearing" or "listening" within and across academic "fields." Indeed, as James Steintrager points out in his essay, "Hermeneutic Heresy: Rey Chow on Translation in Theory and the 'Fable' of Culture" (Steintrager 2010), few—if any—theorists and writers within translation studies have taken up the challenge to hermeneutics that Chow posited and explored specifically with regard to Fifth Generation Chinese filmmakers in *Primitive Passions* (Chow 1995). Chow's challenge, Steintrager claims, resides in her focus on *mediation* as key to understanding both identity formation and the construction of "culture" itself. In his unfolding of Chow's work, Steintrager argues that hermeneutics and the translation theory derived from it are largely products of *print* media. The shift to *film* in the global marketplace has un-

dermined the conceptual apparatus of both. We will discuss this further in the following chapters. But for now, a few further preliminary comments should be made about "cultural translation."

If Chow demonstrates what Frow represents as a general condition of otherness, then what become increasingly called into relief are the problems of engaging with this often unexpectedly "unbound" alterity. Hence, what keeps coming to the fore, both in Chow's work and in critical responses to it, is the central usefulness of the notion(s) of translation. As a theoretical problematic and an academic discipline in its own right, translation is not a new cultural and intellectual field, of course. However, what Chambers, for example, clarifies in his article on Chow is the perhaps unique—certainly uniquely insistent—accent given to the meaning and "work" of the notion of translation in Chow's approach. As Chambers puts it:

> Translations are neither neutral nor passive, and this cultural turbulence is most sharply exposed, Chow argues, in contemporary mass culture. It is here, beyond the narrow premises of literary and philosophical concerns, that the question becomes most "legible" and significant in its consequences. The ubiquity of contemporary mass culture challenges facile distinctions and anxious separations. The elements to be compared, to be translated, are con-temporary and coeval: they occupy a shared time and space, invariably inscribed in the same objects and languages. Such proximities, leading to inevitable contamination and creolisation, seeded with mutual affects, promote a new critical configuration. (Chambers 2010: 262)

Thus Chambers elucidates Chow's attentiveness to the status and work of different sorts of translation throughout culture; and, crucially, "beyond the narrow premises of literary and philosophical concerns."

This "beyond" is another key dimension to the important nature of Chow's interventions. As argued more fully in the following chapters, Chow's work tests and explores theoretical and philosophical interpretive machines and positions by way of very close and yet wide ranging readings of all manner of "objects," unconstrained by contingent disciplinary demarcations (such as those between literature, media, popular culture, film, identity, and so on) and led rather by what Frow calls "the drawing together of incommensurable places and objects of knowledge" (Frow 2010: 273) in a way that reveals the complex discursive relations, reticulations, implicit and explicit interconnections between as well as gaps, hiatuses, aporias and barriers across putatively separate "realms."

Accordingly, other studies of Chow's work have engaged with different dimensions of its implications, and amplified its importance and productivity for different discourses and disciplinary contexts. In "Fashion as Cultural

Translation: Knowledge, constrictions and transgressions on/of the female body" (Calefato 2010) for instance, Patrizia Calefato connects Chow's important insights about the status of film as a specific kind of cultural translation to the realms of fashion and the politics of ethnic identity. A theory of "the image" is key here, and this is precisely what Zahid R. Chaudhary homes in on and explores in his analysis of Chow's theory of the image, "The Labor of Mimesis"—a text which traverses and connects visuality and translation in Chow's work (Chaudhary 2010).

"Translation," as a theoretical problematic and as a diversely lived reality, is prominent both in Chow's works and in different ways in much work inspired by her. But the practical and theoretical stimulation of translating Chow's work from English to Italian is the focus of Maria Rosaria Dagostino's study, "With great affection: Translating Rey Chow: listening and emotion"—a work which elaborates the *différance* both of Chow's language(s) and of "itself," as an "originally" uneasily Italian reflection on an English text in which the translator perceives evidence or traces of a Chinese linguistic element that is self-consciously and self-reflexively played and erased to produce a particular kind of academic work that, Dagostino claims, not every translator could actually translate (Dagostino 2010).

Other Chow-inspired texts explore questions of ethnicity and cultural translation in different but intimately related respects. For instance, Keiko Nitta explores the trailblazing transnational travellers that are Bruce Lee's martial arts films of the early 1970s. Keiko Nitta's article, "An Equivocal Space for the Protestant Ethnic: U.S. Popular Culture and Martial Arts Fantasia" (Nitta 2010). This begins with a reflection on the importance of Bruce Lee for the very palpable kind of cross-cultural migration and dissemination that arose through and in the wake of his films, and ties this to a reassessment of a generation of academic work which approached Bruce Lee in terms of questions of "models of masculinity" and what becomes, in the light of Chow's interventions a clearly *protestant* understanding of "ethnicity." (Bruce Lee will return in the penultimate chapter of this book too, as an interesting site of "cultural translation.") The object shifts in other articles on Chow, but the ethico-political impetus and concerns do not: all of the best works on Chow are inspired and motivated by the insights of her lucid and rigorous focuses. Floriana Bernardi's "Gazes, Targets, (En)Visions: Reading Fatima Mernissi through Rey Chow," focuses on the representation of the female in the contexts of classic orientalism in culture, discourse, art and contemporary news media (Bernardi 2010). Bernardi articulates Chow's textual and often theoretical work with the often-empirical work of Fatima Mernissi, in order to clarify

some important points of connection, particularly in terms of the questions of visuality and power-knowledge in relation to Islamic women.

With yet another focus, Todor Hristov engages Chow's contributions to thinking governance and biopower, in his essay "Making Difference Work: Post-Socialist Biopolitics through the Lens of Rey Chow" (Hristov 2010). This work is explicitly focused on macropolitical biopolitical strategies and discursive logics in Bulgaria—a world away from Jeroen de Kloet's use of Chow in "Created in China and Tozer Pak's Tactics of the Mundane" (Kloet 2010), which focuses entirely on the art scenes in various Chinese locations, such as Shanghai, Beijing and Hong Kong. However, what both articles demonstrate are the intricacies of the articulation of biopolitical strategies and the central and cortical status of ethnicity within even such apparently distant or distanced contexts.

The formidable interplays across and between the many different fields and problematics that Chow's work engages and elucidates is, then, a primary reason a book like *Reading Rey Chow* is called for. Yet, still, some might enquire into the reasons for or value of the type of genealogical, forensic and analytical complexity that Chow's work entails. There is no simple reason for Chow's indisputable complexity. But Chow's work ought to be understood in the light of and in terms of a very particular ethico-political intellectual project. This can be aligned (at one and the same time and for one and the same reason) with the supposedly rivalrous or antagonistic realms of deconstruction, poststructuralism (or "Theory") and cultural studies, cultural politics or approaches which valorize "practice" ("politics," "action"). As will be laid out in more detail in the next chapter, and in the conclusion, Chow implicitly and explicitly follows a line of reasoning that has been expressed by Stuart Hall as the need to say "yes" and "no" *both* to the necessity of theorization and rigorous academic analysis *and* to the urgencies and exigencies of ethical and political issues (Hall 1992). Put bluntly, then, my contention would be that Chow's position may be rendered like this: *yes*, there is a need to organize our thinking and our efforts around important ethical and political problematics, but, *no*, these urgencies do not mean that we should renounce strenuous and rigorous *reading*, theorization, analysis, and even the much-decried process of subjecting ideas and arguments to Derridean deconstruction's "interminable ordeal of the undecidable." In other words, then: *yes*, there is a need to be almost hyper-academic, in order to avoid falling into casual, imprecise and quite possibly skewed lines of thought, connections and conclusions, but, *no*, this should not be taken to stand in for politics, action or intervention *per se*, even as it participates within, supplements and translates such notions.

One may discern a dizzying logic of fidelity (and its vicissitudes) at play here—a sense in which fidelity shades into, warps or transforms into, its nominal opposite, infidelity. It is certainly the case that Chow always proceeds in full awareness of the perspectives afforded by deconstructive approaches. Indeed, Chow arguably owes a great deal to Derrida, even if her work more frequently acknowledges the influence of other thinkers, including Foucault, Benjamin, Lukács, Lacan and prominent feminist film theorists, such as de Lauretis, Mulvey and Silverman, for instance. But in all cases (and following a torsion that I identify with deconstruction), as Steintrager contends, "Chow's approach certainly *translates* theory—betraying and faithful at the same time" (Steintrager 2010: 301). As readers of Chow's reworking of the notions of translation in "Film as Ethnography: Translation in a Postcolonial World" (the essay which concludes *Primitive Passions* and which we will look at more closely in chapter five) will be aware, this faithfully betraying translating dimension to Chow's work certainly encompasses her relation to deconstruction: in "Film as Ethnography," Chow reads and deconstructs Derridean and Demanian approaches to and understandings of translation. But nevertheless—indeed, perhaps, given Chow's complex relation to Derridean deconstruction—a brief account of certain of the relevant aspects of Derridean deconstruction that seem to be consistently operative (subversive) and influential in Rey Chow's thought will be justified and helpful at this point.

In Fidelity to Deconstruction

Although there are arguably many ways that it would be possible to broach an introduction to or reiteration of some key points of deconstruction—via the logic of the *supplement*, or *différance*, *dissemination*, *monolingualism*, or *hostipitality*, and so on and so forth—"perhaps"—it seems appropriate to begin where we are, where we find ourselves, where we have just been: in terms of a consideration of the logic of fidelity.

Derrida once expressed the unstable relation of fidelity in the following formulation: "I am a monster of fidelity, the most perverse infidel" (Derrida 1987: 24). With this, he provided a very concise insight into the strategy and effects of deconstruction: namely, being so faithful to whatever one is engaged with that one effectively warps it. Despite the obvious violence of such transformation, deconstruction is still often mistaken to be a peaceable and beatific activity. But as Derrida insisted: there is *no* escaping from relations of force and economies of violence (Protevi 2001). So, unless deconstruction is some-

how exempt from the law it identifies, then its own strategies and operations must also be irreducibly violent. Chow's work, as we have seen, clearly displays an intense awareness of this

In the face of the constitutive character of violence, perhaps the key saving grace of Derridean deconstruction could be Derrida's insistence that *therefore* there is an injunction to strive for "the lesser violence" (Derrida and Bass 2001: 313, note 21). Yet this does not mean that deconstruction *is* a lesser violence. In fact, it doesn't really mean anything—yet. Affirming the "quest" for the lesser violence doesn't tell us what "the lesser violence" is, or how to find out, or how to institute it; just as *claiming* that one *should* try is not necessarily *to* try. And moreover, the earlier point remains that the very effort to be "faithful" *will* amount to a kind of monstrosity. Derrida, it seems, was unequivocal on this. Yet, in the name or the aim of "the lesser violence," he always maintained that his main efforts were simply to *read* texts, to try to follow them as faithfully as possible. Of course, as Gilbert and Pearson have pointed out, this was "not simply an engagement with a handful of philosophical texts, but [rather an examination of] some of the terms according to which almost all thinking occurs" (Gilbert 1999: 57). So, although Derrida mainly read and wrote (monstrously faithfully) about supposedly "mere" philosophical texts, these texts are to be understood, in the words of Protevi, as "indices of real history," produced by and productive of particular biases: effects that have effects— particularly that of the Western philosophical preference for "presence" and the skewing bias that this preference has exerted over theory and practices of all orders. This discursive bias "is thought by Derrida under the rubric of 'force'" (Protevi 2001: 20). Thus, Derridean deconstruction is a perversely faithful "reading" which—in tracking the movements of arguments and the conceptual systems, values, legislations and institutions that underpin them— foregrounds what John Protevi calls the "interweaving of force and signification," revealing that signification and meaning are constituted forcefully. Sense is *made*. There is no *natural* meaning. Sense is *instituted*, with serious effects.

In other words, deconstruction foregrounds the ways in which Western rationality (as exemplified by Western philosophy) can be regarded as irreducibly violent. Derrida's own work may be regarded as something of a response to this violence, itself doing a kind of reciprocal violence to the institutions of philosophy because of the ways that the philosophical fantasy of "reason allegedly free [from] force" has been used to "justify hierarchical patterns of social forces" (Protevi 2001: 63). For, on this reasoning, reason is not free from force; there are violent exclusions, privileges, hierarchies; and the fantasy of

"reason" has itself been used to "justify hierarchical patterns of social forces." Thus, Derrida reiterates and deepens Walter Benjamin's point that "There is no document of civilization which is not at the same time a document of barbarism" (Benjamin 1999: 248). Deconstruction, then, is animated by violence and is itself a violent operation. But strangely so; for, the "violence" of deconstruction arises from a fidelity to *reading*—or, in other words, *a fidelity to the other with which one is intimately engaging.* Its "violence" arises from an almost loving fidelity—an *over*-faithfulness; to use Slavoj Žižek's term, a kind of "overidentification" (Butler, Laclau and Žižek 2000: 220); and, of course, its characteristic (putatively excessive) *over*-analysis, and *over*-interpretation.[1] But this is not the kind of violence arising from a *blind* or *over-zealous* lover's fidelity—such as that of the lover who becomes jealous, obsessed or mad and perverts into a stalking, controlling monster. Nor is it that of interpreting fidelity to a text (or god or country or whatever) as demanding militancy, fundamentalism, millenarianism, separatism or genocide. It is ("ideally") not the violence of the jealous zealot, the fundamentalist, or stalker (who have their sacred objects); but merely that of asking—for instance—precisely *how* "*rational*" supposedly Rational institutions are, how conclusive conclusions are, and why certain kinds of connections and steps are made in argumentative constructions. This is why deconstruction is, in Derrida's words, both "very strong and very feeble" (Derrida 1997: 42): it is weak, it has no power of its own; but it is strong, as it calls the other to task in its own terms. It is often a strategy of "literalization"—of simply *looking for* that which is claimed or assumed to be real, present, actual or true (such as the notions of *presence, justice, responsibility, univocal truth*, etc.).[2] In looking, it reveals that these are both undecidable *and yet* forcefully imposed, in contingent institutional forms. As Derrida spelt it out: "*différance* instigates the subversion of every kingdom. Which makes it obviously threatening and infallibly dreaded by everything within us that desires a kingdom" (Derrida 1982: 22).

In this spirit, Derrida famously contended that "the best liberation from violence is a certain putting into question" (Derrida 2001: 141). Although, in the same essay, Derrida claims that "the difference between the implicit and the explicit is the entirety of thought" (142), the particular kind of "putting into question" that he at least implicitly deemed to be the "*best* liberation from violence" was deconstructive questioning. So, one thing should be clear: Deconstruction is all about violence—even proposing that violence is constitutive. Deconstruction proposes, at the same time, a similarly constitutive status for the relation to alterity; and hence an ethical obligation to strive for the lesser violence. The "best" way to do this, Derrida argues, is through interminable,

vigilant "reading." But this strategy itself cannot somehow simply be free from violence. On the contrary, it is irreducibly violent, strategic, and conflictual. For, deconstruction takes what is declared and returns it as a question; thereby "entering into" the other's space and dynamics, and levering it against itself, in its own declared terms and values. In this way it is a "faithful" reading: (ideally) only taking and using what is presented. It proceeds by what Kristeva refers to as "listening": that is, tracking, tracing; discerning and going with the direction and lines of force, the moves and movements, of the other; not opposing head on but rather yielding and moving with the moves; revealing the biases and fault-lines, opening up, unraveling, inverting, displacing.

Whether this is definitively "the lesser violence" is debatable. What is clear is that it sees itself as a counter-movement to violence. And it is in this milieu that I think Rey Chow is best to be understood. Accordingly, some further consideration of the emergence, development, characteristics and receptions of poststructuralism and deconstruction in the academic and intellectual world will be helpful, as it will enable us to clarify the nature and significance of Rey Chow's interventions more precisely.

Rey Chow and the Receptions of Poststructuralism

Derrida's Cat

Jacques Derrida, who was one of the most famous figures of poststructuralism, died on the 8th October 2004. Over the following days, weeks and months, newspapers and other media the world over contained reactions, responses, comments and obituaries to him. Many of these were surprisingly hostile; they were often irreverent and disrespectful; and often also mocking, joking and scornful. Some were starkly abusive and aggressive. In fact, many obituaries, reactions and responses to the news of Derrida's death attacked or slandered not only his work but also cast aspersions on his character and personality. A large proportion made crass jokes about whether we could actually be sure that this character—who had infamously questioned the truth and reality of "truth" and "reality," and who had proposed that "there is nothing outside the text"— had ever "really" lived or died.

The fact that such spite, spleen, slander and vituperation came in response to the news of a philosopher's death would tend to suggest that the reception given to Derrida, in journalistic circles at least—but also in academic circles (many of the obituaries were written by prominent academics)—was far from hospitable. This is ironic, because much of Derrida's work itself actually in-

volved explorations of the questions and themes of "reception" and "hospitality." One of the many questions that Derrida often (re)posed, for instance, was that of how we should respond or react whenever we encounter something "other," something "different." This is an important matter because, as Derrida reiterated, the decision about how we should respond to anything, or about how we can establish what is being asked of us or required of us, is both a daily occurrence and also a potentially interminable philosophical and theoretical puzzle, one which *always* has ethical and political stakes and consequences.

The ethical and political stakes and consequences are present, according to Derrida, all the way through every decision and action we take or response we make. They are never "merely theoretical." They are always active. How should we (re)act? On what basis? How should we respond, responsibly?—to anything, whether that be the call of a stranger or a family member, a friend, a foe, a preacher or beggar on the street, a migrant at a national border, a knock at the door, a strange new object or question or practice, a new technological innovation or scientific discovery, or indeed—to recall one of Derrida's famous examples—the mewing of a cat (Derrida 1995a: 69-70). As Derrida points out, the decision to respond to his own cat's apparent call for food or for affection should be assessed in the context of every other apparent call that one does not or cannot or claims not to be able to respond to: calls from other cats, for instance, or calls for assistance or hospitality from strangers versus calls for hospitality from friends, and so on. These questions of interpretation (how do we know how to "read" any signifier, mark, image, practice, movement or sound) and of ethics (how do we know how to respond) and of politics (how do we know what the consequences will be) are central to Derrida's (and others') poststructuralism—aka deconstruction. They are often thought through in terms of questions of reception, response and responsibility.

Derrida himself—as well as his body of writing, which became known as deconstruction and which may be regarded as a pinnacle of poststructuralism—was from the outset no stranger to inhospitable reactions and receptions. This remained the case even (perhaps especially) after he attained a degree of success and recognition through his work. According to one obituary—an uncharacteristically well-informed and competent piece of writing—which appeared in the British newspaper *The Guardian* on Monday 11th October: "The French academic establishment never took him to its heart, and academic philosophers everywhere were generally uncomprehending" (Attridge and Baldwin 2004).

Despite the many "uncomprehending" responses and receptions of his work, Derrida nevertheless attained various forms of institutional and interna-

tional success. But this was never simple or straightforward: Derrida was never "mainstream," even if his name became more widely known than perhaps any other poststructuralist. But he was never simply "marginal" either. As Derrida wrote about his own "reception":

> the academic institutions that have hosted and even "crowned" me, so to speak, were themselves marginal—prestigious yes, but not universities. You have to keep in mind that I did teach in major institutions, but during a time when entrance to the university was refused me. A closer look at the field of higher education in France would make it clear that—not only in my own case—installing someone in a major institution may be precisely a way of rejecting him, or a confirmation of his rejection on other institutional levels. (Derrida 2003: 17)

Rejected on many institutional levels, and in many places, Derrida and deconstruction were nevertheless welcomed into others. Moreover, at still other times and in still other places, deconstruction did make its presence felt, did intervene and did have palpable effects—however unwelcomed or disavowed they may have been. And deconstruction was certainly no stranger to hostility. But nor was Derrida "alone." As he wrote of the many scandalized reactions to deconstruction:

> If it were only a question of "my" work, of the particular or isolated research of one individual, this [scandalized sort of reaction] wouldn't happen. Indeed, the violence of these denunciations derives from the fact that the work accused is part of a whole ongoing process. What is unfolding here, like the resistance it necessarily arouses, can't be limited to a personal "oeuvre," nor to a discipline, nor even to the academic institution. Nor in particular to a generation: it's often the active involvement of students and younger teachers which makes certain of our colleagues nervous to the point that they lose their sense of moderation and of the academic rules they invoke when they attack me and my work. If this work seems so threatening to them, this is because it isn't eccentric or strange, incomprehensible or exotic (which would allow them to dispose of it easily), but as I myself hope, and as they believe more than they admit, competent, rigorously argued, and carrying conviction in its re-examination of the fundamental norms and premises of a number of dominant discourses, the principles underlying many of their evaluations, the structures of academic institutions, and the research that goes on within them. What this kind of questioning does is to modify the rules of the dominant discourse, it tries to politicize and democratize the university scene... (Derrida 1995b: 409-410)

We will return to this important idea of understanding poststructuralism in terms of it being part of a "whole ongoing process" in due course. But what is most notable vis-à-vis the reception of Derrida and his work is that although he trained in philosophy and studied and worked in Paris, it was neither in the disciplinary field of philosophy nor in the context of French or even Eu-

ropean intellectual life that Derrida made his initial or most dramatic or enduring impact. It was in fact in the USA that Derrida received his warmest reception; and instead of in philosophy departments, it was in the field of litliterary studies (especially comparative literature) that his work found (or sparked) a hospitable readership. According to Attridge and Baldwin's obituary:

> The event that projected him into the international limelight was a conference at Johns Hopkins University in Baltimore in 1966, where the relatively unknown (but incontrovertibly glamorous) young philosopher upstaged the likes of Lacan and Jean Hyppolite. This was to be the start of a long relationship with English departments in the US, where he was made more welcome than anywhere else in the world. (Attridge and Baldwin 2004)

Given this complicated "position" within both geographical and disciplinary "space," it already seems incorrect to say that deconstruction and/or poststructuralism is somehow *simply* "French Philosophy" or (even more vaguely) "Continental Philosophy." Nevertheless, the widely received or assumed version of the history of poststructuralism is that deconstruction somehow *simply* "is French" and that "French poststructuralism" was exported to and translated into English in America. Yet, even a surface knowledge of such events as this 1966 conference and its consequences, and a cursory consideration of Derrida's influential relationships with American academics and universities (or, rather, academics in America) really muddies the familiar idea that poststructuralism was "originally" the French version of a broader realm of Continental Philosophy that was *then* exported and translated into English.

This is not to try to erase France, Paris, the French language or French intellectuals from the history of poststructuralism. Far from it. It is rather to point out that the familiar kind of narrative of "original," monolingual or monocultural "origin," followed by secondary "translation" is precisely the kind of narrative or thought-process that poststructuralist thinkers such as Derrida worked so hard to teach us to distrust, to question, to challenge and to problematize. This is indubitably a lesson that Rey Chow has learned well, as is apparent from all of her analyses, which clearly follow Derrida in problematizing the idea of unitary identities or original and essential culture, for instance. This is because, as Derrida himself would often elaborate in his writings, an "origin" is never a simple, singular, or unitary event. Perceiving its complexity and lack of unity is the first stage of overturning or inverting conventional assumptions and displacing the terms of the debate. Rey Chow does this repeatedly. So, in this case, the inversion and displacement that takes place in the rethinking of the origins of "French theory" is a movement away

from ethnic, cultural or geographical simplification, and a perception of the complex geographical, institutional and disciplinary processes involved in its "invention"—its constitution, foundation, inscription, and institutionalization.

Poststructuralism Translated

In one of his later works, *Monolingualism of the Other; or: The Prosthesis of Origin* (1996), Derrida actually argued, as the book's subtitle makes plain, for the need to regard all "origins" as involving paradoxical "prosthetic" or "supplementary" relationships between "things"—"things" that don't exist as such or in anything like the way they subsequently seem to exist "after" the prosthetic supplementing of each with the other that "produces" them as such. When it comes to origins (and indeed "ends"), Derrida argues frequently, temporality is jumbled up or "out of joint" (Derrida 1994). Rey Chow follows this logic through in many of her readings, whether in terms of popular culture, film, gender, ethnicity, or indeed academic work itself—including the arguments of many poststructuralists.

Derrida strove to persuade us that an origin is always a supplementing, a prosthesis, a grafting. This involves a dizzying type of logic, in which the "things" that go into the production of one or more identity cannot be said to have existed in anything like the way they now (or subsequently) seem to, before their interconnection or interimplication. This is why, in deconstruction and poststructuralism, it is often emphasized that "first things" do not come "first." Rather, things conventionally deemed secondary (such as a supplement, or a prosthesis) are argued to be strangely fundamental, ineradicable, and actually paradoxically "primary."

The examples of this "primacy of the secondary," or the "constitutive character of the supplement," are numerous, and have been documented widely in many places (see Bennington and Derrida 1993). Derrida himself carried out very many readings of philosophers, arguments, literary, artistic and other kinds of texts, throughout a long writing career in which he showed again and again that what is conventionally deemed to be primary relies on a secondary or supplementary dimension that is either overlooked, rejected, belittled, strictly policed, distrusted, repressed, or (mis)treated in any number of other manners (Derrida 1981). Rey Chow's works regularly follow suit. Other poststructuralists, especially in Derrida's wake, have added to this already long list. Rather than reiterate the main ones here, it seems both illuminating and pertinent to point out that we can actually see a few "very poststructuralist" processes involved in the institutional emergence of deconstruction and post-

structuralism themselves. These are processes that Rey Chow has not only re-marked upon but deepened our understanding of, as we will see.

The starting point here, once more, relates to questioning the widely received standard narrative about the development of poststructuralism. The common understanding, as mentioned, proposes that ("once upon a time," as it were) there was an "original" (and) "French" poststructuralism. This entity was subsequently "translated" into English. In this narrative, an "original French" text is all too easily regarded as primary and authentic, whilst the translation into English is regarded as derived and secondary (supplementary). But what such a narrative completely overlooks is the complexity and *constitu-tive* (productive and constructive) role played by such multi-lingual, inter-national and cross-disciplinary *institutional* events as—for instance—the academic conferences (not to mention visiting professorships, publishing contracts, lecture tours, and the emergence of "secondary" texts of commentary, discussion, definition, reaction and response) that substantially *produced* poststructuralism and deconstruction as such, in the first (or should that be second?) place. This putative "secondary" elaboration of poststructuralism, in America and other contexts, this putative "translation" of or from the French, is in fact rather more "primary" than has often been acknowledged. And this is something that takes us very close to Rey Chow's (and not Jacques Derrida's) understanding of a very specific form of translation that she terms *cultural translation*.

Born in the USA: "French" Poststructuralism

To use a pair of terms that Derrida appropriated from linguistics, we tend to think in terms that are *constative* (as if things merely *"are"*), whereas in actual fact, there is a strongly *performative* dimension to acts, events, encounters, interpretations and interactions—including, of course, acts of speech and writing. That is to say, there was (and is) no "French Poststructuralism" residing somewhere (in Paris, perhaps), like an essence, prior to its construction and (performative) elaboration in the texts and contexts that came subsequently to be regarded as those of "French Poststructuralism." Moreover, much of the production of "French Theory" didn't happen "in France." Nor was it derived from simply "French" material (words, works, questions, topics, themes, problematics). Nor was it simply "Continental" or "European." Derrida, it deserves to be mentioned, was in no way "simply" French himself: a French subject, yes, but also a Jewish Algerian, who had suffered the ill-effects of the colonial French regime's anti-Semitic policies during the 1940s.

All of these pragmatic and practical historical, geographical, linguistic and sociological considerations might be brought to bear to make sense of some of even the most philosophical dimensions of poststructuralism. For instance, the critique of "self-presence" or the philosophical critique of what Derrida called "the metaphysics of presence" (for, in what way is poststructuralism or deconstruction, like any supposed being or thing, actually an "entity" with one singular identity, an identity that is *one* and that is ever fully present in the here and now of consciousness?); or the critique of "being" and of "essentialism" (for where is the essence of poststructuralism? In what sense could it—or anything—be said to have or be an essential "is-ness" or being, outside of complexity, partiality, process, or (to use the Deleuzean term) "becoming"?); or in the sense in which poststructuralism has always been connected with the critique of Eurocentrism (Derrida and other poststructuralists came from societies that were colonized by European powers, and poststructuralism arguably emerged against the backdrop—or perhaps a foreground—of what are now called post-colonial struggles and processes); etc.

So, perhaps it might be better to think of deconstruction and poststructuralism not as "arriving" in America or as being "translated" into English, but as emerging performatively—being *inscribed*, being *written* into existence—in such institutional contexts as the 1966 Johns Hopkins conference. And it is important to note, too, that any academic conference itself is both constative and performative. For, although on the one hand, we might tend to think that speakers at conferences are speaking at conferences *because* they are *already* "names" (whether experts, authorities, or, indeed, "stars"), on the other hand, and at the same time as this, "names" and reputations are *made* at such events. To use Derrida's borrowed terms again: academic conferences are not simply *constative* (descriptive of a state of affairs), they are also *performative* (productive of a new state of affairs).

Indeed, it is possible to observe that the "reception" of Derrida in America shows one way we can deconstruct the binary of origin/translation or production/reception—an exercise which will in due course give us an important insight into Rey Chow's unique contributions to theory and analysis of culture, cultural identity, "communication" and cultural translation. The reception of poststructuralism in America was "originary," generative: it helped to produce poststructuralism as such, and not merely "American poststructuralism," but also the very idea of "French poststructuralism." The reception given to Derrida and to poststructuralism more generally in America was provided by English Literature departments in elite Ivy League institutions (the principal figure guiding this reception arguably being Paul de Man). All of which ought to

help us recast our understandings both of the relations between origin and translation or original and secondary and between politics and academia, as well as margins and periphery, inclusion and exclusion.

Merely Academic (or) Hyper-Political

It is significant that poststructuralism was (to use some of its own terms) "performatively elaborated" and "institutionally inscribed" in and through the disciplinary sites of elite academic subjects such as comparative literature in prestigious academic institutions such as Yale and Johns Hopkins. But this should not lead us too quickly to the conclusion that deconstruction is *therefore* "elitist" or "merely academic." This is so even though in many ways Derridean poststructuralism is avowedly *hyper*-academic: Derrida made no bones of the fact that he regarded his approach as hyper-analytic and hyper-questioning, always involving the putting of every statement, phrase, formulation, claim, argument, connection or other construction through what he would often call "the harrowing ordeal of the undecidable"—by which he meant the process of demonstrating the uncertainty of every foundation, every connection and every step—a process which inevitably makes Derrida's work difficult to follow, often seeming digressive, discursive, as well as allusive and saturated in philosophical and literary references (Derrida 1998: 29). But, despite this, deconstruction is not merely academic.

There are various ways to demonstrate this. It is possible, for instance, to "historicize" poststructuralism and to relate the deconstructive questioning of institutions and of the status quo per se (a questioning characteristic of poststructuralism in general), to broader historical processes of critique, contestation, uprising and struggle—as found in the postcolonial struggles of once-colonized areas of the globe as much as in countercultural movements in the West. However, it is also possible to show that poststructuralism was never "merely academic" even when it is regarded as avowedly "hyper academic." For, deconstruction in particular is certainly hyper-academic, but it is so in a very particular sense: it aims many of its questions at the university.

Crucial here is that deconstruction regards the university *as an institution*: a social and culturally consequential institution, one that has been instituted and orientated in particular contingent ways—ways that could always be reorientated, with different biases, and with different consequences. So, unlike other academic "methods" or "approaches," deconstruction is less concerned with "establishing" or even "transforming" meanings, readings and interpretations of texts, and more concerned with *how* meaning is *made* within various

forms of institution (whether by "institution" we mean an approach, a disci-
pline, a department, a school, or a style of scholarship and the type of herme-
neutic or disciplinary field it maintains, etc.). This is because it is a
deconstructive contention that *meanings are made.* Meaning is forcefully, cul-
turally, and institutionally forged. As such, deconstruction is less concerned
with the interpretation of this or that literary text (for example) *as such* than
with the institutional and cultural biases and forces which tend to select, "see,"
conceptualize, produce and maintain this or that reading of this or that kind
of "text." Rey Chow's readings straddle both orientations.

This dimension to poststructuralism can be seen most clearly perhaps in
the work of Roland Barthes, especially in such influential essays as "From
Work to Text" and "The Death of the Author" (1997), in which he argues
(among other things) that the belief in the "author," and the belief that an au-
thor's "intentions" are to be sought out and respected when reading a work, is
a type of almost religiously deferential orientation, which produces passive
readers who defer to the authority of "the critic." Barthes proposes instead
that one should not regard a work as the product of one "intending" mind
(the author), but instead should be regarded as a web-like work constructed
and stitched together from wider discourses of textual (textile-like, thread-like,
fabric-like) material. (Barthes is discussing literary works, but ultimately, his
argument can be extended and applied to many other things—any other
"text"). As such, the author is neither to be regarded as the origin of his or her
work, nor the owner of it, nor the ultimate authority on what it could or
should mean. Thus, contrary to the way that many people and institutions
tend to approach works, Barthes argues that "the author" is neither the origin
nor the owner of nor the authority on his or her productions. Their works are,
in other words, not theirs. For these productions are constructed from pre-
existing references, allusions, citations, cultural traces and materials, and are
disseminated widely and received unpredictably and diversely. So, people who
read works with one eye on the question of "finding" the "proper interpreta-
tion" are, according to the Barthesian critique, inadvertently subordinating
themselves to "authority"—the authority of the critic. As such, there is a sus-
tained micro-political focus in the textual approach to literature, culture, and
reading—a focus which deepens and intensifies the concerns of earlier cultural
theorists such as Gramsci, Adorno, Horkheimer, Althusser, or Barthes' con-
temporary Foucault. This is so even though Barthes would often focus on
questions of pleasure, desire, enjoyment, emotions and textual details, rather
than telegraphically announced "political" matters. As we will come to see, Rey
Chow's works are clearly steeped in such lessons of Barthes as these.

The General T-Shirt of Force and Signification

Despite an investment in *undisciplined* productivity and creativity, Barthes was initially and most widely received in Anglophone academia as a key figure of the *discipline* of semiotics. His name remains to this day indelibly attached to the extremely widespread study of processes of signification in culture. This is because of the influence of his early work *Mythologies* (1957), in which, through journalistic cultural criticism, Barthes offers an account of the way that "ideology" (what he calls "myth") may be rethought not as a monolithic entity, but rather as something that happens through ongoing productive and inventive practices of "myth-making." In the collected case studies that make up *Mythologies*, Barthes shows the ways that such cultural institutions as newspaper headlines, adverts, cover images, and the relations between image and text in conventional combinations like captions and photographs, as well as in various other forms of popular cultural practices and institutions (Hollywood film conventions, wrestling, striptease, tourist and cookery guides, even arguments in courts of law, etc.), all rework repositories of cultural "myths" in order to produce or reproduce social meanings. According to Barthes, signifiers become transformed into "myths" by virtue of the power of the connotations that certain stock images, formations and formulations hold in certain cultural contexts.

Mythologies contained a long final chapter, which sought to clarify the technical operation of mythical language. Employing the terminology of Ferdinand de Saussure's structural linguistics, Barthes constructed what became the famous diagram of first and second order signification (denotation and connotation), and in doing so offered the world a clear and compelling framework for the analysis of all sorts of signs and signifying systems. As such, in the wake of this influential early work, Barthesian semiotics travelled widely through cultural and humanistic disciplines such as literature, art, anthropology and sociology; and to this day, Barthesian semiotics maintains its palpable presence across a wide range of disciplines, from those using the most empirical and empiricist of approaches in the analysis of culture and society to those using the most literary, textual, theoretical, rhetorical and philosophical. This range exists because Barthes' other works are considerably less formalizable and considerably more complex than the enduringly popular *Mythologies*, and they focus on linguistic, literary, rhetorical and often highly technical aspects of cultural phenomena and practices, such as listening to music, the significance of vinyl recordings and photography. In short, the semiotics of *Mythologies* is undoubtedly much easier to grasp, formalize, teach and communicate

than Barthes' other texts, and this surely accounts for its more widespread influence.

In the UK context, Barthes' work on myth and on the signifying power of almost any cultural material was picked up in the immediate prehistory of the establishment of the messy field of cultural studies. According to Stuart Hall, the key ingredients that went into the establishment and institution of British cultural studies were the class analyses and the ambivalent and critical relations to Marxism that could be found in literary studies and sociology. But cultural studies—as a named institution—was established in the UK in 1962, with the establishment of the Centre for Contemporary Cultural Studies as a postgraduate programme in Birmingham University. Much has been written about the institutional history of cultural studies as a discipline, but here it need primarily be mentioned that, under the directorship of Stuart Hall, cultural studies self-consciously and deliberately sought to tackle "theory."

As Hall wrote in his 1992 retrospective on cultural studies and its "theoretical legacies," there was a sense that there should be "no theoretical limits" from which cultural studies should turn back (Hall 1992). This is because, according to Hall, cultural studies was always both an academic endeavor *and* a political project: a politicized academic endeavor which sought to engage rigorously, comprehensively and unrelentingly with all aspects of culture, power, and their structures, processes, formations, deformations and transformations. In his interpretation of this endeavor, Hall regarded theory—and poststructuralism in particular—to be of fundamental and foundational importance.

Hall notes that poststructuralism was crucial to cultural studies because one of the formative problematics of cultural studies was the matter of critiquing, overcoming and surpassing Marxian economism—or, that is, escaping the stranglehold of interpretations, such as "crude Marxism" which reductively regard the economy as determinant in the last instance of social relations (Hall 1996: 148-149). According to Jennifer Slack, both cultural studies and the post-Marxist theory that was developed by thinkers like Ernesto Laclau during the 1970s amounted to the "struggle to substitute the reduction that didn't work"—namely Marxist economic reductionism and structuralist theory's reductionism—"with ... something." The problem with theories saturated in economic or structuralist determinism is that they are fatalistic or even antipolitical in that they have often decided *in advance* that individuals, groups, agents, and indeed culture and politics in their entirety are epiphenomenal and inconsequential. This, says Jennifer Slack,

> pointed to the need to retheorize processes of determination. The work of cultural
> theorists in the 1970s and early 1980s, especially the work of Stuart Hall, opened up

that space by drawing attention to what reductionist conceptions rendered inexplicable. It is as though a theoretical lacuna develops, a space struggling to be filled.... In theorizing this space, a number of Marxist theorists are drawn on: most notably Althusser (who drew on Gramsci and Marx), Gramsci (who drew on Marx) and, of course, Marx. Its principal architects have been Laclau and Hall. (Slack 1996: 117)

Slack finds it remarkable that "in spite of the importance of Laclau's formulations, he has been excluded—as has Mouffe—from most of the popular histories of cultural studies" (Slack 1996: 120-121). Rather than this, Slack emphasizes the founding importance of the poststructuralist post-Marxist theory of Laclau and Mouffe for cultural studies (Laclau and Mouffe 1985). As do Morley and Chen, who begin their "Introduction" to the important book *Stuart Hall: Critical Dialogues in Cultural Studies* by reminding us that "back in the mid-1980s, as an alternative to formalist and positivist paradigms in the humanities and social sciences, British cultural studies, and Stuart Hall's work in particular, began to make an impact across national borders, especially in the American academy" (Morley and Chen 1996: 1). Immediately after making this contextualizing point, the very first point that they mention—the very first thing, the very first problematic, and the very first orientating discussion within cultural studies that they mention—is Stuart Hall's discussion of Laclau and Mouffe's "seminal book, *Hegemony and Socialist Strategy* (a key statement of postmodern political theory)" (1). They conclude: "When we look at it retrospectively," this engagement "can be seen as a starting-point" (2), a constitutive cultural studies engagement with the "postmodern" political theory of post-Marxism. However, Morley and Chen are perhaps too quick to deem this encounter with post-Marxist poststructuralism as something "from which cultural studies moved on, through another round of configuration" (2). But Stuart Hall himself was never prepared to do this. For him, the problematic established by this encounter with poststructuralist post-Marxist political theory is *constitutive*, and hence *ineradicable*. Indeed, Morley and Chen have almost said as much, in saying that Laclau and Mouffe's theory is "*seminal*." But Hall insists on the need to maintain fidelity to this "starting-point," arguing:

one cannot ignore Laclau and Mouffe's seminal work on the constitution of political subjects and their deconstruction of the notion that political subjectivities flow from the integrated ego, which is also the integrated speaker, the stable subject of enunciation. The discursive metaphor [central to post-Marxist theory] is thus extraordinarily rich and has massive political consequences. For instance, it allows cultural theorists to realize that what we call "the self" is constituted out of and by difference, and remains contradictory, and that cultural forms are, similarly, in that way, never whole, never fully closed or "sutured." (Hall 1996: 145)

Hall even declares, "if I had to put my finger on the one thing which con-stitutes the theoretical revolution of our time, I think that it lies in that meta-phor" (145): the metaphor of "discourse." For Stuart Hall, then, the question of the political, of intervention and responsibility that comes to light in the cultural studies engagement or encounter with post-Marxism is not something that will—or should be permitted to—simply go away. This is why, after some qualifications and caveats, Hall maintains that he remains "a post-Marxist and a post-structuralist, because those are the two discourses I feel most constantly engaged with. They are central to my formation and I don't believe in the end-less, trendy recycling of one fashionable theorist after another, as if you can wear new theories like T-shirts" (Hall 1996: 148-149). One can feel the pres-ence and force of these impulses and problematics in Rey Chow's work, espe-cially in such works of hers of the 1990s as *Writing Diaspora: Tactics of Intervention in Contemporary Cultural Studies* (1993) and *Ethics after Idealism* (1998).

Cultural Studies and "Theory"

In this formation, then, cultural studies is, was, should be or should have been hospitable to poststructuralism. Certainly, key poststructuralist categories, such as text, context, intertextuality and discourse were appropriated within cultural studies (and much more widely, besides... Indeed, one question might be: *which* disciplines in the arts and humanities today do *not* make use of the once-poststructuralist concepts of text and discourse?). But, as Hall's point about "trendy recycling" announces, there was always a hesitation, in the work of prominent thinkers associated with UK or Birmingham Centre Cultural Studies, to welcome "theory" *tout court* with open arms or with unconditional hospitality. Rather than this, one finds in the writings of the most theoretically informed or theoretically alert thinkers of cultural studies a regular caveat: one should certainly not retreat from theory, but theory should be approached al-ways with at least one eye—if not a firm focus—on the question of its political point, purpose, orientation or utility.

Reciprocally, given its messiness, its newness, its eclectic character, and its incorporation of poststructuralism, cultural studies was not welcomed with open arms into the university. Stuart Hall's account of the experiences of the Centre for Contemporary Cultural Studies at Birmingham University can be taken to exemplify many of the initial, initiating and ongoing sorts of reactions to and receptions of cultural studies. Hall writes:

> On the day of [The Centre for Cultural Studies at Birmingham University's] opening, we received letters from the English department saying that they couldn't really welcome us; they knew we were there, but they hoped we'd keep out of their way while they got on with the work they had to do. We received another, rather sharper letter from the sociologists saying, in effect, "... we hope you don't think you're doing sociology, because that's not what you're doing at all." (Hall 1990: 13)

These reactions arose because of the new combinations of poststructuralist theory and various modifications and manipulations of method and practice that were emerging in cultural studies. In different times, places, incarnations and orientations, work in cultural studies has experimented with various methodological options and orientations. This is why, in much cultural studies work one finds strongly poststructuralist language and categories, but employed within very heavily empiricist endeavors—often kinds of empirical work that one would normally regard as anathema to the poststructuralist questioning and problematization of positivist, empiricist and otherwise "naïve" ontologies. Nevertheless, where both Derrida and Foucault, for instance, had each argued for the *necessity* of prioritizing the philosophical or theoretical as the only way to avoid falling into what they both regarded as clumsy, naïve or indeed "incompetent" empiricism, many working within cultural studies would never follow Derrida or Foucault very far down this line, fearing that poststructuralism's hyper-academic and excessively philosophical approach would have "depoliticizing" consequences, and preferring instead to employ selected poststructuralist theoretical insights in empirical, sociological, anthropological, social science or ethnographic studies of "obviously" political issues. As we will see throughout this book, Rey Chow negotiates a very different route through the supposed alternatives between theory and practice or theory and empiricism.

Indeed, it is certainly the case that Chow is not alone here, that many academics and intellectuals working within cultural studies and related disciplines have always refused to accept either the subordination of theory to "obviously" political issues or "obviously political" ends (Hall 2002) or to other forms of (supposedly) "being practical"; and of course poststructuralism was disseminated extremely broadly across and incorporated very diversely into Anglophone disciplines in the UK, USA and elsewhere. But it was in the disciplinary contexts of literary theory, comparative literature, cultural studies and then media and film studies that poststructuralism was most prominently "tackled" and negotiated in Anglophone contexts. Some of these fields selected only the choicest morsels of poststructuralism, while others arguably morphed into scenes dominated by the problematics of poststructuralism. But this negotiation never took place univocally or entirely in any *one* disciplinary con-

text. Disciplinary borders are always shifting, contested, and cross-fertilized or pollinated in unpredictable ways and from disparate sources. Moreover, in every discipline there have always been "divides," disputes, disagreements and schools of thought at odds with each other. But it is important to note that in Anglophone contexts at least, the name of the main structuring divide of the arts and humanities disciplines has long been "Theory" (Hall 2002; Hall and Birchall 2008).

"Theory" has since the 1970s been the enduring term of (dis)affection for the disagreement not only about *how* to do work in this or that discipline but also about *what* this or that discipline actually "is," "does" or "should be" (Bowman 2007). And the term "Theory," of course, refers ultimately to post-structuralism, even though it has travelled under this or another alias (such as, depending on the discipline: deconstruction, Continental philosophy, post-modernism, poststructuralism, French theory, the textual approach, the discourse approach, post-Marxism, or some other similar term).

Feminist (Language) Differences

Poststructuralism was transported far and wide by various key carriers. Feminism was one key carrier, Foucault another, and the critique of structuralism, Marxist orthodoxy or the status quo per se, another. One could add more to this list. The point, however, is that it is difficult to isolate, pin down, or specify a *single* "cause" of or for poststructuralism's widespread reception. It is possible to connect poststructuralism to several different post-War critiques of various kinds of institutions, such as countercultural movements, civil rights and anti-racist movements, second-generation feminism, postcolonial struggles and even liberalism. But it is certainly clear that feminism is an important and illuminating case, which we ought to consider. Again, feminism "itself" has never actually been simply univocal or singular. It has multiple variants, concerns, inflexions, theories, aims, and modes of operation and existence. But what came to be known as "French Feminism" became a key player in very many contexts. This is because "feminism" is a force that is not discipline-specific. It is something that enables all different "kinds" of feminism to cross the borders of disciplines and fields—often like wildfire.

So-called "French" feminism was heavily influenced by modernism, by de Beauvoir, by Jacques Lacan and a passionate, often ambivalent, relationship with psychoanalysis generally. The complex relation to psychoanalysis arose insofar as Freud might be regarded simultaneously as an obvious agent and theorist of patriarchy ("penis envy" indeed!) and yet nevertheless as someone

whose work offers a way of conceptualizing and hence possibly subverting or changing patriarchy. Thus, "French" feminism followed the theoretical insights of the "French Freud," Jacques Lacan, and elaborated itself as a concern with viewing (or "scopic") relations, processes of identification, cultural phantasy and gender performance or performativity. Like other forms of intellectual activity informed by poststructuralism, "French" or poststructuralist feminism also often displayed an investment in avant-garde modernist aesthetics and hence involved a very stylized or "difficult" theoretical language. Given the often-bemused reactions to the language used by such notable contemporary figures of poststructuralist feminism as Judith Butler, for example, many would say that it still does.

This use of complex theoretical language and the attendant engagement with complex theoretical problematics has often caused critics of poststructuralist feminism to propose that poststructuralist feminism is not really feminist at all, in that it does not seem to concern itself with urgent or pressing political issues but rather contents itself with very abstract or "entirely academic" philosophical pseudo-problems. In response, poststructuralist feminists themselves have been known to propose that other (non-poststructuralist) forms of feminism are—despite appearing to be militantly politicized—nevertheless *neither political nor feminist enough*, insofar as they un-self-reflexively use the language, terms and concerns set out by the dominant patriarchal modes of discourse. The argument is that in *being* "militant" and in using the *dominant* styles of discourse (such as polemic and strident, often aggressive critique and complaint), "mainstream" feminists have remained unaware of the extent to which their language and their orientations remain *therefore unwittingly patriarchal*—insofar as their discourse is *militarized, masculinized, aggressive*. So, in preferring to try to construct "other" styles of writings and "other" styles of discourse, poststructuralist feminism (like poststructuralism per se) regarded itself as being political through and through. Chow (2002: 54-60) provides an excellent analysis of the complexities of this disagreement—a debate which continues to this day. It is most often focused around such prominent and "difficult" poststructuralist feminist figures as Judith Butler and Gayatri Spivak—two very different scholars who nevertheless share a deep commitment to poststructuralist styles of discourse.

Alterity: Don't Even Go There

This investment in alterity (otherness, other discourses, etc.) is another familiar trait of poststructuralism. For, if mainstream cultural life—for instance,

mainstream language—is saturated by "patriarchal" codes, orientations and values; if everything familiar has been "hegemonized" or "colonized" by the most subtle, invisible and saturating kinds of power (discursive power), then "alterity"—otherness—whether in the form of foreignness, the elsewhere, the marginal, the overlooked, the drowned out, the subaltern, the unheard, the unseen, the unconsidered, the repressed, the alien, the abject, the exotic, the mystical, the unknown, or the yet to be constructed—all of this, gains an automatic value. And, as Rey Chow has pointed out many times throughout her work, poststructuralism has certainly displayed a wide array of different sorts of interests and investments in all kinds of alterity—linguistic, ethnic, geographical, sexual, aesthetic, ideological, etc. (This investment became so much the case that when in the 1990s Simon Critchley took to pointing out that "other" is not automatically a synonym of "good" or "better," his observation was taken to be something of a remarkable point to make—and an important redressing of the balance, or a pointing out of the biases and implicit assumptions of much poststructuralism, cultural studies and cultural theory (Arditi and Valentine 1999). Needless to say, Rey Chow's unfaltering attention to the logics and vicissitudes of identity-construction and its often phantasmatic relationship to "alterity," amplifies and refines this enabling observation, as we will see.)

However, to propose that poststructuralism championed alterity *tout court* or without caveat or condition would be a caricature. Nevertheless, key figures in poststructuralism certainly "used" alterity prominently. Jacques Derrida launched deconstruction's critique of Eurocentrism in *Of Grammatology* (1974/1976) by evoking what he represented as a kind of absolute difference between China (and Chinese writing) and Europe (and European alphabets). This was a founding gesture that *Of Grammatology*'s translator, Gayatri Spivak, remarked upon and problematized in her Translator's Preface. It is also something that Rey Chow and others have explored conceptually and in terms of its ethical and political implications. What Chow demonstrates in her analysis of Derrida's act in *Of Grammatology*—Derrida's gesture of defining or specifying "Europe" by way of drawing a line of essential difference between "European alphabets" and an absolute other, "Chinese writing"—is that this act (which must be regarded as one of the founding gestures of deconstruction) is ultimately part of an *undeconstructive foundation of deconstruction.* Yet Chow does not move from this revelation to the easy conclusion that "therefore" deconstruction is somehow of less virtue or value to political and ethical thinking than it might otherwise have been. Rather, Chow accepts the inevitably "impure" and "non-simple" origins of deconstruction, and insists nevertheless that

deconstruction remains a powerful tool of critique and ethical, political analy-sis.

Before Derrida, many other thinkers had made many similar—often much stronger—types of claim and taxonomic gesture (dividing "China" and "Europe" along some line of supposed absolute difference). Derrida's highly politically problematic philosophical predecessor, Martin Heidegger, for instance, had made the same kinds of claims, as had many earlier thinkers and philosophers, including Hegel—and many thinkers and writers continue to make such dividing gestures to this day. However, Heidegger's insistence on the absolute difference and distance between what he called European and East-Asian thought and "existence" would lead him ultimately to settle on a strong preference for Europe and European philosophy, despite his fascination with the world of East Asian thought (Heidegger 1971; Sandford 2003).[3] But, as Chow has pointed out, for Derrida, the encounter with alterity in the form of European versus Chinese writing does something different.

Like Heidegger, to whom Derrida is definitely indebted, the Far East certainly equals a kind of inaccessible otherness. This "encounter" (or non-encounter) primarily leads Derrida's thought to turn back towards Europe—but not in the way that Heidegger and other philosophers have done. Rather, Derrida *problematizes* European thought and even the very idea of Europe. Admittedly, this begins through the contrast with a "China" that he never explores. But nevertheless, the contrast still enables Derrida to launch a critique of European thought; a critique which unpicks and unsprings the unthought, repressed, unexplored, and stymied directions that European philosophy did not take.

In other words, the problem is that despite Derrida's frequent mentions of "China," especially in his earlier works, he never actually explores this geographical, sociocultural or linguistic alterity. Rather, Derrida's work is concerned with the handling of alterity within the canons of Western philosophy. Perhaps the clearest early example of this is in the essay "Différance" (1982), in which Derrida explores the way that several fascinating and hugely stimulating figures, from Saussure to Freud and Nietzsche, handle the "problem" of the *excess* of signification, an excess that is also strangely a *lack* or an *absence*—a lack of finality, a lack of presence, a lack of fixity, univocality or identity—that permeates all language, and which Derrida calls *"différance."* Derrida famously coined this neologism to make a performative point about writing's unacknowledged and unexpected "priority" over (or strange kind of "superiority" to) speech. For example, you can perceive the difference between the word "difference" and the word "différance" (among myriad other homophones)

only when reading, and not when listening. Nevertheless, Derrida notes, Western thinkers extremely frequently insist on prioritizing "speech" over "writing" and in regarding spoken language as prior and primary to writing. This is a prioritization that Derrida calls *phonocentrism*, something he regards as one of many kinds of manifestations of Western philosophy's privileging of the notion of *presence*.

But if, when it comes to geographical alterity (i.e., foreignness), Derrida does "not even go there," other poststructuralist thinkers certainly did. Julia Kristeva wrote about Japan, Japanese culture, Japanese women and especially Japanese peasants. But, as Rey Chow points out, she treated them as the bearers of a fascinating alterity. Rey Chow often problematizes this sort of treatment of fascinating others, from her first book, *Woman and Chinese Modernity*, onwards. Similarly, Roland Barthes went to Japan and delighted in being unable to read the signs, and hence in being entirely free to produce his own readings of everything. In a way, Barthes regarded the whole "alienating" experience as an illustration par excellence of the most emancipatory way of relating to any written signs or texts at all. Luce Irigaray wrote some extremely problematic ruminations on cultural difference, the body and spirituality, inspired by her taking up of yoga. And others such as Avital Ronell and Eve Kosofsky Sedgwick mined the reserves of eastern mystical pedagogical traditions in studies of culture, teaching and learning. But, perhaps most influentially of all, Gayatri Spivak studied and wrote about those she regarded as the poorest of the poor and the most other of the others—for example, the most impoverished women of Calcutta and elsewhere across the continent of India, and implicitly also the rest of the world as such.

All of these forms of treatments of and relations to alterity are different, of course, and they all have different sorts of significance. They have had widely different kinds of impact. It almost goes without saying that Gayatri Spivak's studies of those who are absolutely excluded from power and even from the ability to "speak," to produce discourse, or to be "heard" by power (those she calls "subaltern") are obviously of a different status to those writings of Luce Irigaray which were inspired by taking a yoga class. And Spivak's work in this regard has rightly been considerably more influential.

Disjointed Connections: Postcolonialism and Poststructuralism

Spivak was the translator of Derrida's *Of Grammatology*, which, with its initial (albeit unfinished) critique of "Europe," could reasonably be regarded as one of the founding texts of the field of postcolonial studies. She followed up on

this with a series of hugely influential essays and monographs on postcolonial and feminist issues, all of which can be characterized as poststructuralist, as well as groundbreaking, not to mention controversial, influential and—as has been widely remarked upon—notoriously difficult to follow. Nevertheless, what remains clear is that the initiation, the history and the growth of the field of postcolonial studies was ineradicably marked from the outset by the influence of poststructuralism from such sources.

Of course, the intervention of Derrida and Spivak in postcolonial studies is less widely recognized than that of figures like Frantz Fanon or Edward Said. But even these figures can be connected to similar theoretical impulses and problematics. Fanon's thought on race and ethnicity was informed by his psychiatric training, and Edward Said's influential work *Orientalism* (1978/1995) is steeped in the notions of "discourse," "discursive formation" and "power/knowledge," which were provided directly by the work of Michel Foucault. Indeed, so Foucauldian is *Orientalism* that it is in many ways possible to regard Said's text as a preeminent example of Foucauldian post-structuralism applied to the unmasking and delineating of a globally present "discourse," the one that he calls "orientalism." For, although Foucault developed and elaborated his theoretical contributions through considerations of the history of psychiatry, discourses of madness, penal institutions and practices, and mechanisms of discipline, surveillance, and so on, Edward Said picked up the Foucauldian theoretical, perspectival and methodological baton and ran with it, taking the themes of discourse and power/knowledge right out into the open—characterizing the entire approach of Western scholarship, philosophy, popular, pulp, low and high culture to "the Orient" as overwhelmingly dominated by a reductive, stereotyping bias, that he called orientalism.[4]

Said's work certainly guaranteed the development and proliferation of postcolonial studies. As a new or emergent field, postcolonial studies was "instituted" either as a style of scholarship or set of animating problematics within extant disciplines such as literature, anthropology, sociology and history; or as an interdisciplinary field in its own right. Thus, postcolonial studies took (and takes) many forms. But what is prominent in all of its incarnations is the focus on the issues and ongoing problems faced by once-colonized countries—problems of culture, power, tradition, language, memory, the writing of history and the establishment of cultural identity in the wake of colonialism, imperialism, and what we now call globalization, neo-colonialism and neo-imperialism. Given poststructuralism's formative role in the emergence of postcolonial studies, it might seem that poststructuralism found a home or at least one of its proper locations there.

In her reading of the history and dissemination of poststructuralism, Rey Chow (1998) argues that poststructuralism was always implicitly connected to a critique of European institutions, values, practices and power—and as such that it always had a fundamental affinity with what later came to be so widely "baptized," canonized or institutionally inscribed *as* "postcolonialism." Moreover, Chow proposes, "postcolonialism" can be understood as the academic-institutional response to (or reception of) diverse social and cultural problems of "reconstruction" faced by once colonized countries, and that this understanding can recast not only academic postcolonialism but also poststructuralism as such in a new light. For, just as academic postcolonialism reflects and registers older historical cultural and political struggles, problems and projects, so poststructuralism can be relocated and re-categorized as emanating from those same historical impulses and antagonisms. As already mentioned, Derrida's status as a French colonial Jew from Algeria had a marked influence on his writings—perceptible in his early work and (or perhaps because) explicitly engaged with in his later writings of the 1990s.

But from this, Chow notes a peculiar paradox: on the one hand, the avowed politics of poststructuralism are characterized and animated by a concern for the marginal, the exploited, the silenced, the oppressed and the other, and they carry a very strong anti-Eurocentric and hence anti-status quo edge; but on the other hand poststructuralism was nevertheless elaborated in a hyper-literate, hyper-theoretical "literary" language in some of the most elite and privileged academic institutions in the world. Chow actually proposes that poststructuralism, in its investment in, elaboration through and "performance" of complicated and hyper-self-reflexive "literary" language, amounts to a kind of return of Literature in a slightly displaced and modified location and mode of articulation. We will return to this dimension of Chow's problematization of post-structuralism more than once.

Visual Pleasure and Poststructuralism Disciplined

The status, the routes of navigation and the various different ways of attempting to resolve—or at least make sense of—this paradox of poststructuralism's investments, languages and locations are all ongoing. What is clear is that at one extreme, poststructuralist impulses have seen and elaborated themselves as anti-institutional or anti-disciplinary (Mowitt 1992; Bowman 2007); at another, poststructuralism, like other "politicized" academic endeavors, has sought outlets, connections, interventions and activities outside of the university, often turning to the realms of art, performance practices, literature, technology,

new media and myriad forms of creative cultural production. In the blossom-
ing of the heyday of this impulse (during the 1980s and 1990s in particular),
for many commentators (and still, to this day) poststructuralism became syn-
onymous with that much-maligned term, postmodernism. At another extreme,
the critical insights of poststructuralism became bound up in various forms of
empiricism and positivism, taking the form of various types of discourse analy-
sis, often involving moving from theoretical propositions and hypotheses
about (most commonly) the political biases of culture, society and its institu-
tions into various forms of sampling, measuring, quantifying, coding, indexing
and—ultimately—counting.

But it is not just in its incorporation into social- or semi-scientific practices
that poststructuralism became disciplinary. For, as "radical" or "anti-
institutional" as it often seems, poststructuralism nevertheless has often
worked to *discipline*, to *stabilize*, to *normalize*, and to *institute*. For instance,
Chow (2007) elaborates the way that an encounter between disparate forms of
film criticism and psychoanalysis (particularly Lacanian psychoanalysis) be-
came what she calls a key "disciplining moment" of film studies. That is to say
that, whereas the prehistory of the discipline (or disciplining) of film studies
included disparate and heterogeneous approaches with multiple orientations,
there came a point after film studies' ongoing engagement with the ground-
breaking work of thinkers such as Walter Benjamin, Christian Metz and oth-
ers, at which film studies became a discipline. Chow connects the moment of
the disciplining of film studies with an engagement with Lacanian psychoanal-
ysis. This can be seen most clearly the 1970s feminist essay of Laura Mulvey,
"Visual Pleasure and Narrative Cinema" (1975), in which a coherent psycho-
analytic paradigm for film and visual culture analysis comes to the fore. Mul-
vey's enduringly (in)famous essay is steeped in Lacanian psychoanalysis, like
many others published in the influential journal *Screen* at that time. But per-
haps uniquely, Mulvey's essay is such a stark polemic, which sets out the terms
of a debate about patriarchy and the power of "the male gaze," that it still gets
film studies academics heated and animated to this day. As such it could be
said to define the polemical disciplinary space of film studies: being for or
against Mulvey can often be translated into being for or against Lacan-
informed poststructuralism. This "for or against" structure can be taken as an
index of the extent to which poststructuralism informs the discursive constel-
lation of positions "within" film studies.

Of course, in film studies, as in many disciplines, the "for and against"
structure or disciplinary divide is not "one." For, if in film studies, there is this
strongly implicitly or explicitly Lacanian poststructuralist school or tendency, it

does not simply have "one" other, or one alternative disciplinary school or approach, one alternative that is somehow "not poststructuralist" (whether that be positivist, empiricist, historicist, or whatever). Needless to say, as in all other disciplines, there *are* resolutely anti-theoretical positions. But in film studies, if the first generation of film studies might be classified as Benjaminian, Adornian, Metzian, etc., and if a second generation can be characterized as Lacanian (Mulvey, Heath, de Lauretis, Silverman, etc.), then a third generation can be called Deleuzean, Rancièrean, Badiouian, or Žižekian. In other words, still "theoretical," still strongly poststructuralist, but now yet another variant of poststructuralism—often a variant which underplays its connection with the poststructuralist legacy from which it has arisen.

Preeminent here is Gilles Deleuze. The work of Gilles Deleuze is often held up in the fields of film and philosophy as anti-Lacanian. But this is a simplification. Deleuze certainly sought to be anti-Freudian, but closer inspection of his work reveals that he was heavily indebted to Lacan and was in no way anti-Lacanian as such (Valentine 2006). Nevertheless, Deleuzean approaches to film (among other things, including philosophy, politics, geography, music, culture and technology, to name but a few) are widely regarded as a rejection of former poststructuralisms, such as the poststructuralism of Lacan, Derrida and Foucault. Indeed, some essential or putative difference between Deleuze and his poststructuralist others is widely assumed (Žižek 2004), even though Deleuze openly acknowledged his debts to and affiliation with Lacan's work, and even though Derrida often remarked that he personally never disagreed with anything his friend Gilles Deleuze wrote, and even though Deleuze arguably picked up the baton passed to him by Michel Foucault, whose work he clearly admired. But, in any case, Deleuzean theory, in its own right, has, since the early 1990s at least, had a growing impact on arts and humanities disciplines of all sorts. This impact is characterized by a rejection of ontologies of "lack" and "absence" associated with Lacan and Derrida. Deleuze and Guattari suggest that worldviews of absence, lack and scarcity were inherited by early poststructuralists through their critiques of Freud and Saussure. However, Deleuze and Guattari argue that the ontology of "scarcity" is symptomatic of a capitalist outlook. So they sought to replace this instead with a focus on the productivity of desires, of intensities and flows of forces, and so on. With this change of emphasis in the theory of ontology, and in their attendant change in vocabulary, the language, questions and foci of "theory" transformed again. So much so, perhaps that many might ask what remains of poststructuralism in Deleuze and other current theoretical luminaries as Alain Badiou, Jacques Rancière, Giorgio Agamben, and even the hyper-

formalist Hegelian-Lacanian Slavoj Žižek. But—given that this little account of some key movements of theoretical history is informed by Rey Chow's own (2007) discussion of this history—it is fair to say that her own work is clearly diversely nourished by and regularly engages with them these figures, fields and formations, at different times.

From Poststructuralism to Post-Foundational Thought

Rather than entering into a dissection of the lines of connection, disconnection, convergence and conflict that characterize the contemporary scene and connecting or disconnecting it from the recent past, it might be more helpful to conclude this section by proposing the usefulness of a less overburdened term than "poststructuralism" to help us to make sense of both the ongoing legacies and the prehistories and wider significance and status of what has long been called poststructuralism. Oliver Marchart (2007) offers an analysis which helps to clarify the fundamental way in which it is possible to identify a certain topos, ethos or common ground defining the problematics shared in common and confronted differently by multiple disciplines and diverse thinkers—the topos or ethos that we have so far been calling poststructuralist. This "fundamental" connection is figured in Marchart as a certain shared engagement with questions of fundamentals: ontology, the grounding of society, the foundations of culture, society, politics and philosophy. This widespread—even epistemic—engagement with a shared problematic, Marchart calls *postfoundationalism*.

Post-foundational thought is defined by a particular line of thought that problematizes origins, foundations, certainties, unities, and essences. Marchart finds this exemplified in (but not limited to or defined by) the work of Heidegger. And certainly, the status of Heidegger's philosophy for work in poststructuralism has been widely acknowledged. Despite being tarred by association with a terrible politics (Heidegger was a member of the Nazi Party), his philosophical ruminations have nevertheless been extremely influential. Marchart undertakes an interrogation of why and what it is about Heideggerian thinking, that has such far reaching implications for our understanding of a whole range of important contemporary intellectual landmarks, including those of thinkers such as Nancy, Lefort, Badiou and Laclau, but also thinkers such as Machiavelli, Gramsci, Schmitt and Arendt, recent beacons such as Levinas, Lyotard, Deleuze, Lacan, Habermas and Derrida, as well as contemporary theorists including Mouffe, Rancière and Žižek.

The centrality of Heidegger to post-foundational political thought relates to his philosophical engagement with questions of ontology and difference. This has been called the ontico-ontological difference, and it has many dimensions. Here it pertains directly to those questions which became, in debates in French, for instance, carried out in terms of the difference between *le politique* and *la politique*, or politics construed as ontic arrangements of society, its institutions and orders. These contingent ("political") arrangements arise as such (with different aspects of them becoming at different times the stuff of "politics") because of the nature of ontology—an ontology that has come to be thought of as "political." That is, it is only because the ontological level enables/necessitates contingent arrangements that politics is both possible and indeed inevitable. Thus, contingency is necessary for fundamental reasons. The "foundations" of society are fundamentally contingent. Politics is contingent. Ontology is political.

It is the significance of a shared understanding of the relationship between *politics* (understood as contingent and variable "ontic" social arrangements) and *the political* (understood as the "ontological" condition of inevitable contingency permeating and defining any possible social formation) which perhaps constitutes the abiding connection between poststructuralism "proper" (or the named thinkers we have come to associate with the term) and contemporary mutations, transformations and variations in this ongoing strand or impulse of thought. And it is in this sense of coming in response to a shared problematic about "foundations," certainties, stabilities, identities and essences that poststructuralism can be said to continue as a problematic even after the end of the writing careers and indeed the lives of the first generation poststructuralists. Rey Chow's work is steeped in this history and its problematics. But it never simply "uses" (or "is") the approaches of poststructuralism, or indeed of postcolonialism. Rather, Rey Chow's work incessantly urges an intensification of rigor based on an ethics of reading that are as indebted to poststructuralism as they reveal the transgressions and problems inherent to poststructuralism. This comes to light clearly in Chow's readings of film and visuality, as we will see in the following chapter.

Gender, Race, Ethnicity and Visual Culture

Introduction: Film as a Cultural Technology

The connections between mass-mediated forms of popular culture, such as film or pop music, and matters that could be called political are often difficult to discern. This is so even though they can be said to be overwhelmingly *visual* matters. More specifically, they are matters of *representation*, and more precisely still, matters of representation that are ineradicably wedded to particular types of media technology. To elucidate these propositions, this chapter first shows some of the ways in which cinema and film in general can be shown to be significant *cultural technologies*, and some of the ways in which they have complex effects on culture and identity. It then goes on to analyse two music videos in terms of what they could be said to show us about gender, sexuality, race and ethnicity in the contemporary media-saturated world. It is strongly informed by Rey Chow's work, and is designed to elucidate Rey Chow's arguments in this regard.

To begin, let us note: more and more of the world could be said to be media-saturated. However, we might also note: "media saturation" is not a particularly new thing. There have long been media. It is rather that the types of media that are dominant in different times and places change. The 19th century was arguably the century of the dominance of literature and of the British Empire. Literature was the dominant cultural form; Britain the dominant national force. To the extent that this is the case, it can also be said that the 20th century can be regarded as the century of the United States of America and cinema. The USA emerged as the dominant (or hegemonic) cultural and economic force and presence, with the cinema as the dominant cultural form or technology. The complex processes involved are often distilled into the word "Hollywood," a term which evokes the global ideological hold of the USA and the channeling of that ideology through the film form and the cinematic apparatus.

We might ask, what then is the 21st century? Historians of all areas of life—from culture to economics, from military to market, from language to technology—have proposed that the 21st century seems likely to be the century of China and the Internet. We will defer a sustained consideration of the question of "China" at this point—although the effects of the changing status of China is a fascinating question (Chow 1993; Park 2010). Instead, let's begin our visual cultural analysis from the question: what kind of cultural form or technology is the Internet? As I write these words in 2012—over 20 years after the birth of the World Wide Web—the jury is, in fact, still out. Rather than trying to predict the future by trying to anticipate the cultural significance and development of the Internet, let us first consider the fate of the older 20th century cultural technology of film when considered in the context of the emergence of the Internet.

Some cultural theorists have recently started talking of the transition from a cinematic age to what they are calling a post-cinematic age. Such an idea will doubtless undergo further revision and elaboration and find different sorts of formulation as time goes on. But for now, Steven Shaviro's book *Post-Cinematic Affect* (Shaviro 2010) leads the way in this process of rethinking, by engaging with the effects of post-cinematic technologies on our experiences, orientations, emotions, feelings and lives.

"Post-cinematic" technologies include all that is associated with the rise of interactivity, gaming, multimedia, and the proliferation of different internet platforms, as well as various new types of text, such as the music video, the new ways, modes and contexts of experiencing and consuming them and the effects they have on consciousness and perception. Shaviro considers the rise to dominance of these "post-cinematic" technologies in terms of a transformation of "affects": mutations of experiential landscapes, emotional geographies, and perceptual and sensorial ecosystems. Using a famous term developed by the pioneer of cultural studies, Raymond Williams, (yet developing this term in ways informed more by the French philosopher Gilles Deleuze), Shaviro characterizes this as an epochal transformation in dominant "structures of feeling." In other words, the rise of the post-cinematic context has transformed our lives in ways related to our day-to-day and moment-to-moment experience.

If such post-cinematic technologies have transformed structures of feeling, this is not the first time this has happened. For instance, we might consider the emergence of cinema itself. Rey Chow opens her 1995 book *Primitive Passions* (Chow 1995) with a reconsideration of the famous story of the turn towards a writing career of the monumental figure of Chinese literature, Lu Xun. Whilst he was a medical student at the very beginning of the

20th century, Lu Xun watched with horror the cinema newsreels depicting atrocities committed in the Russo-Japanese War in Manchuria, including the executions of Chinese people. Lu Xun's account of his response to these sights is complex and provocative. Indeed, his response to these first cinematic news-reels actually prefigures many of the dominant questions that have arisen in the face of cinema and other forms of viewing or "passive consumption" of mass media messages. For instance, Lu Xun asked, how could the witnesses to executions be so passive; how could audiences, of any kind, do nothing; and, more to the point, what could he himself do in the here and now to address such wrongs and escape the incapacity and passivity of being nothing but a viewer?

These first problems, arising very early on in response to the first cinematic experiences of news reports, arguably set out many of the entrenched problems associated with the cinema, especially the problem of a sense of incapacity, castration, helplessness and passivity. Rey Chow's analysis of Lu Xun's emotional and intellectual response is far-reaching and immensely important (Chow 1995). But the point I want to single out and draw attention to here is one that Chow emphasizes about the significance of the fact that this new technology (the cinematic apparatus) precipitated a peculiar response from Lu Xun: in response to the media images, he turned away from his chosen career path of medicine and towards literature, believing that he could do more to improve the health of China by cultural or ideological intervention than by medical intervention.

Central to Chow's reading of this famous narrative is the following: Xun's response to the new cultural technology (cinema) sends him into a relationship with an older technology (literature). As such, Chow proposes that it is possible to perceive the effects of cinema in (and on) Xun's literature. From this point, one may broaden the perspective and begin to explore the significance of the emergence of cinema within subsequent developments in literature. Indeed, we might even be tempted to regard the majority of 20th century literature as "post-cinematic," in that it is literature produced in a cultural world that the cinematic apparatus has intervened into—and has in fact dominated and transformed.

In other words, this is the same as to say that after the birth of cinema, literature could never be the same again. In this sense, Lu Xun's story is exemplary of the epochal mutation entailed in the shocks and jolts that are such a central part of life in modernity. The shock of the new attendant to the emergence of cinema had effects in untold ways in untold numbers and kinds of context—so much so that literature itself, in modernity, since the birth of cin-

ema, might best be regarded as post-cinematic. Of course, this reverses the chronological periodization and emphasis that organizes Shaviro's book. For, the idea of the "post-cinematic" that Shaviro uses in his book is one which points to all that new stuff that comes after cinema: computers, the Internet, the dynamism and interactivity of gaming or Web 2.0; before that, cable and satellite TV, multiple (indeed myriad) television and radio channels, video, DVD, and all the rest. Nevertheless, as was implicit even in the very first theorizations of the word "postmodern" by such philosophers as Jean-François Lyotard, one of the key points about the postmodern is that everything you can say about the features of the "post" are actually already there, at the outset, before the emergence of the period of "the post" as such (Lyotard 1984): so you can see elements of postmodernity at the origins (and throughout) the historical period called modernity. Postmodern thinkers such as Lyotard have long pointed out that the postmodern is implied in and active in the very emergence of the modern, right from the start.

Rey Chow's reading of Lu Xun's affective response to these early experiences of (or encounters with) cinema demonstrates this explicitly. The new technology intervenes into, informs and thereby transforms the cultural landscape in ways that have knock on (albeit unpredictable) effects on other forms of cultural production and reception. To see this at a basic level, one need merely consider the extent to which so many literary best sellers today have clearly been written with the production requirements of the standard Hollywood film form firmly in mind. This is but one register of the hegemony or dominance of the cinematic form and its "hegemonization" even of other cultural realms, such as literature.

In any case, Shaviro argues that contemporary cultural conditions are such that the cinematic epoch is coming to a close. We are now at the end(s) of the cinematic. This is being registered within cinema, even though cinema remains strongly influential across all of its inheritors—all of the new technologies that are taking cinematic technologies forward in new directions. This is why the times are to be regarded as "post-cinematic" and not "anti" or "non-cinematic." Cinema is on the wane while other technological forms are on the rise, just as the USA is on the wane in terms of its global hegemony, while China is on the rise in terms of economic and military strength. Thus, gaming, all things interactive, the music video, and other new arrivals on the audiovisual technological scene, all remain hugely informed by cinematography, but they move away from its technological limitations.

Meanwhile, cinema (or film, more generally) attempts to incorporate the new technological advancements within itself: from DVD menus, extras,

commentaries, outtakes, integrated marketing strategies with other realms (gaming, animation, toys and merchandise, spin off series) and other supplements, all the way to the inclusion of forms of interactivity that ultimately signal the demise of the older form. According to this perspective, films like *Blade Runner* (1982) or *S1mOne* (2002) are not post-cinematic, whilst *The Matrix* (1999) or even the Korean film *Old Boy* (2003) are. The former are films *about* future technologies, whilst the latter *incorporate* future technologies into themselves, insofar as both films famously affect the styles of computer simulated choreographies in their most famous fight scenes, albeit in different ways: *The Matrix* employs the sharpness and precision of arcade game fights, whilst *Old Boy* incorporates the two-dimensional plane of older forms of computer game, but it counterbalances this with the inclusion of all of the scrappiness, imprecision, stumbling, gasping, moaning and, indeed, messy brawling that almost all action films exclude or repress (as exemplified by the ultra-precise choreography of *The Matrix* or *The Bourne Identity* trilogy (2002, 2004, 2007)).

What's the big deal about cinema?
Or: What does film *"do"*?

Case Study 1: Activity, Passivity, Gender and Sexuality

Now, whether post-cinematic or classically cinematic, one important question is that of what the cinema *does*, or what the cinematic apparatus *does*, or what effects film has: what effects this type of media has on people, what difference it makes to culture and society. As already indicated, one abiding argument made especially by Marxist thinkers is that the cinema makes us *passive* (Adorno and Horkheimer 1986). Some thinkers have been concerned that societies dominated primarily by the imposition of viewing relations in which we're all spectators not only work to make us passive but actually work to make us acquiescent to or even enthusiastic for the worst kinds of political power. In the worst cases we can become enthusiastic for populist or fascist dictators who exploit the cinematic apparatus to make us think that they are charismatic, wise, authoritative, avuncular or loveable father figures or suchlike. (Chow discusses the fact that the film theorist Bazin argued that this manipulation of cinematic effects was at the root of Stalin's success in the Soviet Union.) At the very least, it is clear that we can have our heartstrings plucked by formulaic and clichéd devices of emotional or affective manipulation.

The cover of Guy Debord's classic *The Society of the Spectacle*—one of the most influentially pessimistic Marxist texts about the effects of a media saturated society—has an image of rows of transfixed viewers sitting in a cinema, wearing 3D glasses, all facing towards the screen, all equally and identically enthralled. This has become one of the defining images of the positions which see a media saturated society as one which produces passivity, not only in audiences but effectively in everyone (Debord 1994).

But this argument about passivity, docility or plasticity is not the end of the story about cinematic effects. As mentioned in the previous chapter, one of the most influential analyses of the ideological effects of the cinematic apparatus was delivered by Laura Mulvey in 1975. In her essay entitled "Visual Pleasure and Narrative Cinema" (Mulvey 1975), Mulvey uses psychoanalytic (not Marxist) theory to argue that "the unconscious of patriarchal society has structured film form." Specifically, she argues, the regular repeated "image of the castrated woman [is used by Hollywood film] to give order and meaning to its world." The men fight for the woman. They fight over the woman. The drama circles around the woman. So, "woman" is "tied to her place as bearer of meaning," but she is not the "maker of meaning." The woman is objectified. She is the motive force of the action, but she is essentially excluded from it. Specifically, argues Mulvey, in classic Hollywood, woman is the object of the gaze. She is there *to be looked at*. And this has significant implications, she argues. For it clarifies the extent to which filmic and other media images work to reinforce patriarchal, sexist or misogynistic ideologies.

A clear example of what Mulvey calls the classic effect of such a style can be seen in many pop music videos. One of the best, to my mind, is that of the video for the song "Ayo Technology," performed by Justin Timberlake and Fifty Cent. In this video, set in London, we see the male performers play ersatz James Bond characters. However, although they are slick-suited and sporting various forms of weaponry and technological gadgets, like Bond, they are not spying on villains, criminals, terrorists, or other stock kinds of antihero; rather they are spying on various female characters. Early shots in the video see them looking through night vision goggles and peering through the sights of large guns at women who are scantily clad and, in unusual locations, performing strangely incongruous erotic dances. An early moment sees Fifty Cent spying through a gun sight from a rooftop, looking down at a girl dressed only in her underwear and high heels as she gets into a sports car.

Other scenes see Timberlake spying through binoculars from a chauffeur-driven car at a woman who is writhing in underwear, back-lit, in silhouette, in the window of a city flat or apartment. Later on in the video, Timberlake and

Fifty Cent also appear to command futuristic sci-fi-like technologies, which can evidently act on women at a distance: Fifty Cent controls a virtual computer akin to the device that Tom Cruise uses to see events with omniscience in *Minority Report* (2002). For Tom Cruise's police officer character in the movie, the computer functions to help him master imponderable amounts of data and to perform calculations that attempt to predict the future. Fifty Cent, however, uses a similar-looking device in such a way as to make women become sexually aroused.

Eventually, the video devolves down to the protagonists entering a private or luxury and exclusive-looking lap-dancing club. This has all the hallmarks of a traditional upper-class London "gentleman's club," plus strippers. At this point, we see the male protagonists enjoy lap-dances whilst they themselves are blindfolded, as if inverting the original form of pleasure: at the start of the video, the men indulge in the scopophilia of looking and desiring. By the end, in contrast to the common understanding of the etiquette of lap dancing establishments, in which customers can typically look but not touch, the males, in being blindfolded, are evidently now allowed to touch. Apparently, being blindfold will somehow enhance this experience for them. (This scene is intercut with others in which Timberlake also appears elsewhere: erotic scenes on the stairways, in the doorways and on the landings of a residential apartment building.)

There is much that could be said about such a video, and many others like it. From the perspective offered by Laura Mulvey, the video first illustrates the desiring, objectifying, controlling aspirations of *the male gaze*. The male gaze is a voyeuristic, "scopophilic," controlling gaze, she argues. It is a sexualized and sexualizing gaze. It literally *targets* the female form and objectifies it. In this case, the gun sight through which Fifty Cent spies is clearly a phallic image. The gun targets the woman, and the act of sighting the women is in itself an enactment of power. He could easily "shoot." He could easily "take" her. He feels in control. The decision is in his hands. In a sense, therefore, he is already in control, by virtue of his viewing position.

Similarly, the night-vision binoculars used by Timberlake confer upon the screen the green tint that has been associated (in film and television, in news, fact and fiction) not only with security cameras and military weapons sights, but also with the visual look of various much-publicized celebrities' private/personal pornographic sex tapes. Many of these came to light at around the same time as this music video. The Paris Hilton sex tapes are perhaps the most famous (and perhaps most cruel) example of a rash of "private" sex videos to emerge around that time. Moreover, at such points in the video, the

camera angle changes to that of a handheld private or amateur video, which emphasizes the pornographic allusions. (This song, "Ayo Technology," was reputedly first titled "Ayo Pornography," but the decision was taken to rename it and change the lyrics accordingly because the word "pornography" would damage its ability to receive prime time TV and radio airplay, and hence to maximize sales and revenues.)

So, the video performs a certain male fantasy of desire, control and sexualizing objectification. At the same time as this, and in a way that is entirely consistent with Mulvey's argument, the video depicts women as reciprocally (or perhaps even primarily) performing *for* a male gaze—and, crucially, doing so even when a literal male gaze is not normally assumed to be present. The point at which we see the female figure writhing at the window is the clearest example. For, via this scenario, the video seems to suggest, this is precisely the way that beautiful women will behave when they undress; that even when they believe themselves to be home alone and even when they are simply changing their clothes, they are still basically "asking for it."

The idea of identity as "performance"—that is, as something that is not simply natural or inevitable, but is rather a culturally obligatory performance—was perhaps most widely popularized in the arguments of the early work of Judith Butler. Butler's arguments have since become widely accepted—to a greater or lesser extent—in cultural and media studies (as well as the humanities more widely). It is a perspective that has significant implications for what we might call the politics of media and culture—for part of the argument is that we learn how to "perform," how to "be," from what we *see*.

There are many implications and ramifications here. The video reiterates a version of masculinity as gaze and femininity as "to-be-looked-at-ness"—or male as controlling and female as controlled. With the lyrical repetition of "oh, she wants it, oh, I'm gonna give it to her," and similar sentiments, it repeats the misogynistic perspective that women are "asking for it." But, the question then becomes one of *our agency* in front of the text. Or in other words: once we see that the text is patriarchal, misogynistic and sexist, the question is, does that mean that the viewer will be or become patriarchal, misogynistic and sexist? Is the viewer *passive*? Does the filmic text manipulate us the way that the virtual technology used by Fifty Cent in the video manipulates the woman?

I am reluctant to propose that the watching of videos, films, TV or other media, is going to generate a case of "monkey see, monkey do." In other words, I am not proposing that such videos in and of themselves cause or deepen misogyny or patriarchy. However, this is certainly a possibility that needs to be entertained. For, according to the implications of Mulvey's ap-

proach, what such texts do is that they *normalize* these patriarchal viewing relations: we—male and female—become *used to* (habituated, acclimatized to) viewing the world this way, to apprehending the female as body, as object, as sex, and to regarding the male as powerful, controlling, gazing; we get used to regarding the woman as *wanting* to masquerade and "perform" her femininity as her sexuality for the male gaze, etc.

Another clear example of this can be seen in many Beyoncé Knowles songs and videos, in which apparently "feminist" sentiments are uttered—declarations about "independence" and "strength," for instance, which might at first glance seem to be feminist. But the problem is that these sentiments emerge within songs which are otherwise entirely organized by the performance of desire for a man. One song, which claims to celebrate strong independent femininity, nevertheless repeats the phrase "if you like[d] it then you should have put a ring on it." In other words, the song is organized by a kind of bitterness—a bitterness about and a desire for male commitment. Such resentment hardly seems to be a feminist sentiment, or even the sentiment of a truly "free" and "independent" person. Rather, in this performance, we see a combination of contradictory sentiments which show that the celebration of independence is in fact a grudging resentful response to the disappointment elicited when the (absent) male refused to "put a ring on it"—i.e., to commit, to get engaged or married. To this extent, all the words about "feminism" or "strength" in the song are a mere replaying of the most patriarchal of assumptions or stereotypes about males and females: that men will not commit, and that all women really want is a man.

Many other of Beyoncé's "feminist" or "post-feminist" songs replay this logic: the character who frantically performs her desire through myriad costume changes and insanely energetic erotic performances in front of an entirely stationary and unresponsive "cool" male character; or the woman who ditches her partner because he is not up to scratch, singing about how she will be "over you in a minute" and that she will have "another [one of] you in a minute"—all of which confirm that ultimately what is desired is standard patriarchal heterosexual domesticity.

But just because these popular cultural media texts are evidently patriarchal, sexist and *heteronormative* (in that they reiterate the message that heterosexual norms are both the standard and the objective, the expectation and the ideal), does this mean *either* that we are passive before such texts *or* that we ourselves will "become" patriarchal, sexist and heteronormative ourselves by virtue of our exposure to them?

There are many approaches to culture and identity to propose that we may "become" what we are exposed to. However, many of these are simplistic (or indeed what is termed "essentialist"), in that they propose a kind of "monkey see, monkey do" relationship between what (certain types of) people are exposed to and what they will do—especially if they *enjoy* what they see. And, it is important to note, we may well enjoy Beyoncé's or Timberlake's videos, and for any number of reasons: we may find the beat irresistible; we may be enthralled by the faces and bodies in the videos; or the sheer complexity and rapidity of the flashing and changing scenes in a music video may be compelling. But does our enjoyment make us a prisoner or a puppet? The situation is surely more complex.

The Commodification of Sex and Ethnicity

The cultural critic, bell hooks once provided an interesting account of the problems of rap, hip-hop music and black youth identity in the 1980s and early '90s. Hip-hop was arguably one of the main contexts in which black youth culture gained anything like cultural visibility and prominence. During the 1990s and up to the early 2000s, hip-hop and rap could actually be said to have utterly transformed mainstream popular music and global popular culture in myriad ways. But there was a problem at the heart of it. According to hooks, the black rapper *character* and the hip-hop music video *style* became entangled with a damaging image of blackness.

The logic, according to hooks, is that of a vicious circle. The circle is this: first, hip-hop gains prominence as a nominally black musical genre. It is associated with poor black youth and also with anger and protest. It is organized by a connection with "the street." This all gives hip-hop and rap a strong identity. But it also becomes a cliché, a stereotype, a cheap commodity. It becomes another way of defining the black: angry, dangerous, poor, politicized, apparently aggressive, often violent. Over time, sexuality comes to the fore too. Black rap and hip-hop videos (along with white spinoffs and related enterprises) increasingly involve the tried and tested marketing device of always including sexy female "eye candy." So what becomes produced is *a genre which can all too easily act as a stand in for black culture per se*. This genre—and this interpretation of what black culture "is"—becomes reduced to violence, guns, money and girls.

Now, what hooks proposes is not that "people" (viewers, listeners) simply "change" and "become" more violent or more sexist. Rather, it is that certain generic and formulaic rules, certain sorts of lyrics, types of imagery and styles of video (involving guns, girls and money) gain a dominance and act as a kind

of stranglehold. To be a success, artists perceive that the easy—or the only—route is to produce texts and performances that now conform to this new norm. In other words, what Adorno and Horkheimer called *the culture industry* produces cultural and media effects, effects which play themselves out in people's daily lives, fantasies and desires.

Nevertheless, despite the importance of bell hooks' arguments and insights, the media are not simply "external" to us. The audiovisual media texts that permeate everyday popular culture are not simply fictional or fake, with no relation to our hearts and minds, our actions and inactions. As all of the foregoing discussions have implied, audiovisual media texts are potentially hugely important vis-à-vis individual and collective identity-formation. To see this, let us turn to another concise media text—a text which dramatizes in a hyperbolic and comic way the effects on identity of attractive media images. What the text lacks in seriousness, it more than makes up for in providing a thought-provoking scenario about identity.

Case Study 2: Ethnicity, Sexuality, Identity and Coercive Mimeticism

The text I want to focus on here is the music video for the song "Pretty Fly for a White Guy" by the band The Offspring (1998). It is a comic and frivolous text—both in the lyrical content and in the video. But what it explores and dramatizes is both recognizable and serious, and raises some fundamental questions about identity, desire and phantasy.

The song is structured by the refrain "all the girlies say I'm pretty fly for a white guy." In the video, these words are uttered by a white "wannabe." The lyrics narrate the tale—or rather, the situation—the plight—of an apparently affluent, suburban white American teenager, a teenager who nevertheless fantasizes about and evidently fetishizes edgy nonwhite ethnicity. In the video, we see several of the scenarios that define his phantasy. Whether black African-American or Latino, our eponymous "white guy" wannabe wants-to-be *that*: he identifies *with*, he fantasizes *as* that. He wants to be one of *them*. Unfortunately, what is absolutely clear here is that the one thing he is not is "pretty fly." Rather, he is presented as ridiculous, a fool, utterly lacking in self-awareness or self-knowledge—living, as the lyrics put it, "in denial."

So, the song is all about getting it wrong, wanting the impossible, and denying that impossibility. The reason for wanting the impossible boils down to a *phantasy*. (I use the "ph" spelling here to highlight the psychoanalytic/cultural theoretical specificity of this usage. The "ph" spelling is more likely to be used in British-English rather than American-English academic contexts

in any case. However, elsewhere I use the "f" spelling, usually where the "ph" spelling would appear awkward, but also where psychoanalytic specificity is not necessary.) This is dramatized in the call-and-response (and commentary) that opens and permeates the song. The song opens with it: a female chorus chant "Give it to me baby." In the video, our hapless hero responds in the affirmative. This call and response is repeated. It is a chant of female call and male response that dramatizes what is evidently a male sexual phantasy about specifically ethnic female desire. It is followed by the gravelly voiced claim: "And all the girlies say I'm pretty fly for a white guy," whereupon the song "proper" begins. This, it soon becomes clear, is the structuring fantasy (or *phantasy*) of our misrecognizing, fantasizing white guy. This is what he wants. This is what he thinks it would be like if only he were the ethnic he wants to be. This is what he wants to see and hear. He imagines the call. He "performs" a response. So, in the video representation, the song runs: repeated female chant ("Give it to me baby"); he answers ("uh huh, uh huh"). This is followed by the voice of his phantasy, which asserts his conviction that "all the girlies say I'm pretty fly for a white guy."

After this intro, we are "counted-in" in incorrect Spanish ("Uno, dos, tres, cuatro, cinco, cinco, seis"). If we had been in any doubt up until now, this *mis-count*—this moment of getting it just a bit but fundamentally wrong—not quite getting the Spanish right—clarifies things for us. This is a joke. This is about misrecognition, getting it wrong. Moreover, the girls in the video are clearly non-existent fantasy constructions: there never were girls thronging around him on the way to his car, by the side of the road, or covered in glittering paint by the pool. They are entirely his phantasy.

An initial assessment of the song, taking into account any mirth it might produce—and the extent to which we might share, understand, or "get" the joke—suggests that this popular cultural text is saying something quite precise about identity, about "cultural" identity, "identity performativity" and ethnicity. And this appears to be something quite different from what is widely supposed to be held by many thinkers, from Judith Butler to Homi Bhabha and beyond. For, the text seems to be saying at least one, or perhaps all, of the following:

1. that a white ethnic cannot—or should not—try to "perform" another ethnic identity;
2. that trying to be other than white for the white is ridiculous;
3. that trying to do or to be so is premised on "not getting it," on "denial";

4. that white ethnicity is not like other ethnicities—not porous, not dilu-
 table, not "hybridizable" or "fragile"; and
5. that the only compensation for the sadness and disappointment that
 this might cause for our wannabe is the contemporary Confessional:
 "At least you know you can always go on Ricki Lake," say the lyrics.
 Indeed, don't worry, be happy, add The Offspring: "the world needs
 wannabes." So, "hey, hey, do the brand new thing."

The song is very clear on this. After staging the fantasy scenario, after be-
ing miscounted-in, the narrative voice begins to tell us all about it. The lyrics
begin by addressing us in terms of a shared lot, a common problem that we all
recognize: "You know it's kinda hard just to get along today." *We all know this,*
right? Furthermore: "Our subject isn't cool, but he thinks it anyway." Isn't this
a familiar story? How many of us are guilty of it ourselves? We may recall La-
can's contention that, in love, "*You never look at me from the place from which I
see you.* Conversely, *what I look at is never what I wish to see*" (Lacan quoted in
Chow 1998: 81). Moreover, as Rey Chow points out, this "dialectic of eye and
gaze" need not be *literally* intersubjective; a man may fall "in love, not with a
woman or even with another man, not with a human being at all but with a
thing, a reified form of his own fantasy" (1998: 78). As The Offspring put it:
"He may not have a clue, and he may not have style / But everything he lacks,
well he makes up in denial."

Is *this* his problem: "denial"? "Denial" is surely the most abused, misused,
bandied-about psychobabblistic term ever. Everyone, it seems, risks living in
denial. Overcoming denial is indeed an abiding concern of an enormous range
of popular cultural texts and discourses. But, if denial is deemed to be the
problem, what is deemed to be the solution? The popular answer is: come to
terms, recognize, accept. But how? By talking about yourself; by *confessing.* Go
on Ricki Lake. Even if you are "fake," you *can* have a moment of real-world,
recognized, "authentic" success ("fame"), by coming clean, by confessing, pub-
licly: the only authentic redemption in a world which thrives on the produc-
tion of fakes and wannabes, say The Offspring.

If we can laugh at all of this it is also because we can recognize all of this.
According to the implications of the argument of Michel Foucault in *The His-
tory of Sexuality, Volume 1* (Foucault 1978), this familiarity and recognizability
comes from the fact that The Offspring song plays with the material thrown
up by and circulating in and as a discursive constellation—a very old discursive
constellation, says Foucault, which came together in the 18th century. In this
discursive formation, the terms ethnicity, identity, authenticity and autobiog-

raphy—or *confession*—encounter each other in an overdetermined chiasmus. In it, whenever issues of identity and ethnicity arise as a (self-reflexive, "personal") problem, this discursive constellation proposes that the route out is via the self-reflexive side-door of autobiographical (self) confession.

There is more to this than observing that engaging with ethnicity requires an engagement with one's own identity, one that ought to lead into a searching self-interrogation and ideally a deconstruction of questions of authenticity and autobiography—although this is certainly a part of it. For the Foucauldian point is that precisely such discourses of the self, especially in terms of the brands of self-referentiality that nowadays feed chat shows like Ricki Lake, can be seen to have emerged decisively in modernity. And they emerged with an attending argument about self-referentiality's subversive relation to power and its emancipatory relation to truth. That is, it refers us to the implications of Foucault's argument about what he called "the repressive hypothesis"—namely, that almost irresistible belief that power tries to silence us and demands our silence (Foucault 1978: 18; Chow 2002: 114). As Foucault argued, however, almost the exact opposite is the case. Or rather, even if there are places where power demands silence or discipline, these are more than matched by an exponential explosion and proliferation of discourses—in this case, discourses about the self.

These discourses include arguments about self-referentiality's subversive relation to power and its emancipatory relation to truth, which relate to the Enlightenment idea that an introspective turn to the self is emancipatory: the ingrained idea (whose prehistory is the Catholic Confessional, and whose contemporary ministers Foucault finds in the psychiatrist and psychoanalyst) is that seeking to speak the truth of oneself is the best method of getting at our essential truth *and* the best way to resist power. Similarly, modern literary self-referentiality emerged with an attending discourse of resistance—a discourse which regarded *literature "as such"* as resistance to the instrumentalization of technical and bureaucratic language, first and foremost. And, by the same token, self-referentiality emerged as an apparently ideal solution to the knotty problem of representing others. For, how do you represent others truthfully, adequately, ethically? The answer given here is: *you* don't. *They* should represent themselves. Here, the self-reflexivity of self-referentiality is regarded not as apartheid but as *the* way to bypass the problems of representing others—by throwing the option open for everyone to speak the truth of themselves.

However, in Foucault's phrase: "the 'Enlightenment,' which discovered the liberties, also invented the disciplines" (Foucault 1977: 222; see also Chow 2002: 113). In other words, the desire to refer to the self, to discuss the self, to

produce the self discursively, the impulse to indulge in autobiography and confession, can be regarded as a consequence of disciplinarity. Psychiatry demands that we reveal our selves. As does psychoanalysis, as do ethnographic focus groups, as do corporate marketing focus groups, not to mention the Confessional, the criminologist and chat shows like Ricki Lake. And so on. Autobiography and confession are only resistance if power truly tries to repress the production of discourse. Which it doesn't—at least not everywhere.

The point is, autobiography and confession are genealogically wedded—if not welded—to recognizable disciplinary protocols and—perhaps most significantly—proceed according to the terms of recognizable metanarratives. Thus, says Chow:

> When minority individuals think that, by referring to themselves, they are liberating themselves from the powers that subordinate them, they may actually be allowing such powers to work in the most intimate fashion—from within their hearts and souls, in a kind of voluntary surrender that is, in the end, fully complicit with the guilty verdict that has been declared on them socially long before they speak. (Chow 2002: 115)

Of course, in thinking about postcoloniality, ethnicity, social semiotics and cultural politics, it is very difficult *not* to think about oneself. Indeed, even in full knowledge of Foucault, there remains something of a complex *imperative* to do so, even (perhaps especially) if, like me, one does not have a blatantly postcolonial ethnicity in the classic sense—even if, that is, like me (in the predominantly white UK), one has an entirely hegemonic socio-cultural identity: an ethnicity without ethnicity, as it were; the *hegemon* of a hegemony; that is, the "norm." For, surely one must factor oneself into whatever picture one is painting, in terms of the "institutional investments that shape [our own] enunciation" (Chow 1993: 2). Indeed, suggests Chow:

> the most difficult questions surrounding the demarcation of boundaries implied by "seeing" have to do not with positivistic taxonomic juxtapositions of self-contained identities and traditions in the manner of "this is you" and "that is us," but rather, who is "seeing" whom, and how? What are the power relationships between the "subject" and "object" of the culturally overdetermined "eye"? (Chow 1991: 3)

Might acknowledging as much make *me* "pretty fly for a white guy"? As thinkers like Robyn Wiegman and Rey Chow have pointed out:

> the white subject who nowadays endeavors to compensate for the historical "wrong" of being white by taking on politically correct agendas (such as desegregation) and thus distancing himself from his own ethnic history, is seldom if ever accused of being

disloyal to his culture; more often than not, he tends to be applauded for being politically progressive and morally superior. (Chow 2002: 116-117)

Chow proposes that we compare and contrast this with nonwhite ethnic subjects—or rather, in her discussion, with nonwhite ethnic critics, scholars and academics. These subjects, she argues are pressured directly and indirectly to behave "properly"—to act and think and "be" the way "they" are supposed to act and think and be, *as* nonwhite ethnic academic subjects. If they forget their ethnicity, or their nationalistically or geographically—and hence essentialistically and positivistically—defined "cultures" and "heritages," such subjects are deemed to be sellouts, traitors—*inauthentic*. But, says Chow, if such an ethnic scholar "should...choose, instead, to mimic and perform her own ethnicity"— that is, to respond or perform in terms of the implicit and explicit hailing or interpellation of her as an ethnic subject as such, by playing along with the "mimetic enactment of the automatized stereotypes that are dangled out there in public, hailing the ethnic" (110)—"she would still be considered a turncoat, this time because she is too eagerly pandering to the orientalist tastes of Westerners" (117), and this time most likely by other nonwhite ethnic subjects.

Thus, the ethnic subject seems damned if she does and damned if she doesn't "be" an ethnic subject. Of course, this damnation comes from different parties, and with different implications. But, in any eventuality, Chow's point is that, in sharp contradistinction, "however far he chooses to go, a white person sympathetic to or identifying with a nonwhite culture does not in any way become less white" (117). Indeed, she claims:

When it comes to nonwhite peoples doing exactly the same thing...—that is, becoming sympathetic to or identified with cultures other than their own—we get a drastically different kind of evaluation. If an ethnic critic should simply ignore her own ethnic history and become immersed in white culture, she would, needless to say, be deemed a turncoat (one that forgets her origins). (2002: 117)

It is important to be aware that it is not just whites who pressure the nonwhite ethnic to conform. Chow gives many examples of the ways that scholars of Chinese culture and literature, for instance, relentlessly produce an essentialist notion of China, which is used to berate modern diasporic Chinese (and their cultural productions). This essentialism takes the form of evoking an essence *that none can live up to*, precisely because *they are alive* and as such contaminated, diluted, tainted or corrupted by non-Chinese influences.

At least one side of this key difference between the white and the nonwhite is dramatized in the Offspring song. Whilst postcolonial critics often recount cases in which nonwhite ethnic subjects are pressured directly and in-

directly to start to behave "properly"—to act and think and be the way "they" are supposed to act and think and be as nonwhite ethnic subjects—in other words, to be both *interpellated*, in Althusser's sense, and *disciplined*, in Foucault's sense—I think that the very intelligibility of the Offspring song and its fairly unequivocal condemnation of the white-wannabe-nonwhite suggests that the white guy who shows too much interest in nonwhite culture, rather than being "applauded for being politically progressive and morally superior," can quite easily and will quite frequently be deemed not only "disloyal to his culture" but *ridiculous. Yet, he remains no less white.* In fact, it seems, *he can become no less white.* But he is still a traitor. Thus, corroborating Chow's thesis, white ethnicity is here presented as absolutely immovable and essentially (or wholly/holy) incorruptible.

All of this, Rey Chow calls "coercive mimeticism" (2002: 107). Coercive mimeticism designates the way in which the interpellating, disciplining forces of all different kinds of discourses and institutions *call* us into place, *tell* us our place, and work to *keep* us in our place. As Chow writes of the ethnic academic subject: "Her only viable option seems to be that of reproducing a specific version of herself—and her ethnicity—that has, somehow, already been endorsed and approved by the specialists of her culture" (117). Accordingly, coercive mimeticism ultimately works as "an institutionalized mechanism of knowledge production and dissemination, the point of which is to manage a non-Western ethnicity through the disciplinary promulgation of the supposed difference" (117). As we see through the Offspring song, this disciplinary mechanism extends far beyond the disciplines proper, far beyond the university. In Chow's words:

> unlike the white man, who does not have to worry about impairing his identity even when he is touched by a foreign culture, the ethnic must work hard to keep hers; yet the harder she works at being bona fide, the more of an inferior representation she will appear to be. (124)

Reciprocally, we might add, the harder the white guy tries to be nonwhite, the "more" white he will appear. In trying to be other—so say the interpellating voices, tropes, discourses and institutions—he is of course, just being *silly.* Whether this means that the white attempt to be like the other is silly, or that the other is silly—or both—is perhaps debatable. What is not debatable is that in all cases "authenticity" ultimately translates as a hypothetical state of non-self-conscious and non-constructed essential "being." The fact that this is an essentialism that is essentially impossible does not mean that it does not "happen"; rather it means that "ethnicity" becomes an infinitely supple rhetorical tool. It is available (to anyone and everyone) as a way to disparage both *anyone*

who is not being the way they are supposed to be and anyone who *is* being the way they *are* supposed to be.

As Chow explains, "ethnicity can be used as a means of attacking others, of shaming, belittling, and reducing them to the condition of inauthenticity, disloyalty, and deceit" (124). Ironically, such attacks are "frequently issued by ethnics themselves against fellow ethnics, that is, the people who are closest to, who are most *like* them ethnically in this fraught trajectory of coercive mimeticism" (124). What this means is that the most contempt, from all quarters, will always be reserved for he or she who does not stay in their place, play their proper ethnicity. All too often, criticism is leveled *individually*, as if it is a *personal* issue, "despite the fact that this historically charged, alienating situation is a collectively experienced one" (124). Such is the disciplining, streaming, classifying force of coercive mimeticism. Such are the "uses of ethnicity."

In the words of Etienne Balibar: "the problem is to keep "in their place," from generation to generation, those who have no fixed place; and for this, it is necessary that they have a genealogy" (Balibar quoted in Chow 2002: 95). As such, even the work of sensitive, caring, deeply invested specialists, and expert ethnic scholars—even ethnic experts in ethnicity—themselves can function to reinforce ethnicized hierarchies, structured in dominance, simply by insisting on producing their field or object in its difference. What is at stake here is the surely significant fact that even the honest and principled or declared aim of studying others otherwise can actually amount to a positive working for the very forces one avowedly opposes or seeks to resist.

Visible Space and/as Power

The two case studies discussed above may seem very different. One focused on gender performativity and the force of "the male gaze." The other focused on issues around the performance of ethnicity. But both are unified in what they reveal about the visual field's relation to power. If these case studies indicate anything, it is the extent to which the space of visual media is steeped in power relations which extend beyond it. There are codes of propriety in gender and ethnic performance—and even where one might least expect it, such as in the supposedly irreverent (con)texts of popular music videos. In other words, although our case studies may have taken us far and wide—from Hollywood to the Internet, from 19th century British colonialism and imperialism to 20th century Chinese literature, from the semi-pornographic codes of a contemporary pop video to the irony of some late 20th century rock/pop, via complex poststructuralist theory—each reading pointed to the conclusion that the visual

and performative space of popular culture is saturated with power, power that cajoles and coerces us to identify with some things and to disidentify with others, and to "perform" ourselves according to the dictates of dominant cultural discourses about gender and ethnicity.

Cultural Politics before China; or "the foundation of contemporary cultural studies"

I f one shouldn't judge a book by its cover, so academics shouldn't "read" books by their titles. Yet they do. Rey Chow's book titles have sometimes featured words such as "China" and "Chinese film": *Woman and Chinese Modernity: The Politics of Reading between East and West* (1991), *Primitive Passions: Visuality, Sexuality, Ethnography, and Contemporary Chinese Cinema* (1995), and *Sentimental Fabulations, Contemporary Chinese Films: Attachment in the Age of Global Visibility* (2007), for instance. However, more often than not, Chow's book titles do not mention China: *Writing Diaspora: Tactics of Intervention in Contemporary Cultural Studies* (1993), *Ethics After Idealism: Theory, Culture, Ethnicity, Reading* (1998), *The Protestant Ethnic and the Spirit of Capitalism* (2002), *The Age of the World Target: Self-Referentiality in War, Theory and Comparative Work* (2006), and most recently, in 2012, *Entanglements, or: Transmedial Thinking about Capture* (2012), for instance. Yet still, for many, Rey Chow is a name that is overwhelmingly associated with Chinese film studies, or rather with the ("American" or "Western") study of Chinese films.

But, as we have already established in the previous chapters, there is much more to Rey Chow's work than issues essentially related to China and Chinese film. Certainly, Chow frequently explores ideas, questions and problematics *through* issues involving "China" and analyses of Chinese film. She often examines questions of race, place, gender, sexuality, class, communication, translation, culture and politics through examples of and from Chinese film. However, a closer look reveals these examples to have been selected not because of their specific local or regional "Chinese" characteristics, but rather because of their unexpectedly challenging and illuminating place in international, transnational, cross-cultural and even global networks and relays of culture. Indeed, this applies not only to Chinese examples but also to China itself

as example. In one respect this is because, as Chow once argued, in many ways, "'modern China' is, whether we know it or not, the foundation of contemporary cultural studies" (Chow 1993: 18). We will explore this claim and its relation to Chow's work on and around "China" and cultural politics in this chapter.

As all of this might already be taken to indicate, and as we have already seen, Rey Chow's work invariably combines complex issues in unusual ways to produce often-surprising conclusions. Her readings often combine quite a few already complicated issues and sets of questions into what is putatively "one" analysis of "one" thing. But through such analytic and interpretive entangling, Chow regularly shows the extent to which supposedly discrete issues are intertwined and entangled—in ways which thereafter come to seem glaringly obvious—but only *after* Chow's incisive excavations. This is surely why her most recent book to date is called *Entanglements* (2012).

Doubtless Chow proceeds in a "complicated" manner because "things themselves" are not simple, so therefore no academic engagement should simplify things by subjecting them to only one possible set of questions or procedures. Of course, this is not to say that Chow does *everything*, or that she lends every possible approach, methodology or every possible set of questions equal weight. Indeed, as set out in chapter one, and as many readers may suppose by taking one look at Chow's references and bibliographies, it could be quite easy to conclude that her work is located *entirely* within the tradition of poststructuralism. Accordingly, some might say that, because poststructuralism can seem to be an intellectual tradition almost hell bent on apparently *deliberately* complicating things, then perhaps Chow is simply following a certain poststructuralist style—that of endlessly problematizing things, or of indulging in complicating for complication's sake.

But this is too simple. Moreover, Chow herself has directly (and more than once) confronted the question of difficulty "versus" directness in academic writing, and has analyzed and discussed at length what she calls the poststructuralist strategy of "making complicated." As she writes in *Primitive Passions*, for instance: "'to make complicated' remains poststructuralist textualism's primary strategy of resisting domination," and this is why, in poststructuralism, "surfaces, simplicities, and transparencies can only be distrusted as false" (Chow 1995: 191). In other words, on Chow's interpretation, "poststructuralist textualism" is an orientation that has overwhelmingly regarded itself as being against, opposed or resistant to some quite specific things— things that manifest themselves in *particular linguistic styles*. Accordingly, poststructuralist language is complicated because—according to poststructuralist

sensibilities—anything and anyone who trades in "surfaces, simplicities, and transparencies can only be distrusted as false." Upon discerning this, the question therefore becomes, for Chow, what is the intellectual, political and historical status of poststructuralist complexity?

In *The Age of the World Target* (2006), Chow argues (primarily through a reading of Michel Foucault) that the reasons why poststructuralism has always tended to be so resolutely difficult to read relate to its investment in modernist literary aesthetics. Homing in on his reflections on literature and language in *The Order of Things* (Foucault 1970), Chow draws attention to Foucault's statement that the "the most important" response to the "demotion" of the status of language in the world was the "appearance of literature, of *literature as such*" (Foucault 1970: 299; quoted in Chow 2006: 5; emphasis added by Chow). Chow goes on to problematize the implicit essentialism (and cultural elitism) lurking within Foucault's phrase "literature as such" (namely the very idea that there simply is such a thing as "literature *as such*"). But first she notes:

> The notion of literature as a compensatory anchor in a world that has become over-technologized and over-bureaucratized is, of course, not exactly new—in Victorian England, Matthew Arnold's investment in literature as a kind of custodian of morality in the advent of secularism is a good case in point. But Foucault approaches the uniqueness of literature quite differently. By "the appearance of literature," Foucault is referring to a kind of writing that, in revolt against language's loss of agency, takes on a permanently oppositional stance against the world—in the form of an *impenetrable self-referentiality*... Barthes, in a similar vein, would allude to (the cryptic expressions of) modern poetry as his primary literary example of such a linguistic resistance.... (Chow 2006: 5-6)

She goes on to note that, from all quarters, but specifically in and around nascent poststructuralism, "we repeatedly come upon claims of revolt, denial, and contestation, on the one hand, and assertions of literature's detachment from—indeed, severance of all ties with—the rest of the world, on the other" (Chow 2006: 6).

From these and related observations, Chow at once insists on the primacy of questions of language and literature to poststructuralism and *thereby* displaces the matter. For, where Foucault, Barthes, Derrida and others were wont to proceed as if literary language were inevitably "political" and "resistant" (and indeed it may well be, in any number of potential ways—Chow would certainly not deny this possibility), Chow makes what can perhaps best be described as the faithfully subversive gesture of problematizing the deconstructive drive to problematization and historicizing the emergence of so-called "literature as such." (Of course, Foucault is not Derrida; and neither Foucault nor

Derrida in and of themselves could be said to exhaust the field and range of work and approaches that might be termed "poststructuralism." Perhaps this is precisely why Chow deconstructs Foucault in Foucauldian terms, and elsewhere deconstructs Derrida in Derridean terms.) As she says of Foucault's early investments in literary language "as such":

> The notion of literature as resistant and transgressive—qualities that are mapped onto the non-communicability, the hysteria as it were, of language in certain modern literary examples (examples that would include Raymond Roussel, Antonin Artaud, Maurice Blanchot, and Georges Bataille at other moments in Foucault's writings), only then to be declared as the definition of literary writing itself—is, to say the very least, problematic. Whereas Foucault would go on, in his subsequent work, to criticize the "repressive hypothesis" in modern practices of sexuality such as psychoanalysis, at this point in his career he seemed invested in none other than a *repressive hypothesis of literature*, whereby literature, rather than being the vehicle and effect of power (as he would teach us about sexuality), is conceived of, romantically, as power's victim and opposition. (Chow 2006: 7-8)

Chow's treatment of Derrida and "deconstruction proper" is different to this, as we will see in subsequent chapters (see also Chow 2006: 176-202). But throughout *The Age of the World Target* the primary, organizing and orientating question remains the perhaps surprising one of *language*. This may be surprising inasmuch as *The Age of the World Target* is a title which strongly suggests that its pages are likely to cover matters related to *the whole world*, to *targeting*, and surely therefore to matters related to global politics, the military, militarization, and so on. And indeed, it does. But, Chow shows some of the ways in which none of this is *unrelated* to language. Indeed, Chow in one sense *fully accepts* the poststructuralist theorization of language as central, constitutive and cortical; but in another sense she *fully transforms* its status. As she writes in the introduction:

> How have we come to write in the manner we do in the Anglo-American world of humanistic studies today? How might this condition of writing be assessed against the larger forces of cross-cultural encounters and entanglements—specifically, since the end of the Second World War? What might we learn by juxtaposing area studies, poststructuralism, and comparative literature—academic spheres which seem to lead separate existences but whose developments are all closely tied to postwar North America, in particular the United States? (Chow 2006: 1)

This is a series of what for many readers will have been *unexpected questions*, but they are questions which, through their very posing and juxtaposing, already start to accrue some *unanticipated associations*. Even the questions' sugges-

tion that unexpected connections may in fact exist starts to sound both plausible and compelling.

The eternally returning question of the style of academic writing, for instance, is not formulated by Chow as if styles of academic writing and other activities are simple "free choices"—as if, for instance, the difficult language of cultural theory were based on a petulant narcissism or a navel-gazing disconnection from "the real world," as it is so often formulated by those hostile, resistant to or jaded by cultural theory. But at the same time, the styles of writing associated with cultural theory are not treated by her as somehow heroic, free or "superior" to other forms of writing or discourse. As Chow illustrates through her analysis of the structure of some key disputes around different versions of feminist writing, in *The Protestant Ethnic and the Spirit of Capitalism* (2006: 154-160): tit-for-tat disputes about this or that style of writing being more or less "engaged," more or less "real," or more or less "political," often miss far wider discursive and historical factors, subtending and organizing our positions and relations (see also chapter one). Put differently: as we have already seen in terms of "literature," so we can see in disputes about styles of academic language, and about the differences between disciplinary approaches, orientations, paradigms and organizations. In all of these disputes, "we repeatedly come upon claims of revolt, denial, and contestation, on the one hand, and assertions of...detachment from—indeed, severance of all ties with—the rest of the world, on the other" (2002: 6). One approach accuses the other approach of being useless, disengaged, deluded or of missing the point.

Rather than rushing to occupy a position for or against this or that approach or this or that style, Chow rather prefers to assess matters in term of "the larger forces of cross-cultural encounters and entanglements" (2006: 1). This means that on the one hand, Chow will seek to historicize the reasons for particular preferences, whilst, at the same time and on the other hand, assessing them (indeed, deconstructing them) according to their own terms. But these "two" dimensions are not really separate: your or my "own terms" have not arisen spontaneously. Rather, they are entangled in other—often unexpected—forces and relations.

To put it bluntly, this is again to say that Chow does not seek complication for complication's sake. Nor does she regard "making complicated" as some kind of political mode of resistance or even political strategy. In other words, hers is *not simply* the strategy of classic poststructuralism. Chow's injunction or objective is not "*to make things complicated*"—even if she is clearly committed to processes of complex ethically focused reading and even if this is an injunction that she associates with deconstruction. This is so even though

deconstruction and other forms of poststructuralism are often explored by and mixed into her work, and even though it seems clear that Chow has a great deal of time for poststructuralism and deconstruction. Indeed, this is so even though her 2012 book is entitled and is all about *Entanglements*.

Rather than simply complicating and "resisting," Chow clearly seeks to take things forward. Things change—even before we have understood them. And this can be seen at all "levels." From the time of writing her first two books, for instance—*Woman and Chinese Modernity* (1991) and *Writing Diaspora* (1993)—books which focus heavily on the status of "China" (as *object*, as *other*, even as *abject*), it is clear that "China" has changed, on all levels: economically, socially, theoretically, discursively. "China" is not one thing and will not stay in one place. What it "is" depends on time, trajectory, viewing position, theoretical frames, and the force and consequences of all manner of intervention. Whatever else "China" may ever have been, Chow emphasizes in her first books that from the 1960s to the 1980s, at least, "China" functioned as a signifier of alterity, a signifier of the limit, the other of Europe, and as an object of projection, desire, and fantasy, in countless ways and contexts, up to and including those of the growing fields of poststructuralism, deconstruction and postcolonial studies.

The flourishing of these fields saw the flourishing of ideology critique and of the exposure of biases: the exposing of Eurocentrism, ethnocentrism, racism, sexism, elitism, and, of course, orientalism. By the mid-1990s, however, Chow was urging us in no uncertain terms to move on from an older denunciatory mode of cultural criticism. As she argued in the important essay "The Dream of a Butterfly" (1998): so many decades after Edward Said's monumental book *Orientalism* (Said 1995) taught us about the massive ancient and ongoing production and circulation of orientalist ideas about non-European peoples and places, *surely we now need to move on*. By this, Chow clearly did not mean to suggest that, when faced with orientalist or otherwise racist texts and cultural practices, we should just "get over it." Rather, what she meant was that the revelation of orientalism in this or that text should *now* be a preliminary observation, and not a final conclusion: an easy thing to discern; an easy thing to see. Put differently, Chow's question is "what else?" What else is going on in an orientalist text? Yes, it may be orientalist, but is that all there is?

In "The Dream of a Butterfly," Chow reads an ostensibly orientalist text in such a way as to point out that judging it negatively simply because it clearly has orientalist dimensions is a mode of reading that overlooks many other complicated and culturally important features: questions of cross-cultural communication, of attraction, of identity and desire, of seduction, and the

performance, establishment and destruction of identity, to name but a few. It is in this kind of way that Chow always seeks to move things (and thinking about things) forward. Because of it, Chow inevitably becomes a notoriously difficult thinker to "place." She does not sit squarely within one disciplinary space because she pushes the frontiers of such spaces (including—perhaps primarily—their internal frontiers—a proposition that will be developed in chapter six). Chow does not write or think to a disciplinary brief. She clarifies the ways in which such structures are also strictures which emerge and establish themselves according to different types of historical, institutional and disciplinary inevitability but which (therefore) should not be respected or deferred to. For they are in fact also sites of *capture*.

Entanglements (2012) focuses on capture. It contains essays on captivating, on capture, on entanglement, and on mimetic violence; on topological looping together and on enmeshment. Chow asks, can entanglement be the figure of meetings not necessarily defined by proximity or face-to-faceness? But it not only focuses on the now familiar (poststructuralist) concept-metaphor of this or that textile/textual material that is entangled. It also focuses on its reciprocal or conceptual obverse: the cut, the fragment, the break, rip and tear. In the chapter "When reflexivity becomes porn" Chow revisits modernism, returning to Benjamin on Brecht and the constructive/destructive effects of cuts, of cutting up into parts—in other words, of *editing*.

Chow's discussion of cutting and editing encompasses the philosophical, theoretical and practical considerations of what she calls the infinitization of the parts, the partial and partitioning. She theorizes Photoshop in terms of modernist montage and returns to Benjamin's thinking on photography, characterizing his contribution as a landmark transformation in the thinking of what the artistic image could be and do (in terms of its new capacity to offer a perfect replication), when the copy/image becomes a kind of proliferation of *place*. According to Chow's reading, given the perfect copy image, Benjamin's take on photography is that it inaugurates a new logic of capture. The copy multiplies and proliferates and sets reality into movement. The captured proliferates and disseminates. Accordingly, she proposes, understanding this impulse within Benjamin's approach to images offers an insightful way to understand (and to recast) the later work of Foucault and then Deleuze. But more than this—more than retheorizing images, entities and relations (for retheorizing's sake)—Chow is concerned to pose the question: what *happens* when images are set loose like this?—when, in other words, contemporary technologies of image capture and the virtual simultaneity of their production and circulation mean that capturing the image is in a sense cotemporal or perhaps

now even conceptually indistinguishable from the making of any event. The event is not in some sense prior to the image of the event any more.

Montage, cutting, the break, the gap, the distance and, of course, the difference, are constant concerns in Rey Chow's work. She is perhaps much more concerned with these "ontological" factors at play in everyday life than with any specific, particular, concrete or, in Heideggerian terms, "ontic" objects. Of course, this is not to say that Chow's focus is an entirely theoretical focus on the "ontological"—such as the sort of approach you might find in the work of Ernesto Laclau or Slavoj Žižek, for instance. Chow does not use theory simply to "correct" or to transform our understandings of the world or our interpretations of this or that. So, where someone like Slavoj Žižek, for instance, will start from everyday understandings of a certain object, practice, issue or problem, and then turn to theory in order to argue for a transformed understanding of it, usually along Lacanian or Hegelian lines; Chow will turn to theory in order to demonstrate the complexity and lack of univocity of any "one" thing, in order to urge critical thought to attend to the implications of what we might call ontological fractures, disjointedness, or temporal out-of-step-ness.

In putting it like this, people may see another affinity to Derrida and deconstruction. However, effective (and affective) spatial, temporal, conceptual and ultimately ontological cuts and breaks are not treated by Chow as simply *always and everywhere* active and pressing concerns. Rather, she is concerned to emphasize the ways in which global filmic and media technologies amplify the effects of rupture and disjointure as much as entanglement. Which is another way in which Chow is not "simply" Derridean, say, or "simply" poststructuralist. In fact, Chow has often argued that, as important and helpful as Derridean deconstruction is for any kind of critical cultural study, it is limited in that it is not geared up to fully consider medium specificity in what she calls the age of hypermediality.

Another way to put this is to say that Rey Chow practices cultural studies. But quite what this may mean deserves some further elaboration.

Rey Chow and Cultural Studies

"Cultural studies" is an umbrella term that covers a multitude of different possibilities: studies of popular culture, national culture, regional culture, cross-cultural or intercultural encounters; studies of subculture and marginal or "subaltern" culture; studies focusing on questions and issues of class, gender, ethnicity and identity; others focusing on the significance and effects of differ-

ent aspects and elements of technology, globalization, "mediatization" and virtualization; still more on the historical, cultural and economic contexts of the production and consumption of literature, film, TV and news media; others elaborating on the cultural implications of government policy, law, legislation, educational paradigms, and so on; as well as the multitudes focusing on any of the myriad details of everyday life, approached in terms of anything from power to pleasure to politics, and beyond. This diversity and heterogeneity can have a dizzying effect. For, on the one hand, it may seem that all of these different cultural studies are entirely unconnected or unrelated, and that the term "cultural studies" does not necessarily refer to anything in particular, or designate a specifiable or delimitable field.

Yet, on the other hand, many of these diffuse things also often seem ineluctably and ineradicably interconnected, interimplicated and interrelated. For despite being so divergent and dislocated, these heterogeneous phenomena often seem to converge. Local practices of everyday life cannot be extricated from larger economic and political forces. Cultural activities and issues involve dimensions and decisions that are ethical and political. Phenomena that are often felt to be most intimate, private and personal can turn out to be ensnared within or even produced by larger technologies. One may consider the printing press, the airplane or the film camera, for instance, which have all been instrumental in the production of public and private sensibilities and passions, and hence of both collective and individual (or individuated) identities. The techniques of representation in literature, newspapers, radio, TV and film have, throughout their histories, all been strongly implicated in the production, amplification or magnification of such structures of feeling as nationalism and racism, and the emergence, manipulation or management of personal, private and group affects, sentiments and investments.

Given the complexity of culture, as a "field" of relations, connections and separations, where does one begin? How does one select, organize and orientate one's scholarly, analytical and interpretive efforts? What is to be deemed important, and on what grounds? As Stuart Hall once put it: because of the irreducible complexity of culture, "it has always been impossible in the theoretical field of cultural studies—whether it is conceived either in terms of texts and contexts, of intertextuality, or of the historical formations in which cultural practices are lodged—to get anything like an adequate theoretical account of culture's relations and its effects" (Hall 1992: 285). Given this complexity and uncertainty, the question is how might *intervention* be established? How does "motivated" work—whether scholarly, cultural or political—fit in, connect

with, impact upon or alter anything else? In what relations do our efforts exist, and with what effects? In Hall's words:

> The question is what happens when a field, which I"ve been trying to describe...as constantly changing directions, and which is defined as a political project, tries to develop itself as some kind of coherent theoretical intervention? Or, to put the same question in reverse, what happens when an academic and theoretical enterprise tries to engage in pedagogies which enlist the active engagement of individuals and groups, tries to make a difference in the institutional world in which it is located? These are extremely difficult issues to resolve, because what is asked of us is to say "yes" and "no" at one and the same time. It asks us to assume that culture will always work through its textualities—and at the same time that textuality is never enough. But never enough of what? Never enough for what? (1992: 285)

As introduced in Chapter 1, in the wake of both post-structuralist and post-colonialist thinkers, including Louis Althusser, Michel Foucault, Edward Said, Jacques Derrida, Gayatri Spivak and, indeed, Stuart Hall, and following hard on the heels of feminist theorists of film and culture such as Laura Mulvey and Teresa de Lauretis, Rey Chow's work starts out from a number of what may nowadays appear to be methodological and empirical "givens": culture is regarded as always in some sense biased; knowledge-production or knowledge-establishment as always in some sense contingent and conventional; and these biases, contingencies and conventions have consequences that are ethical and political. These are postulates or propositions that may seem uncontroversial or even commonplace today. But they owe their "givenness," intelligibility and acceptability to some immensely significant and still-contentious disciplinary innovations, associated with the work of cultural studies, feminism, post-structuralism and post-colonialism, in particular. At the same time, much of what is specific to Chow's interventions doubtless relates to the way she uses features of the contingencies of her own cross-cultural and cross-disciplinary intellectual history.[1] But the personal history of Chow's own cross-cultural experience is never allowed to remain unquestioned within her work, nor to present itself as if her biography endows her voice with an aura of cross-cultural legitimacy or postcolonial authenticity. Rather, Chow uses personal experience as a point from which to stage and illustrate investigations which interrogate the familiar by exposing it to a very rigorous questioning and analysis.

For, there is a risk of assuming that an ethnic subject owns or equals some kind of essential authenticity or truth. Moreover, there is a closely related risk of according the opinions of a traveller from "there" the status of profound insights into the truth of the "here." Rather than assuming anything like this, Chow's interrogations of the familiar do not proceed according to romantic or

orientalist notions of the value of defamiliarizing the familiar by viewing it as if through foreign eyes, whether naïve (like, say, Mick "Crocodile" Dundee or Forrest Gump) or alienated through the excesses of hard experience (like Gulliver). Rather, the personal and familiar is approached by Chow both by way of attending to the deeply-felt problematics of postcolonialism and cultural studies and—perhaps surprisingly—certainly controversially—the rubrics and rigors of poststructuralist theory, as well as film theory, particularly feminist film theory.

In other words, Chow's work consistently executes the precise but difficult maneuver implied in Hall's famous injunction that responsible intellectual work must "say 'yes' and 'no' at one and the same time" (1992: 285). Chow consistently says (or, indeed, "*performs*" a) "yes" to poststructuralist theory, but "no" to certain of its own biases and contingencies (what the vernacular of poststructuralism would call its own "founding violences," "enabling violations," inaugural "blind-spots," and "constitutive outsides"—some of which we have already discussed, including what she follows Spivak in calling poststructuralism's "Chinese prejudice").[2] Chow also says yes to the fraught, felt, lived and very real political stakes, exigencies and urgencies that congregate, condense and flare up around aspects and issues of race, ethnicity and cultural identity. But this yes is accompanied by a clear no to any essentialist thinking, or thinking which would help notions of race, ethnicity and nationalism to persist in ways that are *violent*—whether physically, institutionally, legislatively or intellectually—*vis-à-vis* other ethnicities, peoples, identities or other thoughts of self and other. In all of her studies, but especially in her work which develops Fredric Jameson's claim that stereotypes are inevitable in cross-cultural representations and encounters,[3] Chow's interest is in working out how to ensure that the potentially violent antagonisms which always threaten to arise at the borders of cultures might be transformed—to use the vocabulary of Chantal Mouffe—from warlike *antagonistic* relations into productive/political *agonistic* interactions (see Mouffe 2005, especially chapter two). But, at the same time, Chow also focuses on the problematic way in which even the most radical, subversive, or leftist Western thought is often complicit with an indifference to non-Western lives, cultural productions, and histories. This indifference is often the outcome of simple ignorance, of course. But, Chow asks, how has such ignorance been historically sanctioned and why is it all right to continue to "practice" it?

Chow's double-pronged methodological decision is exemplary of the injunctions *both* of post-structuralism (particularly Derridean deconstruction) *and* of cultural studies (particularly in such versions as the account given by Stuart

Hall to which I have been referring here).[4] As such, it is not surprising that Chow's work is not immediately straightforward to all readerships. For, the decision to "say 'yes' and 'no' at the same time" without merely accepting or rejecting alternatives *and* without simply sitting on the fence, is neither easy to execute nor easy for the reader to keep up with. Nevertheless, Chow's steps and conclusions are always remarkably concise and clearly put, even though her method proceeds according to the oft-declared need to think and study and analyze as fully, attentively and rigorously as possible, *before* making any interpretive decision or declaration. In this regard, Chow's work is reminiscent of Jacques Derrida. Indeed, it is important to note that even though Chow is now well known for her work in film studies, cultural studies, and so on, her work has always involved the study of language, literature, and narrative. Her shift across disciplines may not always foreground her investment in the literary, but questions of the literary, the figural, and the way language works are always present in Chow's readings. This investment is testified to by the fact that Chow has always held appointments in Comparative Literature, and arguably owes her skills as a reader to a literary and theoretical training that is perceptible even in her analyses of film, media and technology.

Yet Chow's prose and argumentative moves differ in crucial ways from that of most deconstructionists and poststructuralists. This is not least because Chow picks up the gauntlet thrown down by Gayatri Spivak who, in her Translator's Preface to Derrida's *Of Grammatology* points out that "Although something of the Chinese prejudice of the West is discussed in Part I [of *Of Grammatology*], the *East* is never seriously studied or deconstructed in the Derridean text." This, Spivak points out, means that the enigmatic, inscrutable term "the *East*" exists in Derridean deconstruction "as the name of the limits of the text's knowledge" (Spivak in Derrida 1976: lxxxii; emphasis in the original). Where poststructuralism has tended to ab/use the idea of "the East" by figuring it as the Other of Western metaphysics in long, circuitous and discursive readings of aspects of "the West," Chow—like Spivak—makes no bones about stating the problem directly.

This is not to reject or disdain deconstruction. As is well-known, Derrida repeatedly argued that deconstruction (despite his critics' regular claims) was neither gratuitously complex nor "irrational" nor unjustifiably "excessive"; but was rather a "hyperanalyticism" (Derrida 1998: 35); namely, an approach that, in being *deliberately* hyperbolically inquisitive, was actually attempting to be responsible to the Enlightenment idea of reason, analysis and argument. Chow subscribes entirely to this poststructuralist, deconstructive argument (although she does not simply accept post-structuralism's subscription to the belief in the

necessity and value of "always making things more complicated": indeed Chow explores this trait of poststructuralism, historicizing it and exposing it to the harrowing ordeal of a Foucauldian-inspired genealogical analysis). Thus, rather than "*being*" poststructuralist or deconstructionist, Chow *does* deconstruction in such a way as to transform not only "external" cultural and political questions and topics but also many of the assumptions of poststructuralist and deconstructionist theory, philosophy and analysis itself. She has been greatly influenced by Derrida but has also been receptive to thinkers such as Lacan[5] and increasingly to the legacies of Foucault. This range entails a shift from the more explicitly literary focus on the workings of language to other types of significations, problematizing poststructuralism while never abandoning the Derridean investments in language, alterity, supplementarity, and so on. In other words, Chow's double-pronged methodological decision produces an analytical machine that "holds theoretical and political questions in an ever irresolvable but permanent tension," and which "constantly allows the one to irritate, bother, and disturb the other, without insisting on some final theoretical closure" (Hall 1992: 285).

Many of the topics, themes and problematics with which Chow is concerned are familiar: the varieties and persistence of orientalism, racism, xenophobia and sexism; the complexity of identity-formation and its vicissitudes; the possibilities of cultural transformation and the policing of boundaries; the unequal lines of force structuring intercultural encounters; the ways that ideas such as "resistance," "revolution" and "change" have been approached, both academically and culturally (particularly in feminist and postcolonialist thought), and the ways that these might be rethought; and so on. But, if these themes are "familiar" on first glance, at least two things transform them when they arise in Rey Chow's work. The first is the remarkable revelatory effect that Chow's double-pronged analytical approach regularly has on the study of questions, texts, and debates. The second is the way that Chow treats what I have called certain "empirical givens"–those overwhelming facts of cultural life, whose importance is at once undeniable and yet whose significance is often all too easily overlooked, forgotten or even foreclosed. These empirical givens include such putatively distinct events as the continued presence of the history of imperialism and colonialism, the dropping of atomic bombs on Nagasaki and Hiroshima in 1945, the globalization of academic languages and paradigms, and the emergence of the cinematic apparatus into everyday life. Once again, such givens as these may seem heterogeneous, discrete, and un- or under-related. Yet, in essays such as "The Age of the World Target: Atomic Bombs, Alterity, Area Studies" (Chow 2006: 25-43), Chow amplifies the star-

tling (and, again, all too easily overlooked) connections that can be made between all of these phenomena, and more. As the subtitle of "The Age of the World Target: Atomic Bombs, Alterity, Area Studies" indicates, one of the most significant connections to be highlighted is that which is to be made between the instruments and the instrumental decision-making behind the military activity and the relation of academic knowledge-production to this—specifically in terms of the construction of others, or "alterity," within the discipline of area studies.

Visualizing Postcolonialism versus Area Studies

The common link that Chow foregrounds and magnifies here and elsewhere is the notion of *visuality*. This is because Chow builds upon thinkers and theorists such as Benjamin and Heidegger who regarded modernity as characterized not only by technologization, dislocation, massification, and the shocks and jolts of alienation, but also by technologies and techniques of visualization. In Foucault, methods of visualization such as mapping, measuring, diagramming, filming, registering, recording, revealing, demonstrating and "showing" (in all senses of the word) would come to be regarded as part and parcel of "biopolitics." Chow follows Foucault's line of inquiry here. But, picking up another line too, she also takes up Heidegger's assertion that in modernity the world becomes a picture. Combining these arguments and adding elements from thinkers such as Virilio, Chow adds that that if in modernity the world becomes a picture, it also ineluctably becomes a target. For, crucial to American military domination was not only the atomic technology itself, but also the cartographic and ballistic connections between "seeing" and "destroying."

Indeed, visuality is multiply-inscribed in Chow's thinking. It has the status of a primary problematic in her work, and she pursues it in several senses: the importance in biopolitical administration of making visible; the impact of the cinematic apparatus, not only as an epochal modern field in its own right but also as a new cultural realm which sent shockwaves through other cultural fields (such as literature), challenging them, altering their cultural status as well as their forms; the ethical and political implications of different "ways of seeing" within academic disciplines and cultural discourses; the implications of feminist film studies' assertion of "the primacy of to-be-looked-at-ness"; the significance of the resemblance of ethnography and anthropology to looking at animals in the zoo; and, of course, as we have seen, the way in which the shock of the atomic age entered the world primarily as an *image*—on the one hand, as the cinematic image of the mushroom cloud; on the other, as the mythological

equation $E=MC^2$, which functioned primarily not as meaningful scientific algebra but rather as the other way of signifying the mushroom cloud: the unimaginably, unintelligibly terrible power of modern science.

Along with visuality Chow also focuses on *visibility*. These two terms are distinct but interimplicated. Again, "visibility" carries several senses. It is considered by Chow to involve more than mere literal vision (as in "I see it! There it is") or even metaphorical seeing (as in "Aha! I see! I understand!"). Rather, Chow directs us to the sense of "visibility as the structuration of knowability" (Chow 2007: 11). In this, Chow takes her inspiration broadly from Foucault and occasionally from Gilles Deleuze (especially in his explicitly Foucauldian moments).[6] But one might equally evoke Jacques Rancière's notion of the "partition of the perceptible" here, or Derrida's—or, indeed, Attali's—focus on "hearing" and "audibility." That is to say, as Chow puts it, "becoming visible is no longer simply a matter of becoming visible in the visual sense (as an image or object)" (11). Rather, as well as visible images and objects, there is also a sense in which visibility should refer us to "*the condition of possibility for what becomes visible.*" For, whatever objects and images are visible, and the *way* in which they are visible, depends on what she calls "this other, epistemic sense of visibility" (11).

Visibility and making-visible, then, is a more complex problematic than a simply empirical orientation could comprehend (or indeed "see"). The political issues of visibility involve a lot more than empirical issues to do with the selection and make up of who or what is represented where and when and how. It is rather more "a matter of participating in a discursive politics of (re)configuring the relation between center and margins" (11). Translated from a visual to the phonic "image," Chow's argument here is similar to Jacques Derrida's observation that "being-heard is structurally phenomenal and belongs to an order radically dissimilar to that of the real sound in the world" (Derrida 1976: 63): "being-heard" in a political sense is not simply a matter of shouting louder and louder. Rather, it depends first on the establishment of a shared field of intelligibility as the condition of possibility for understanding ("hearing"/"seeing") and being understood (or "heard"/"seen").[7] The condition of possibility for any "shared meaning" (whether figured through visual or aural concept-metaphors) and hence "intelligibility" or "visibility" per se is always already a complex "achievement," "construction," "outcome" or "stabilization."

Chow's work is not only supplemented by but can be said to supplement and clarify further such theoretical and philosophical perspectives as those of Lacan, Derrida, Deleuze, Rancière, and so on. Yet it does so not by giving fur-

ther philosophical expositions or explications, but rather by producing concrete analyses, demonstrations and verifications through analyses of literature, film, cinema, identity, culture and technology within the circuits of global capital and with specific reference to postcolonial contexts and scenes. Indeed, by "visuality," Chow refers us to the specific epistemological implications and cultural consequences of the cinematic apparatus. The technologies involved with and encapsulated in the film camera are not only cortical to contemporary cultural life, but they also signal an epistemic "tectonic shift" in cultural logics the world over. As she explains: "the ever-expanding capacities for seeing and, with them, the infinite transmigrations and transmutations of cultures—national, ethnic, rural, illiterate—into commodified electronic images are part and parcel of a dominant global regime of value making that is as utterly ruthless as it is utterly creative" (2007: 175).

The immense range and scope of the significances of the near-absolute hegemony of the regime of visuality has become more and more prominent and fundamental to Chow's orientation. Her abiding concerns with visuality extend from its involvement in the most intimate aspects of subjective and intersubjective identity and cultural relationships to dimensions that are, in Heidegger's terms, the most "gigantic." So, visuality, in this sense, refers to the epistemological rupture caused by filmic modernity. But it should be reiterated, this rupture is not simply filmic, nor relegated solely to a particular realm or context. Rather, it permeates what Foucault would term the entire *episteme*.

Within academia, Chow directs us to its emergence in the paradigm of "visualism"—a term she appropriates from Johannes Fabian (Fabian 1983: 106-9), and which she initially takes to refer to "a deeply ingrained ideological tendency in anthropology, which relies for its scientific, "observational" objectivity on the use of maps, charts, tables, etc." (Chow 1991: 174, note 12). This tendency is, as we have seen, entirely attuned to the needs of both the instrumentalist approaches of militaristic or xenophobic interests in "the other" (conceived as threat/target) and the needs of biopolitical governmentality. But the paradigm of visualism also has a direct bearing on the other signature theme of almost all of Chow's work—ethnicity: a topic which permeates Chow's work. It obviously organizes her first book, *Woman and Chinese Modernity* (1991); yet it only emerges explicitly, directly and forcefully in *Writing Diaspora* (1993).

Here ethnicity emerges in the very first lines, and remains in the foreground throughout. The book opens by placing at the forefront of its agenda the question of the formulation and treatment of the notion of ethnicity, by Chinese and non-Chinese scholars alike, beginning with a reading of an essay

by a Western academic who "attacks 'third world' poets for pandering to the tastes of Western audiences seeking 'a cozy ethnicity'" (1991: 1). By considering the formulation of ethnicity implied in the reviewer's critique, Chow launches a problematization of the various ways of approaching and handling the "fact" of ethnicity. The necessity of problematizing the givenness or naturalness of ethnicity boils down to the fact that—to borrow a phrase from Laclau and Mouffe—ethnicity "is not a datum but a construction" (Laclau and Mouffe 1985: 144). For, "having" or "being" this or that ethnicity is not an inevitability; ethnicity is not a natural or spontaneous property of the world; rather, notions, categories and conceptual universes of ethnicity are discursive constructions. One is not *born* ethnic, one *becomes* ethnic. One's ethnic identity and cultural "place" and "status" is determined in contingent and variable ways.

This sort of argument is likely to be very familiar to most readers. This familiarity does not, of course, diminish its significance. Yet debates about ethnicity have attained a peculiarly banal predictability. So, it is precisely *the problem* of this banal, stabilized, regularized dimension to ethnicity-debates that Chow isolates and interrogates. For, as we have seen, she proposes, "ethnicity is fast acquiring the kind of significance and signifying value that Foucault attributes to sexuality in the period since the seventeenth century" (2002: 101). That is, debates and issues of ethnicity involve a "discursive ferment," but a ferment which is extremely regularized and predictable—even if, Chow adds, like the discourse of sexuality before it, the discourses "and mechanisms that surround 'ethnicity' in our time share many similar features with the 'repressive hypothesis' that Foucault attributes to the discourse of sexuality" (101). That is to say, writes Chow:

> One of the most well-known of Foucault's arguments is that sexuality is not natural but constructed, and that in the multiple processes of discursive constructions, sexuality has, however, always been produced as the hidden, truthful secret—that intimate something people take turns to discover and confess about themselves. The discursive, narrative character of the productions of sexuality means that even though our institutions, our media, and our cultural environment are saturated with sex and sexuality, we continue to believe that it is something which has been repressed and which must somehow be liberated. Foucault calls this "the repressive hypothesis," by which he refers to the restrictive economy that is incorporated into the politics of language and speech, and that accompanies the social redistributions of sex. (101-2)

This rather different form of problematization of ethnicity is a consistent feature of Chow's work. In *Writing Diaspora*, Chow asserts, "part of the goal of 'writing diaspora' is to *unlearn*...submission to one's ethnicity" (1993: 25) Such

an apparently "theoretical" problematization of ethnicity is neither willful nor gratuitous. As she points out, and as discussed in the previous chapter, one familiar aspect of the discourse of ethnicity is the element of autobiographical confession: the championing of speaking up; the regarding of speaking out as being a significant act of, first, "resistance" and, second, "emancipation." Without diminishing the historical importance of political movements that have involved this sense of consciousness raising and speaking out, Chow seeks to add the supplementary point that, now that such discourses have become regular and familiar, perhaps their political efficacy has not only waned but actually *switched polarities*. For, if we emphasize the Foucauldian approach, then the belief that to speak out about oneself is an act of "resistance" or "emancipation" can clearly be seen to operate according to a "repressive hypothesis." Thus, cautions Chow:

> When minority individuals think that, by referring to themselves, they are liberating themselves from the powers that subordinate them, they may actually be allowing such powers to work in the most intimate fashion—from within their hearts and souls, in a kind of voluntary surrender that is, in the end, fully complicit with the guilty verdict that has been declared on them socially long before they speak. (115)

Moreover, as we have also seen, Chow points out that, too easily, "ethnicity can be used as a means of attacking others, of shaming, belittling, and reducing them to the condition of inauthenticity, disloyalty, and deceit" (124). Ironically, such attacks are "frequently issued by ethnics themselves against fellow ethnics, that is, the people who are closest to, who are most *like* them ethnically," in what she calls a "fraught trajectory of coercive mimeticism" (124).

Coercive mimeticism designates the way in which the forces of all different kinds of discourses and institutions *call* us into place, *tell* us our place, and work to *keep* us in our place.[8] These forces include those of (Althusserian) interpellation and (Foucauldian) disciplining. Indeed, according to Chow, coercive mimeticism ultimately works as "an institutionalized mechanism of knowledge production and dissemination, the point of which is to manage a non-Western ethnicity through the disciplinary promulgation of the supposed difference" (Chow 2002: 117). To reiterate the words of Etienne Balibar (to whom Chow more than once refers): "The problem is to keep 'in their place,' from generation to generation, those who have no fixed place; and for this, it is necessary that they have a genealogy" (95). In other words, then, even the work of well-meaning and deeply invested specialists of ethnicity, and indeed even expert ethnic scholars—even ethnic experts in ethnicity—can function to reinforce ethnicized hierarchies, structured in dominance, simply by insisting on (re)producing their field or object: ethnicity.

Nevertheless, Chow's focus on Chinese ethnicity, films, figures and phenomena may seem on first glance distant from the concerns of many working on other aspects of film, culture, cultural politics, race, gender, other forms of ethnicity, and so on. But appearances can be deceptive. For, as suggested earlier, Chow regularly reveals the ways that "China" and "Chineseness" are figures (Derridean "specters," "absent presences") that are indubitably inscribed (indeed, *hegemonic*) at the heart of the theoretical and political discourses of "Western" cultural studies, poststructuralism and feminism. According to Chow, this is so in at least three ways. First, the Chinese "other" played a constitutive (haunting) role in the deconstructive critique of logocentrism and phonocentrism, in ways that include but far exceed the general "turn East" (in the search for "alternatives") characteristic of "French" theory and much more besides of the 1960s and 1970s. Second, Western feminism of the 1960s and 1970s actively admired and championed the Chinese encouragement of women to "speak bitterness" against patriarchy. And third, the enduring interest in the "subaltern" among politicized projects in the West has always found an exemplary example in the case of the Chinese peasantry. This is why Chow argues that in these ways and more, "'modern China' is, whether we know it or not, the foundation of contemporary cultural studies" (1993: 18).

Thus, Chow recasts the investments and orientations of cultural studies, poststructuralism, and other politicized "suffix-studies" subjects in terms of the unacknowledged but constitutive "Chinese prejudice," first identified by Spivak. According to Chow, "China" has a multiple status in Western discourses, including cultural studies. As well as representing, for so long, the Other of capitalism, of freedom, of democracy, and so on, "China" has also offered "radical thought" in the West a promissory image of alterity, revolution, difference, alternativeness, and hence resistance as such. And, as Chow also observes, one of the most enduring metanarratives that has long organized cultural studies and cultural theory (plus much more besides) is the discourse of "resistance." "If there is a metanarrative that continues to thrive in these times of metanarrative bashing," argues Chow, "it is that of 'resistance'": "Seldom do we attend a conference or turn to an article in an academic journal of the humanities or the social sciences without encountering some call for 'resistance' to some such metanarrativized power as 'global capitalism,' 'Western imperialism,' 'patriarchy,' 'compulsory heterosexuality,' and so forth" (1998: 113).

The discourses of cultural theory and cultural studies more widely do seem to be structured by keywords or (worse) buzzwords like "resistance," "struggle," "difference," "hybridity" and "multiculturalism." And many have interpreted

this as evidence that such putatively "radical" work is, basically, nothing more than fashionable nonsense. But, rather than writing it off, Chow proposes that one of the key problems with the notion of resistance resides in the consequences of its rhetorical construction. She argues that the popular rhetoric of resistance is itself implicitly organized and underwritten by a subject-object divide in which "we" speak *against* that which oppresses (capital, patriarchy, the West, etc.) and *for* (or "in the name of") the oppressed other. Thus, "we" rhetorically position ourselves as somehow "with" the oppressed and "against" the oppressors, even when "we" are more often than not much more obviously at some distance from sites and scenes of oppression (1993: 11).

Of course, the aim of "speaking out" and publicizing the plight of the oppressed may be regarded as *responsibility itself*. It is certainly the case that a dominant interpretation of what academic-political responsibility *is* boils down to the idea that to be responsible we should speak out. Yet it is nevertheless equally the case that, unless the distances, relations, aporias and irrelations are acknowledged and interrogated, there is a strong possibility that "our" discourse will become what Chow calls a version of Maoism. She explains:

> Although the excessive admiration of the 1970s has since been replaced by an oftentimes equally excessive denigration of China, the Maoist is very much alive among us, and her significance goes far beyond the China and East Asian fields. Typically, the Maoist is a cultural critic who lives in a capitalist society but who is fed up with capitalism—a cultural critic, in other words, who wants a social order opposed to the one that is supporting her own undertaking. The Maoist is thus a supreme example of the way desire works: What she wants is always located in the other, resulting in an identification with and valorization of that which she is not/does not have. Since what is valorized is often the other's deprivation—"having" poverty or "having" nothing—the Maoist's strategy becomes in the main a *rhetorical* renunciation of the material power that enables her rhetoric. (10-11)

In other words, such rhetoric claims a "position of powerlessness" in order to claim a particular form of "moral power" (11): a heady conceptual and rhetorical mix that can be seen to underpin an awful lot of academic work today. Derrida regularly referred to this position as "clear-consciencism": namely, the belief that speaking out, speaking for, speaking against, etc. equals Being Responsible. However, quite apart from tub-thumping and mantra-reciting, Derrida believed in the promise of the "most classical of protocols" of questioning and critical vigilance as ways to avoid the greater violence of essentialist fundamentalisms. Of course, Derrida's attempts to draw such questions as *how* to interpret "responsibility," *how* to establish who "we" are, in what relations "we" exist, and what our responsibilities *might be*, into the crisis of undecidability was equally regularly regarded as an advocation of theoretical obscurantism

and irresponsibility. This charge was—and remains—the most typical type of "resistance" to deconstruction. Despite the clarity and urgency of Derrida's reasons for subjecting all presumed certainties to the harrowing ordeal of undecidability, the resistance to deconstruction surely boils down to a distaste for the complexity of Derrida's ensuing close readings/rewritings of texts.[9]

Such resistance to deconstruction is familiar. It is often couched as a resistance to theory made in the name of a resistance to "disengagement"; a resistance to "theory" for the sake of "keeping it real." Such a rationale for the rejection of deconstruction (or indeed "Theory" as such) is widespread. But when "keeping it real" relies upon a refusal to interrogate the ethical and political implications of one's own rhetorical and conceptual coordinates—one's own "key terms"—the price is too high. Chow points to some of the ways and places that this high price is paid, and reflects on the palpable consequences of it. For instance, in politicized contexts such as postcolonial cultural studies, there are times when "deconstruction" and "theory" are classified (reductively) as being "Western," and *therefore* as being just another cog in the Western hegemonic (colonial, imperial) apparatus. As she puts it, in studies of non-Western cultural others, organized by postcolonial anti-imperialism, all things putatively "Western" easily become suspect. Thus, "the general criticism of Western imperialism" can lead to the rejection of "Western" approaches, at the same time as "the study of non-Western cultures easily assumes a kind of moral superiority, since such cultures are often also those that have been colonized and ideologically dominated by the West" (1998: 8). In other words, "theory"—"for all its fundamental questioning of Western logocentrism"—is too hastily "lumped together with everything "Western" and facilely rejected as a non-necessity" (1998: 8). Unfortunately, therefore:

> In the name of studying the West's "others," then, the *critique* of cultural politics that is an inherent part of both poststructural theory and cultural studies is pushed aside, and "culture" returns to a coherent, idealist essence that is outside language and outside mediation. Pursued in a morally complacent, antitheoretical mode, "culture" now functions as a shield that hides the positivism, essentialism, and nativism—and with them the continual acts of hierarchization, subordination, and marginalization— that have persistently accompanied the pedagogical practices of area studies; "cultural studies" now becomes a means of legitimizing continual conceptual and methodological irresponsibility in the name of cultural otherness. (9)

What is at stake here is the surely significant fact that even the honest and principled or declared aim of studying others can actually amount to a positive working for the very forces one avowedly opposes or seeks to resist. Chow clarifies this in terms of considering the uncanny proximity but absolute differ-

ence between cultural studies and area studies. For, to reiterate a point made earlier, area studies is a disciplinary field which "has long been producing 'specialists' who report to North American political and civil arenas about 'other' civilizations, 'other' regimes, 'other' ways of life, and so forth" (6). However, quite unlike cultural studies and postcolonial studies' declared aims and affiliative interests in alterity and "other cultures," within area studies "others" ("defined by way of particular geographical areas and nation states, such as South Asia, the Middle East, East Asia, Latin America, and countries of Africa") are studied as if potential threats, challenges and—hence—ultimately "information target fields" (1998: 6; see also 2006).

Thus, says Chow, there is "a major difference" between cultural studies and area studies—and indeed between cultural studies and "normal" academic disciplines per se (1998: 6-7). This difference boils down to a paradigmatic decision—itself an act or effort of resistance. This is the resistance to "proper" disciplinarity; the resistance to becoming "normal" or "normalized," wherever it might equal allowing power inequalities, untranslatables and heterogeneities to evaporate in the production of universalistic "objective" knowledge. This is why Chow's attitude is always that:

> In the classroom...students should not be told simply to reject "metadiscourses" in the belief that by turning to the "other" cultures—by turning to "culture" as the "other" of metadiscourses—they would be able to overturn existing boundaries of knowledge production that, in fact, continue to define and dictate their own discourses. Questions of authority, and with them hegemony, representation, and right, can be dealt with adequately only if we insist on the careful analyses of texts, on responsibly engaged rather than facilely dismissive judgments, and on deconstructing the ideological assumptions in discourses of "opposition" and "resistance" as well as in discourses of mainstream power. Most of all, as a form of exercise in "cultural literacy," we need to continue to train our students to read—to read arguments on their own terms rather than discarding them perfunctorily and prematurely—not in order to find out about authors" original intent but in order to ask, "Under what circumstances would such an argument—no matter how preposterous—make sense? With what assumptions does it produce meanings? In what ways and to what extent does it legitimize certain kinds of cultures while subordinating or outlawing others?" Such are the questions of power and domination as they relate, ever asymmetrically, to the dissemination of knowledge. Old-fashioned questions of pedagogy as they are, they nonetheless demand frequent reiteration in order for cultural studies to retain its critical and political impetus in the current intellectual climate. (1995: 12-13)

This statement of the importance of holding and reiterating particular critical and pedagogical stances in order to ensure the ongoing political impetus of cultural studies is as clear as it is rare in Rey Chow's work. And it raises the question: is this all that there is to be said about Chow's method? Does she

have a "method," as such? As we have already seen, her work is clearly not straightforward, even if one can frequently detect that something like the same sorts of "moves" or "techniques" are being carried out. But what are these moves? And, perhaps more importantly, *why* does she do them? What work do they do? And what is their relation to a critical and political impetus of cultural studies?

Rey Chow's Method and the Orientations of Cultural Studies

Introduction: Politics and Cultural Criticism

Rey Chow's method is always surprising, unexpected, revelatory; involving unpredictable connections, to produce illuminating results. But she has not, to date, spent a great deal of time discussing the whys and wherefores of her method. It is clearly connected to *cultural theory* and to *cultural studies*. It is clearly derived from an ethics of rigorous yet sensitive reading. And it clearly involves some kind of sophisticated understanding or implicit argument about the stakes and consequences of knowledge production in and as culture and politics. But what are the features and characteristics of these often tacit orientations?

In what follows, I want to try to amplify what I believe are some of the stakes and understandings that inform Chow's methodological orientations. I will do so in a perhaps unexpected manner: I will first turn from a direct focus on Rey Chow's work and instead reflect on the questions of research, pedagogy and politics in cultural studies—questions which I hope will both cast new light on the hows, whys and wherefores of an approach such as Chow's, whilst also allowing us to broach further aspects of Chow's work in the next chapter.

To begin, let us pause to consider the current ways in which we may think about pedagogy, about teaching and learning, research, academic work in general, and the place and purpose of the university in society. It is worthwhile to do so because—as well as being an important matter in its own right—such reflection will help us to make sense of Rey Chow's work in terms of its relation to or within a tradition (or impetus) of scholarship which seeks to find ways to reorientate discourses about and practices of pedagogy away from current simplistic schemas and paradigms. Such a reorientation would constitute an im-

provement because dominant perspectives on "teaching and learning" and "research" often rely on a limited and limiting conception of pedagogy. Yet limited and limiting conceptions have a strong and constraining hold on edu-educational discourse at all levels, and in more and more countries around the world. Moreover, the topics or problematics of pedagogy, of didactics, of learning, can be shown to far exceed the current myopic focus on teacher-student relations or indeed "learning resource"-student relations, or, worse, "student-centered-learning."

To rethink pedagogy, perhaps what is first and last to be critiqued and recast is the familiar theme of the pedagogical scene. Specifically, we must move away from prioritizing a teacher-student conception of pedagogy, as encapsulated in the mythic Socratic (or Oedipal) scenario of the teacher teaching and the student learning, in a clear communicative transfer. There may well be elements of this relation in pedagogy, but by virtue of its anthropocentric focus (and what Derrida referred to as its metaphysical phonocentrism, as discussed in chapter one), the discourse of "teaching and learning"—at least as it is elaborated in countries such as the UK—too easily misses vast tracts, realms and regions of material pedagogic relations. However, a term like "material pedagogic relations" could be misleading. So let me stress that here it should be taken to refer neither to "new technologies," C&IT, VLEs, nor to any other such acronymic new clothes, nor to teaching and learning "methods," "techniques" or "strategies." These are all versions of the same sort of view or—to coin a phrase inspired by Jacques Rancière—they are all symptomatic of the same "partition of the perceptible" which construes pedagogy in terms of the metaphysics of presence (so critiqued by Derrida), or which is based on an ideal of transparent, unimpeded, ideally face-to-face communicative transfers, boiling down to an idealization of the teacher-student relation (or scenario) that Deleuze called arboreal (because organized by the Platonic vision of teacher teaching student in the quiet tranquility and shade of a tree).

Rather than this, this discussion of *pedagogy*, inspired by and orientated towards a deeper understanding of Rey Chow's method, will instead—and perhaps unexpectedly—focus on teaching and learning's putative other: namely, *research*. More specifically, it will focus on *archival* "research methods." The contention is that a reconceptualization of teaching and learning's supposed opposite ("research") is necessary insofar as it reveals "research" and "research methods" to be neither opposite nor other, but rather a supplement that could and should subvert (or invert) and displace the terms of the entire debate.

Of course, no academic study, paper, theory, exposition, demonstration or argument can, *in itself*, change anything. But in constructing an argument

which first clarifies not only the falsity but also the reductive consequences of the separation of "teaching and learning" from "research" (a separation which prevails in academic, educational, funding and policy discourses), and secondly which champions an approach to "research methods" that is deliberately *anti-disciplinary* (Mowitt 1992)—or, that is invested in a project of *altering disciplinarity* (Bowman 2008),[1] which is precisely what I understand Rey Chow's overarching orientation to imply. Such projects are vital because—put bluntly—given the sustained attacks—in the UK, at least, as well as in Europe and Australia—not just on "theory" but on "useless" arts and humanities tout court, both at (macro) government policy levels and at (micro) disciplinary orientation levels, it is vital that arguments, rationalizations, explanations and accounts at least exist which make cases for how and why to *proceed otherwise*—in ways that are different to the dominant approaches to pedagogy, in research and in teaching and learning "methods."

Without strong counterarguments, representatives of practices deemed "useless" by the dominant discourse—in this case, dominant educational discourses—will find themselves floundering in the face of political and ideological attacks, as was the case as much during the decimation of UK public university funding initiated by a Labour government and completed by a weak Conservative-led coalition government in 2010 as it was during the trailblazing Thatcherite onslaught on arts and humanities fields in the 1980s.[2] What is perhaps most astonishing about this is the fact that, despite three decades of living under the axe, "critical" academia in the UK developed shockingly few intellectual retorts, rejoinders, responses or indeed simple counterarguments to the neoliberal, instrumental, neo-utilitarian rationales that have dominated and ultimately devastated the "critical" faculties of the university themselves. Instead of arguments, "critical" academics seem to have been much better at delivering denunciations, demonisations and moralizations. Yet, as Jacques Rancière has argued many times, political protests, projects and positions that do not simply demonize the other but that engage the other in detailed dialogue and precisely focused reasoned argument largely fare considerably better than projects which simply denounce and decry the evil enemy. And yet the latter has been the preferred mode of response by embattled and embittered arts and humanities academics and students. And whilst the plight of UK academia may not perhaps be one of Rey Chow's own personal primary concerns, the question nevertheless arises about the utility or relation of such "politicized" work as Rey Chow's—and many others' in cultural studies and postcolonial studies—to wider (or localized) political problems.

The Partition of the Pedagogical

Questions of disciplinary orientation, approach and method may seem to be "entirely academic" or "merely academic"—a world away from politics proper. But even a quick appraisal of the historical relationships between governmental educational policies and the kinds of fields and approaches that are valued and those that are undervalued quickly reveals that one need not be Antonio Gramsci or Louis Althusser to see that education per se is always and everywhere eminently political. The risk always faced by "critical" scholarship is that of being struck from the books, struck from the record. So reasons must be constructed and given, clarifications, demonstrations and cases must be made for the importance, value and even usefulness of even some of the most avowedly "purely academic" work. Rather than entering into this matter from the macropolitical perspective of government (or governmentality), this chapter will instead remain focused on the question of pedagogy. This is because of the role played by what Jacques Rancière regularly refers to as the partition of the perceptible, and what Rey Chow refers to as visibility.

Today, "teaching and learning" is conventionally distinguished from "research"; "teaching methods" distinguished from "research methods," and so on. All of these categories have been in a sense invented, abstracted, isolated and separated out as part of the so-called professionalization (aka proletarianization) of university education. In this process of differentiation, definition, clarification and demarcation (objectification or objectifying), what has become obscured is the irreducible interconnectedness and expansiveness of the pedagogic field. Insisting on this expansiveness should be among the most consistent and insistent challenges to the professionalist, managerialist discourse that—to use the word that Jacques Rancière has put on the pedagogical-political map—*stultifies* all manner of pedagogical scene (Rancière 1987/1991).

In order to set out some of the terms and stakes of this matter, and ultimately to return to Rey Chow's work with a deepened understanding of her orientation, this chapter will now spend some time exploring one text, not by Rey Chow, but rather by the art historian, Adrian Rifkin (2003). It is a text that is immensely rich, expansive and enlightening on many subjects. Given this richness, it is regrettably a text that I will be able to discuss here only very selectively, all too fleetingly and, inevitably therefore, reductively.[3] Nevertheless, despite having to overlook many dimensions of it, I will try to pull one key thread out of it in order to amplify one important impulse within it. Specifically, I will characterize it as a reflection on archival (and theoretical) research methods, and argue that this reflection gives good reasons to regard Rifkin's manner of archival research method as providing a crucial insight into

all "methods" and all pedagogy. In due course, it will feed into our engagement with Rey Chow's theory of cultural translation.

Rifkin is primarily known for his contributions to the fields of art history and queer theory. But, as becomes clear through this very uncanonical text, he should also be connected to the development of cultural studies in the UK. Accordingly, perhaps, Rifkin should also therefore be regarded as involved in the development of cultural studies *as such*, cultural studies as an institutional entity and disciplinary field *per se*—even if, as he suggests, one should really regard the history of cultural studies in terms of various BA degrees "lurching into being" at a particular time (Rifkin 2003: 105) rather than emerging according to any kind of master logic or overarching program.

Even so, placing Rifkin into the foreground of any narrative of cultural studies' emergence is not a proposition that is likely to be met with universal agreement. Certainly, canonical histories of cultural studies would be unlikely to locate Rifkin at any kind of center. Nor would he claim to have been. Nevertheless, like untold others, he was certainly present and active, on the unstable margins, and the occasional dilations or bursting of the banks of these margins into the unstable centers, of the emergent and constantly contested fields of cultural studies. But of course, anyone who knows (or, rather, *thinks*) anything about the history of cultural studies should baulk at the idea of a canonical history anyway. Which is one reason why, given the sustained critiques of the impositions of monolithic or univocal and linear histories on what are irreducibly complex formations, critiques that have been carried out in multiple fields and registers for many decades now, readers might already begin to anticipate why placing Rifkin into a relation with the discipline's formation and history might be productive, enlightening, informative, and educational, in its own right. This is particularly so given that to place Rifkin's narrative of formation at the center of a narrative of formation makes us foreground the complexity of any such narrativization and of the range of interlocking struggles involved. (And this will feed directly into our appreciation of Rey Chow's method.) "It's very easy to forget," Rifkin points out, "that the formation of cultural studies was in fact a very real fight for syllabuses" (104):

> And not just a very real fight for syllabuses *within* institutions, but a real fight to establish those syllabuses in the face of institutions which didn't understand them at all. I don't mean the institutions we were working in—the polytechnics—but I mean the universities, who largely had no idea of what cultural studies was or what was going on in Birmingham, but who at the same time were given power over the polytechnics, in terms of validating and examining our courses, to allow them to come into being.

> So at the same time as we were trying to formulate the syllabuses in cultural studies, or
> the syllabuses in new forms of social historical studies, we had to educate the people
> who were put in power above us to authorise us to do these things. The struggle for
> syllabuses and the production of the new kinds of student through that syllabus
> would then make that syllabus work, which is something that is coterminous with the
> production of the kinds of text which would then further make that set of
> investigations possible. (Rifkin 2003: 104-5)

Readers of Rey Chow may already intuit why I want to spend some time unpacking Rifkin's account of this complex moment of formation, involving as it already does different forms of pulling out of shape, out of time, and out of place.[4]

Against Satisfying Method

Rifkin recalls that at a certain point in his thinking about history, historical processes and methods, during the 1970s, his archival research led him to a conviction that, in history, culture and society, "it's not a question of a dialectic of base and superstructure, but it's a case of the two never meeting in a form in which you can talk about satisfactory forms of historical narrative or satisfactory forms of historical outcome." He continues: "That was the point, in late 1978, when I met Jacques Rancière" (112). In other words, Rifkin met Jacques Rancière in the immediate context of coming to suspect the impossibility of the veracity of satisfactory narratives and outcomes, the impossibility of simplicity, resolution, completion, solution or of dissolution. The other face of such a position, it soon becomes clear, is the enhanced awareness it provided him of the extent to which any acknowledgement of such impossibilities (as impossibilities) is repressed or foreclosed in academic discourse. To say this is not to activate a repressive hypothesis about academic discourse. It is rather to notice the extent to which academic discourse often trades in the fabrication and circulation of *satisfactory* narratives and *complete* outcomes. Realizing and rejecting the repression or denial of the at best asymptotic relation between archive and account is what underpins and fuels Rifkin's theoretical and practical approaches to teaching *through* and learning *from* archival research into popular (and unpopular) culture.

To prefer to dwell with complexity rather than to prefer to try to exorcise it and impose a coherent narrative or conceptual form on material perhaps bespeaks a history, an ethos and a paradigm of cultural studies that is arguably in jeopardy of being, if not forgotten, then certainly subordinated by both disciplinary practices and disciplinary memories and histories in cultural studies and other fields. Such subordination or amnesia would condemn more than

one field to live in more than one type of repetition. Moreover, it could constitute a palpable loss, a denudation of disciplinary possibility—in much the same way that a widespread ignorance about even the most prominent works of cultural studies from the 1970s leads students and academics of "discourse theory," for instance, to constantly recover the same sorts of ground and make the same sorts of arguments, but in much more "disciplined"—as in formalized, constricted, *strictured*, hidebound—manners.

Of course, to say this is not to elevate cultural studies per se from the same sort of charge. Indeed, cultural studies as a field arguably has an increasingly schizophrenic relation to history itself. On the one hand, as is well known, key figures of the field often insist on explaining cultural studies in terms of constructing rather grand narratives about the struggles involved in its disciplinary formation. But on the other hand, "theoretical" cultural studies itself apparently proceeds more and more by way of simple regular replacements of one preferred theorist with another—substitutions, without any attempt to engage with the reasons for the perspectival and paradigm shifts; without engaging the question of why we are all meant to be "doing," say, Deleuze now instead of Derrida, and why we are all going to have to be "doing" Badiou next instead of Deleuze, and so on.[5] Outside of the violent jolts of fashion that grip the movements of cultural theory, on the other hand, more empirical styles of cultural studies proceed with scientific method as the ideal, and inevitably therefore these approaches strongly subordinate, discipline and "police" questions of historical formation, conflict and complexity.

Nevertheless, *some* awareness of disciplinary history, of the formative struggles and arguments around politics, ethics, methods, foci, syllabi, investments, priorities, and so on, in the emergence of the disciplinary present will be helpful in appreciating Rey Chow's orientations. Moreover, following Adrian Rifkin's elaboration of this complex history is surprisingly apposite to any thinking about Rey Chow's work. This is because Rifkin's account of the history of cultural studies does not merely add information that will complete a picture. Rather, his contributions supplement any such picture in a way that pulls the picture or object out of shape and reconfigures it as something rather different, and, indeed, render it *constitutively uncompletable*.

This is not to suggest that either Rifkin or Chow ought to be numbered among the many cultural theorists who ever proposed one or another argument about constitutive incompletion. The phrase "constitutive incompletion" itself certainly had great currency during the 1980s and 1990s, arising through the encounters between various strands of poststructuralism and, in particular, Lacanian scholarship in the study of cultural and political processes (Laclau

and Mouffe 1985). And both Rifkin and Chow can certainly be placed within or in a relation to this moment and movement. Nevertheless, Rifkin's tangent and "take" on it never went with the flow of reiterating the importance of "impossibility" or "incompletion." Rather, like Chow, Rifkin is invested much more in the importance of reconstructing through the principled pulling out of shape the relations between entities, actions, movements and other bits and pieces of history and culture.

"Postmodern" Aims, Objectives and Outcomes

This principled pulling out of shape and constructing new relations and irrelations is of direct importance for cultural studies. For, debates about pedagogy are not only dominant within the aim-, objective-, output- and outcome-oriented world of the "professionalized" contemporary university, in which managerialist approaches to pedagogy have significantly restructured and reorientated university teaching and research activities in recent decades. They are also arguably at the heart of any and every possible cultural studies "project." Many thinkers, influenced directly or indirectly by Gramsci, for instance, regard culture *as* pedagogy. Hence, debates about pedagogy are inextricable from questions of culture, politics and intervention. Gramscian and Bourdieuian paradigms in particular have been dominant touchstones in this regard. But Rifkin's alibi, orientation and theoretical underpinning relates much more to Jacques Rancière's work, and in particular, I would argue, to Rancière's reading of the radical pedagogue, Joseph Jacotot: the educator whose fundamental lesson Rancière claims to have been that not only can one learn without being taught but also that one can teach what one does not know, and that the imposition or enforcement of method and discipline is a *stultification* of the universal capacity to creatively solve riddles that all people are imbued with and whose existence illustrates a much more essential truth than any disciplining or systematizing institutionalization can ever reveal (Rancière 1987/1991).

Rancière's intervention is increasingly well known. But Rifkin's own interpretation or performative elaboration of (ir)responsible Jacototism is less clear cut, and indeed adds some important dimensions to Rancièrean Jacototism. To elucidate this, I would like to position Rifkin within a context of educational debate, a world of different paradigms, many of them utterly different to any of the art, literary, cultural, political, queer, historical and philosophical paradigms that Rifkin himself ever discusses explicitly. Of course, given what I have already said about constitutive incompletion, I can hardly now move on to try to place Rifkin within a definitive history. Never-

theless, I can relate his work and words to some important bits of it. One big tumult in particular: postmodernity.

Most relevant here is that the gathering storm that Lyotard announced in 1979 came to be characterized not simply by discrete, disconnected language games (paralogies) and the corresponding proliferation of mutual unintelligibility between groups and contexts, but rather, across many fields and sectors, by a new type of *connectedness* (Lyotard 1979/1984). This took the form of the rise to dominance of discourses asserting the importance of efficiency, profit, market mechanisms, choice and freedom, coupled with the corresponding intensification of techniques of control and restrictions of autonomy in increasingly professionalized sectors such as education. Indeed, it was in the universities and other public sector institutions such as health, education and social services, that entrance into the "postmodern" era amounted to the growth of managerialism and the intensification of what some came to call "audit culture" (Kilroy, Bailey and Chare 2004). Of course, others, most prominently Foucault, had equally alerted us to the nearly invisible, microscopic, micrological emergence of panoptical power (and of course Deleuze subsequently picked up this baton and ran with it into the famous theorization of societies of control). But Foucault captures perfectly the simple/subtle logic at work in panopticism in an insight that also applies to managerialism, as well as to disciplinarity, and to all of panopticism's mongrel offspring besides:

> The exercise of discipline presupposes a mechanism that coerces by means of observation; an apparatus in which the techniques that make it possible to see induce effects of power, and in which, conversely, the means of coercion make those on whom they are applied clearly visible. (Foucault 1977/1995: 170-171)

The growth of the audit culture in education has seen the implementation of an ostensibly market-based logic that is actually a control-based logic. In universities it has increasingly taken the form of a requirement that disciplines justify themselves according to ultimately utilitarian criteria. Under such criteria, the prevailing questions to be answered are: What is the *point* of this? What is the *use* of this? What are the profits or returns of it, and for whom? On the ground, in the bookkeeping, in the administration, in the paperwork, the registration, the assessment, the documentation, management and delivery of university education, there has flourished all of the micrological apparatuses of surveillance and regulation that, to a greater or lesser extent, anyone involved in university education takes for granted today. "Education" became end-orientated, outcome-orientated. Courses and modules now have to have explicit and detailed rationales. More and more clear expectations are set out for coursework, combined with more and more prescriptive stipulations of as-

sessment criteria and guidelines. Terms like "learning aims" and "learning outcomes" have become so familiar that they are now entirely unremarkable phrases within everyday academic-bureaucratic language. Teaching has to have an aim. Learning has to have an outcome. Both must at least pretend to be knowable and known in advance.

There are enormous problems with all of the premises and propositions underpinning this dominant neo-utilitarianism. Thomas Docherty sums them up concisely when he points out that notion of "outcomes" is "part of the triumph of the managerialist ideology damaging education at the present time," because it demands that educators be obliged "to predict with total certainty... what the student who follows the course will be able to do after she has followed it" (Docherty 2003: 223). Yet, he complains:

> An education that is worthy of the name cannot predict outcomes: it is part of the point of education that we do not know what will eventuate in our processes of thinking and working and experimenting. In this sense, education should be of the nature of the event: the Docherty who is there after reading and thinking about Joyce or Proust or Rilke or Woolf is different from the Docherty who was there before that activity; but the earlier Docherty could never have predicted what the later one might think—that was the point of the exercise of reading in the first place: to think things that were previously undreamt of in my philosophy. (224)

Docherty clearly has a point. However, closer inspection suggests that in order to make it so powerfully he has had to conflate some quite different things along the way, things that do not necessarily run together in quite the dramatic all-or-nothing mode of his polemical formulation. Specifically, Docherty conflates two pedagogical scenes or positions: one of teaching (or of the teacher); and one of learning (or of being the learner). Yet, it is eminently possible to be or become both: it is possible for teacher and student to change positions unexpectedly; for the teacher to learn and the learner to teach, and so on and so forth. There are other problems with Docherty's argument, too, problems that I will return to shortly. But nevertheless, despite the limitations involved in constructing such a stark (hyperbolical) opposition between *the predictable* and *the event*, this all-or-nothing argument clearly flags up the terms of an entrenched and long-raging debate about teaching and learning. Moreover, the terms of this debate do indeed boil down to two starkly different conceptions of education. One position sees (or values) education as *training* (education as predictable). Another sees (or values) education as, so to speak, revolutionary transformation, alteration, or interruption (education as event).

Training and Event

Education conceived as training has been decisively in the ascendant in the dominant neo-utilitarian discourse, in the UK at least, since the Thatcherite onslaught on "useless" arts and humanities in the 1980s (Young 1992). The "good," the "useful" education, became defined as training: for industry, for vocations, for money-making. The values inscribed within this position increasingly hold not only hegemony but actually now a stranglehold on educational policy, funding, and orientations in the UK and elsewhere in the world. This is most clearly testified to by the quick move to withdraw all government funding from the teaching and provision of undergraduate courses in the Arts, Humanities and Social Sciences in England, by the newly elected Conservative coalition government in the UK in 2010.

As radical as the UK government's actions against the Arts, Humanities and Social Sciences have been since 2010, their position is not new. It is in fact programmatically predictable, according to a two centuries old discourse about university education, in the UK at least; a discourse which, according to Robert J. C. Young (1992), has been organized by an ongoing and entrenched polemic about whether university education should have any use. Set up within the utilitarian frames of this discourse, and amplified by the neoliberal marketization of everything since the 1980s (and further confounded by the prevalence of a fuzzy "puritanical realist" logic which, in its insistence on the superiority of "practical usefulness," confuses "usefulness" and "value" and comes up with a naïve sense of "use value" as the yardstick of all use and all value), UK government policy overwhelmingly prefers that which can present itself as unambiguously "useful" in the most instrumental (and indeed metaphysical) sense. Hence the common sense: the only useful education is education that only has a useful use.

The opposite or alternative position available today, in the current discursive configuration, prefers not so much "uselessness" *as such*, but rather involves a critique and a principled rejection of all utilitarian "end and outcome" orientated values in education. It does so for at least two reasons. The first is by dint of an argument which contends that to decide in advance what should be studied, taught and done amounts to a kind of closing down of possibility of discovery and new insight—a closing down of the possibility of encountering the new, the unexpected, the surprise, the event, the different, the other, or indeed even (as Derrida preferred to put it) the future. The second reason is the rather less universal and rather more particular fact that "pragmatic," "vocational," "training" or otherwise end-and-outcome-orientated

values always threaten to close down the future employment of those in education who are not involved in education as training.

Given Docherty's rendition of this position, we can see that the rejection of a utilitarian approach to education (or a rejection of the "education as training" paradigm) is easily associated with the arts and humanities. However, it is a perspective that is equally prevalent within the sciences. In the sciences, a version of the "useful vs. useless" debate has long raged between what Lyotard in the 1970s called "technoscience" (i.e., science that operates ultimately in the service of profit-seeking corporations or the military), on the one hand, and "basic" or "fundamental" scientific research, on the other (i.e., the advocation of theory and experiment; sometimes but not necessarily for theory and experiment's "own sake," but also because of equivalent arguments about the unknowability, in advance, of what might come to be known; or, in other words, because there are more things—whether or not potentially "useful" things—in heaven and earth than can be dreamt of from the position of the present).

Even so, things are not so simple. All-or-nothing interpretations of events and orientations may themselves be rather more predictable than evental—missing subtlety, complexity, multiplicity. For instance, despite the undoubted reality of the intensification of bureaucratic surveillance infusing and permeating the delivery of university education today, surely (and actually according to the tenets of poststructuralist ontologies) there must always be gaps, hiatuses, aporias, spaces, play, scope for the unpredictable, the event, the future, etc. These will exist no matter how all-encompassing the statement and enforcement of rationale, aim, method, outcome. Surely, even the most programmatic programme cannot ward off or entirely control the possibility of an event.

Moreover, to climb down from the hyperbolical: no matter how febrile, surely no administrator ever said that educators must "predict with total certainty" *everything* that students might possibly learn during a course.[6] And besides, surely providing a rationale for a course which consists of reading Joyce or Proust or Rilke or Woolf is not some kind of betrayal or reduction or simplification of the reading of these writers. Indeed, on the other hand, as anyone who has undertaken any kind of "mere training" can testify—whether in martial arts or music or marketing, language learning, or management—there is no sense in which "mere training," rationalized by predictable outcomes, precludes the possibility of a completely transformative event. I as educator can feel strongly and can give reason upon reason why I might want my students to read Marx, Althusser, Laclau, Hall, Chow or Rifkin—or, indeed, why I might want my other types of students to perform a martial art form three times per day (preferably first thing in the morning)—even if they cannot understand why

they should do so, especially in advance of having done so, and even if I cannot predict precisely what they will (also) learn, or what will (also) happen to them, along with what I want them to learn and what I want to happen to them in doing so. Or what happens to me, both in doing the same myself and/or instructing others to do what I do or indeed what I have *never ever done*, and don't know how to do—whether that be "read Rilke" or meditate in the lotus position.

Similarly, it needs to be remembered: the theorists, or artists, or humanists, or eventists, whether from philosophy or from physics, must not be assumed to be thwarted or tragic heroes: as if some noble, principled Banquo to the murderous managerialist Macbeth. There is absolutely no guarantee, for instance, that those involved in areas that neo(liberal)-utilitarianism deems "useless" are not, in fact, terrible elitists; and there is absolutely no guarantee that their works, their subjects, their orientations, their knowledge, and all the rest of it are necessarily "good." Reciprocally, it deserves to be said: nor is panopticism somehow simply "bad." Nor is an audit necessarily negative. As Timothy Bahti once argued, in a deconstructive argument focusing on one of the most often and easily pilloried "useless" subjects, history: to hold to account, to demand a rationale, a justification, a reasoned argument for existence and activity, is not necessarily to condemn "arts" subjects to death or to utilitarianism. It can, on the contrary, be an occasion for retheorizing, philosophizing, and perhaps even politicizing or ethicizing an otherwise "merely academic" field. He writes:

> For all the activity devoted to historical knowledge—by which I mean the courses, the examinations, the papers and dissertations and submitted manuscripts—there [should] be the repeated occasion, on each such occasion, for these small and simple questions: How? Why? So what? ... [E]ach bit of historical knowledge, each occasion for its articulation and transmission, should become the occasion for inquiry into its methodology and teleology. Even to acknowledge, and to insist upon the acknowledgement, that history has a history, and that the history "known" is not a substantial object but a subjectively constructed cognition, can be critical in this context. Put more polemically: no history of literature, no history of art, no history of society, without a philosophy of history, a method of historiography, an internal and external accounting. (Bahti 1992: 72-73)

So, from a broadly deconstructive position, this would be an example of "good" accounting, with potentially "good" transformative consequences. Yet is deconstruction therefore simply "good"? It was precisely deconstructive arguments such as Bahti's that lead Timothy Bewes to argue that, given deconstruction's investment in, so to speak, *restructuring (by other names)*, therefore, it could be said to be the case that:

> The revolution ratified by deconstruction, in fact, is the capitalist one, which effects the gradual anonymization and *atomization* of society. This revolution lacks any "end" other than itself: it involves, as the *Communist Manifesto* puts it, the "constant revolutionizing of production, uninterrupted disturbance of all social conditions, everlasting uncertainty and agitation." (Bewes 2001: 92)

This is not the place to adjudicate the status of anything and everything that has emerged since, within, because of or in relation to something about "capitalism." But Bewes' challenge to the perceived radicality or unequivocal progressiveness of deconstructive scholarship is pertinent in terms of the problematization of what Derrida himself called "clear-consciencism": the belief in one's rectitude, the conviction of one's rightness, the belief that one's position is sound, justified, clean and reliable, and that the outcomes of one's interventions will be beneficial, etc. (Given this, of course, Bewes' own challenge thereby becomes open to the accusation of being symptomatic of something to do with the capitalist revolution too.) The point here is that if what can be picked up is the extent to which, like many radical thinkers, what Bahti wanted and expressed the wish for in his 1992 essay was a deconstruction and reconstruction of humanities fields, including history, then arguably the response to that request was already well under way, well in the post, and is being delivered and injected into arts and humanities departments the world over, through the various different machines of disciplinary deconstruction that travelled under such names as feminism, women's studies, black, Asian, and other ethnicity studies, poststructuralism, postmodernism, and, of course, cultural studies. Of course, the broadly contemporary lurching into being of so many movements, academic and disciplinary revolutions and transformations can be historicized and diversely diagnosed. But although Bewes connects "constant revolutionizing" with "capitalism," many other approaches could couch this in rather less starkly political, conflictual, or indeed potentially or implicitly moralistic terms. Although Marx did not have words like "modernity" in his vocabulary, as Rey Chow has pointed out, thinkers such as Heidegger or Benjamin, for instance, connected modernity (capitalist or otherwise) with *shock*. And this latter kind of vocabulary or worldview is arguably much better equipped to be less liable to collapse into moralism and judgementality. The effort to try to try to prevent thinking and theory about the contemporary world from collapsing into political moralism is what lead Jameson to argue that disapproving of or denouncing the historical period of "postmodernity" and its productions amounted to little more than a category mistake.

All that was solid

This is another way of saying that the modern world is hyperconnected, hyper-communicated and paradoxically *therefore* disconnected, chaotic, cacophonic, isolating, fluid and antagonistic. This is why Chow draws our attention to the fact that in *The Order of Things* (1970), Foucault proposes that knowledge per se must henceforth be understood as "a matter of tracking the broken lines, shapes, and patterns that may have become occluded, gone underground, or taken flight" (Chow 2006: 81). Similarly, Sam Weber reminds us of Bachelard's reflections on the implications that contemporary science has for our understanding of knowledge: "All the basic notions can in a certain manner be doubled; they can be bordered by complementary notions. Henceforth, every intuition will proceed from a choice; there will thus be a kind of essential ambiguity at the basis of scientific description and the immediacy of the Cartesian notion of evidence will be perturbed" (Bachelard in Weber 1987: xii).

Referring to his genealogical work on the history of knowledge *epistemes* in *The Order of Things*, Rey Chow notes Foucault's contention that "the premodern ways of knowledge production, with their key mechanism of cumulative (and inexhaustible) inclusion, came to an end in modern times." The consequence of this has been that "the spatial logic of the grid" has given way "to an archaeological network wherein the once assumed clear continuities (and unities) among differentiated knowledge items are displaced onto fissures, mutations, and subterranean genealogies, the totality of which can never again be mapped out in taxonomic certitude and coherence" (Chow 2006: 81). As such, any knowledge establishment, any construction, even any comparison, must henceforth become "an act that, because it is inseparable from history, would have to remain speculative rather than conclusive, and ready to subject itself periodically to revamped semiotic relations." This is so because "the violent yoking together of disparate things has become inevitable in modern and postmodern times." As such, even an act of "comparison would also be an unfinalizable event because its meanings have to be repeatedly negotiated." This situation arises "not merely on the basis of the constantly increasing quantity of materials involved but more importantly on the basis of the partialities, anachronisms, and disappearances that have been inscribed over time on such materials' seemingly positivistic existences" (81). And all of this bears directly not only on the history but also on the method of both Adrian Rifkin and Rey Chow, in different ways, both in terms of theoretical and empirical justification and mode of enactment. Each is intimately involved in the other, calling it up and reflecting its validity and almost ineluctable appropriateness, even in its idiosyncratic impropriety.

Inevitably, there must be many possible histories, and many possible dis-
putations of the epochal event of the ends of the cumulative. But Adrian
Rifkin's account of the very first undergraduate work in cultural studies de-
serves some consideration here. As he recalls, "between 1970 and 1975 in
Portsmouth ... the first cultural studies BA anywhere had come into existence"
(Rifkin 2003: 101). It emerged

> through the work of a group of staff who came from the kinds of background that
> were themselves part of the formative myth of cultural studies, as some kind of
> epistemic break with previous modes of disciplinary formation. But also a group of
> staff working very closely with Stuart Hall, who came down and helped design the
> courses and who was himself the first external examiner of the course. (101)

Rifkin's discussion of this emergence of cultural studies is itself far from a
simple recounting of a chronology. Rather, it is a reflection on emergence it-
self. As he notes, one of the things that was most striking about this first cul-
tural studies undergraduate work was that "the kinds of words which students
had used in their essays in the 1970s were words like 'articulate' and 'medi-
ate.'" These undergraduate essays, he argues:

> orientated themselves around particular words; certain words which took a kind of
> distance from the materials they examined and suggested that these materials could be
> put together in a way which was not a question of sequence and not a question of
> historical temporality, but a question of the way in which ideas, the logic of ideas, and
> the material conditions of the society, could be mediated through each other via
> something which we might call "articulation" or a series of articulations. (102)

There is an enormous amount that could be said about Rifkin's recollec-
tion of the place of the notion of "articulation" as organizing of cultural stud-
ies discourse even in the early 1970s (long before, say, the first book of Ernesto
Laclau (1977), the one of which Stuart Hall so approved, and up to fifteen
years before Laclau and Mouffe's blockbuster *Hegemony and Socialist Strategy*
(1985), which put the idea of "articulation" on the international academic
map in a huge way, but a book of which Stuart Hall was extremely critical, and
which marks a watershed dividing line between Birmingham-style cultural
studies and an emergent Laclauian and proto-Žižekian "discourse analysis"—or,
rather, "discourse theory"). But what Rifkin singles out is the way it indicates
the emergence of something very important going on: "something which was I
suppose both "metacritical" (taking a step back from the cultural materials and
historical materials with which they were engaged, and seeing them as part of a
cultural process), on the one hand, and, on the other, part of a political pro-
ject" (102):

So there was a project, which was to move forward the relation between disciplinary methodologies and each other in terms of their mutual criticism on the one hand, and to move forward the role of university thinking, in terms of its hold on society, its critique of society, on the other. So if you like, if you started reading the use of the word "articulation" as symptomatic of what was going on you could say that what those essays symptomatized was a desire—in their discourse, that is: in the particularity of their discourse—a desire for theory to be both productive and effective—to both produce new forms of knowledge and to articulate those forms of knowledge in such a way that they were genuinely critical. (102)

Rifkin repeatedly contrasts this "desire for theory to be both productive and effective"—which he associates with frustrated, transformative impulses—with the rather different, but widespread, desire, to "construct satisfactory historical teleologies leading up to oneself and one's own desires." The latter involves "fantasizing around categories," taking such forms as believing in the "otherness of the working class and the bourgeoisie to each other as being a point of non-meeting and non-touching." In *Disagreement* (1999), Rancière characterizes the object under critique here as being the *geometrical* conception of society, wherein each type of social identity is regarded as having—and having to be in—its own proper place. Rancière's work has consistently problematized such a conception. In Rifkin's words:

Put very crudely, this is the burden of those early articles of Rancière: that, if what the worker desires is to be a poet, rather than to be on the barricade, in a sense that desire presupposes a dissolution of the whole social relations upon which the concept of the poet itself has become constructed—if you like it's a kind of Kantian category. So this bringing of a kind of neo-Kantianism into the political field, which Rancière achieved I think, was one of an immense metacritical potential, and a potential to disrupt the ways in which studies can settle down into their own genre of becoming themselves, and becoming consolidated. I think that this has largely happened with cultural studies. (114)

In Rancièrean terms, Rifkin rejects the *police* dimensions of disciplinarity, the way disciplinary structures, categories, fantasies and discursive fetishes work to partition and to police and to discipline the perceptible and the sayable. Rather than this, Rifkin deliberately privileges approaches which demand the "reconstruction of something *in its difficulty*," the refusal of simplification, and in a sense of conclusion, if only to "disrupt the ways in which studies can settle down into their own genre of becoming themselves, and becoming consolidated":

Rancière's work of that period enabled me to precipitate and consolidate the kind of ideas which I was beginning to develop myself. I was not thinking in terms of "the relative autonomy of the superstructure," or in terms of the way in which forms of

figuration then levered out, utopianly or dystopianly, or whatever; so that, for example, the political cartoons of the Paris Commune (which is what I was then working on) become a register *not* of a kind of treasury of socialist history and its tragedies and its ups and downs, but a site on which we can historically represent the impossibility of reading things in that "clean way"—that way in which one can construct satisfactory historical teleologies leading up to oneself and one's own desires. So it is a way of taking oneself out of condensation and displacement and daydreaming about one's politics through cultural materials, and thinking of history not so much pessimistically, but in a way in which, if you like, the hyper-metacritical position has to win out over the archive in the end. You have to precipitate situations in which the metacritical wins out over the potential of the "satisfactory" or "whole narrative" coming out of the archive. (113)

The archive is thus never the repository of the proof of the theory, but rather the source of potentially interminable demonstration or verification of if not the undecidability of the demonstration or verification then certainly at least the impossibility of establishing "satisfactory whole narratives" that are actually reliable or based upon attentive readings. "Satisfactory whole narratives" are then not only imaginary or phantasy gratifications but also actually symptomatic of the enactment or embodiment of a police logic that takes place in the mode of a kind of self-blinding. Satisfactory whole narratives are not based on reading, but are rather produced from condensations, displacements, daydreams and desires. So, rather than this, rather than basing or orientating research on some fantasy of completion, completeness or completability, Rifkin instead follows what he calls a paratactical "method":

It's a kind of, not a diagramaticising (that's too simple) but a topological analysis of quite tiny elements of theory against quite tiny or sometimes quite extensive figures taken from other forms of culture, and (in the Kristevan terms) a *listening to the dynamics* in such a way as not to say "this one has authority over that" or "this one is the subject of that one" or "the material for that one," but in such a way as to listen to the figural densities of the dynamics of the texts which I am setting alongside each other. So the method is one of parataxis. It essentially works with very tiny units of theory, such as a paragraph of Lacan, say, on the formation of the unconscious, a paragraph of Kristeva, on the double disabusal of the young girl with the phallus, in terms of which she talks about the feminine, therefore the concept of the feminine in Kristeva; and the allowing of the configurations of these materials to lie alongside materials so that one begins to make unexpected kinds of readings of or *listenings to* those materials.

Now this means creating new kinds of objects of attention. In terms of the cultural-historical narrative, I call it *anahistorical*. This is a historical equivalent of anamorphic—it's a kind of historical object pulled out of shape by its framings, which might be Lacan and Saint Augustine. But equally, those framings pulled out of shape by the object, and a reading of the suppositions which we bring to it. (121-22)

This method therefore involves acknowledging that any object must necessarily exist "in increasingly complex place," made up of such coordinates as "the textual interpenetrations, the complex textual formations, the processes of listening to the text, listening to yourself listening to the text, and producing a text which is your own text out of that process" (122).

Such a methodology has its historical and philosophical antecedents and precedents, of course. Rifkin's anahistorical method certainly comes close to what Rey Chow discusses in terms of that "materialist though elusive fact about translation" that Walter Benjamin proposed: namely, that "translation is primarily a process of *putting together*." As Chow explains, for Benjamin, translation is a process which "demonstrates that the 'original,' too, is something that has been put together"—and she adds, following Benjamin: "in its violence" (Chow 1995: 185).

Just as Benjamin's take on translation/construction is important to Chow, so Rifkin's method, whether thought of as anahistorical, or as materialist cultural translation, or indeed as a kind of "autodidactics of bits," certainly has a relation to violence. One of its many virtues is the way(s) that its theoretical force does a violence to all scientistic approaches to historical or cultural study of any kind. This theoretical force derives from its facing up to all of the nigh-on impossible complexities implied in academic endeavors, rigorously conceived: the impossibility of omniscience, of encyclopedic knowledge and mastery of a field, of the existence of a field that is one, of the ability to enclose, pin down, and establish facts or unequivocal connections; the impossibility of taking into consideration all of the things that would need to be taken into a consideration were anything like a compelling "objective" or even "satisfactory" account of anything to be possible—in other words, a facing up to the impossibility of objectivity, and the absolute textuality of texts, through deliberately staging encounters, and listening to the dynamics and the evental character of the encounters. It is at this point that Rey Chow's work on "cultural translation" should be more fully elaborated.

Rey Chow's Cultural Translation

Literal and Non-Literal Translation

I n the concluding chapter of *Primitive Passions* (1995), in a chapter entitled "Film as Ethnography," Rey Chow asks the question of the relationships between ethnography and the complex matter of visual media representations. She asks this because by and large any serious consideration of the impact and implications of filmic, TV and other media representations have traditionally been excluded or subordinated in the conceptualization and construction of the classical anthropological ethnographic "scene." The ethnographic scene is a scenario most commonly formulated as being a situation involving an ethnographer and a native subject (or group). The presence and role of all manner of media are not normally immediately considered in this scenario. Yet the contemporary world is, and has been for well over a century, saturated with media—and moreover with a range of mediated images that often claim to testify to some kind of insight into other cultures, in a quasi-anthropological way. There are also types of media text that seem to constitute, precipitate or otherwise relate to one or another kind of cross-cultural encounter, and so on. (I have written about this in Bowman 2010.) The documentary film is perhaps the exemplary contemporary form of media genre that has closest affinities with anthropology; just as the wide variety of texts that seem to represent "other cultures," however falsely or fictitiously—such as action films, set in "exotic" locations—can be numbered among the media which may precipitate various forms of cross-cultural encounter. Both have, to a significant extent, superseded earlier media forms, such as the newspaper report and genres of travel writing, which had been popular for hundreds of years, and that had provided "information" and ideas about different cultures and societies.

Of course, the film or TV documentary remains controversial in many ways, even though it is based on a kind of naïve ethnographic claim: the documentary seeks merely to document. But the problem is that what it documents is always a construction, in that what is shown will inevitably be a prod-product of representational biases, based on editorial decisions, involving all sorts of exclusions, subordinations, selections, emphases and exaggerations. However, this observation allows us to turn things around and to perceive with more clarity that, in some ways, the problems of the documentary film as ethnographic text amplify the problems inherent to ethnography per se. For even the "pure" ethnographic situation will be driven by the perceiving eye and writing hand of the ethnographer, whose studies, reports, essays and monographs are themselves ultimately textual constructs. We will return to this matter below, as Chow does in her later paper "China as Documentary" (forthcoming), which in many respects builds on and advances some of the arguments of "Film as Ethnography." But, we will start from the earlier essay, because in "Film as Ethnography," the first matter that Chow isolates is what she calls the problematic relation between representation of "self" and of the "foreign," all efforts in terms of which often arouse harsh responses from many quarters

Chow follows a strand of criticism of anthropology by arguing that some of the problems of inequality and Western bias in "cross-cultural exchange" were in a sense *caused* by Western anthropology. She evokes the problematic scenario of the Western anthropologist going abroad to study natives (1995: 176). As she puts it, from the outset, the very presence of the anthropologist entering into another culture plays its part in the destruction of what may well formerly have been an "isolated," "authentic" or "uncontaminated" native culture. Just as William Wordsworth waxed lyrical about the wild beauty of the natural environment in the English Lake District, before he subsequently went on to bewail the emergence of a tourist industry and the crowds of tourists who were going there to see the landscape *precisely because his accounts of it drew them there*, so anthropology is in some sense implicated in the eradication of native tribes "untouched" by Westerners.

But this is only one aspect of the problem—and one that is in itself already a problematic product (or symptom) of a nostalgia or fantasy based on ideas about, say, the "noble savage" or a "pure and primitive native." The more significant and palpable problem can be described like this. *After* the anthropological encounter, *after* the study has been written up and published, it becomes that case that anyone who seeks to study or learn about the culture in question—including enquirers who may themselves be part of the native group

in question—must now turn to the books and essays produced by the Western ethnographers. This has a double implication: first, it moves the source of authority to Western books and institutions; second, it requires the enquirer, from any culture or tradition, to adopt the Western protocols and reading practices involved in the construction of the "original knowledge." As Chow puts it, following earlier critics, in this sense, anthropology and ethnology remain a "one way street" (177).

Using a related set of terms—terms that are extremely important to her—Chow reformulates this kind of encounter as a version of "cultural translation," and argues that all of this is irreducibly related to power (177). This is first because, in one sense, anthropology gives unequal access to unequal information. Moreover, "weaker" countries are more likely to have no choice in the representational matter and processes and to have to submit to "forcible transformation in the translation process" (178). On Chow's reading, this is the first key ingredient of what she terms "the anthropological deadlock": the domination of representation by the Western ethnographer or anthropologist. The second key ingredient is the noticing of this representational bias and the refusal or rejection of it on the part of the "others," "themselves," so to speak—that is, the *rejection* of Western anthropology and other sorts of Western representations by "nativist" scholars—i.e., academics and other representatives of the "native" culture in question (178).

Chow refers to the rejection of all foreign (Western) representations of native cultures as "nativism." It is an "-ism" because it is a familiar process with predictable features. According to Chow, the process often becomes one in which "native" critics and opponents of "Western" anthropology go on to make various kinds of claim about the *impossibility* of non-natives being able to understand or being able to represent the native culture *at all*. In some versions of nativism, the argument becomes one in which the native culture is held to be entirely ungraspable in Western terms at all. In other versions, the argument is that only native representatives of the native culture can claim to be able to represent that culture at all. Whilst having sympathy for their emergence, Chow suggests that in these and other such responses to the anthropological deadlock, what we see time and again are *refusals of translation*. The nativist positions are led by a desire to hold onto some kind of tradition unmolested by Western incursions (178). But the problem is that in doing so, nativist scholarship often draws exclusionary lines around a fantasized "pure" object, that little if anything or anyone can ever manage to live up to. For instance, in Chinese studies, Chow regularly perceives the ways in which any modern Chinese cultural productions are disparaged by nativist critics for be-

ing "too Westernized," and suchlike. In short, what is valued is a backward-looking cultural elitism, based on a fantasized essentialism, whose consequences include attempts to hierarchize, police and exclude certain subjects. This is so even though fields like Chinese studies are often elaborated in languages other than Chinese—yet, suggests Chow, to remain consistent with their own demands (and to avoid their "performative contradiction"), shouldn't such orientations be carried out solely in classical Chinese?

Instead of going down these lines, Chow moves somewhat transversally and proposes a link between ethnography and translation. This link that can be clarified and engaged more fully by focusing on the theme of visuality, and thinking about all different kinds of filmic representation, not only documentary. Chow proposes this even though, unlike the laypeople of the general public, who might easily regard a documentary as being more or less "anthropological," anthropologists themselves define anthropology in terms of method and theory (rather than representation). This means that they will not be inclined to define a text as anthropological just because of its subject matter. However, non-anthropologists are not quite so clear on the matter. And this may not simply be because of any lack of "discipline" or "academic rigor." Rather, once one starts to look at the borders and boundaries between a supposedly anthropological and a supposedly non-anthropological text *otherwise* (perhaps using the insights of Derrida and deconstruction, for instance), the ostensibly clear distinctions between the anthropological and the non-anthropological become less and less clear. When one considers any representation as a (textual) representation, it becomes difficult to adjudicate decisively on what might be regarded as ethnographic and what not (179). This is compounded by the fact that ethnography itself is constitutively based in the *subjective*—the *subjective* encounter, the relations between *subjects* (179). This, therefore, is a paradox of ethnographic anthropology, inasmuch as one of the claims of ethnography is its ability to construct a more generalizable knowledge from a subjective (and disciplinary) interpretation of an intersubjective encounter.

Chow reiterates with approval the argument that is sometimes advanced that because ethnographic texts are irreducibly subjective, therefore the question of *whose subjectivity* should be foregrounded. She proposes that we should look at the subjective origins of the work of those who were previously ethnologized but who now ethnologize themselves in different ways and using different media. How do they show themselves? This is a variant of the question of "how do they see themselves?" and this is crucially important, argues Chow, because it is related to—indeed, it demonstrates—the huge importance not only

of *looking* but also of being looked at. Which is why Chow connects the problems of ethnography with Laura Mulvey's feminist arguments about the political and ethical effects of the structures, conventions and structuration of vision and looking, as discussed in chapter 2. As Chow puts it: "the state of being looked at not only is built into the way non-Western cultures are viewed by Western ones; more significantly it is part of the *active* manner in which such cultures represent—ethnographize—themselves" (180). In other words, this is a matter of the force that the way you have been looked at exerts on the way you look at, represent, or even "construct" yourself (180). So, following Mulvey and using her famous (and famously awkward) term, Chow asserts that "being-looked-at-ness, rather than the act of looking, constitutes the primary event in cross-cultural representation" (180).

Having added so many different issues into the mix, it may become difficult to follow Chow's overarching arguments or fundamental contentions. But here, Chow is developing two soon to be intertwined positions. The first is an argument that many different forms of representation (from ethnographic to documentary to filmic and fictional) are different kinds of "translation," from one register to another, following different kinds of protocols, contingencies and biases. The second is that these all feed into the ways in which groups are "seen" (in every sense of the word: from "shown" to "thought of"); and that—claims of anthropological specificity notwithstanding—all types of representation have effects on perceptions and apperceptions (self-perceptions). All texts are constructs, and all representations are texts (180-1). Thus, she affirms, there is always something anthropological/ethnographic, even in fiction; and equally therefore always something fictive in ethnographic texts:

> In studying contemporary Chinese films as ethnography and autoethnography, I am thus advocating nothing less than a radical deprofessionalization of anthropology and ethnography as "intellectual disciplines." Once these disciplines are deprofessionalized—their boundaries between "us" and "them" destabilized; their claims to documentary objectivity deconstructed—how do we begin to reconceive the massive cultural information that has for so long been collected under their rubric? It is at this juncture that I think our discussion about ethnography must be supplemented by a theory of translation. (181)

Drawing on Thomas Elsaesser's analyses of the ways in which various European filmmakers of the 1970s appeared to have constructed intimately detailed studies of aspects of everyday life that were otherwise simply doomed to oblivion—collections, clutter, mess, and the bric-a-brac of everyday lives—Chow points out that in many ways film can be regarded as a vast "transcription service" (180-1). Similarly, Chinese film of the 1980s can be regarded as a vast

transcription service focused on women, the poor, children, and other related themes common to filmmakers at the time (182).

So, there are three senses of translation in play. First, translation as transcription; second, translation as transformation from one medium to another; and third, the problem of translation across and between cultures (182). Readers may wonder where the more standard sense of translation as linguistic translation has gone in Chow's thinking here—or why she waits for so long and introduces so many other "non-literal" meanings of "translation" before introducing it. It is introduced halfway through "Film as Ethnography," and primarily in the context and in terms of matters related to culture (in her words, in terms of its links with issues of "tradition" and "betrayal") (182). This is because Chow clearly wishes to transform (or translate) conventional constructed and biased understandings of what translation is and does.

Translation has always been thought of as linguistic translation, Chow reminds us, even though there are so many other kinds of crossings over and transformations in the world. Moreover, the linguistic understanding of translation itself has always been heavily biased, along lines that Chow ultimately comes to represent as essentialist. This is because, even though in most approaches to linguistics, there are *two* primary elements at play in the any text—a signifier (in the text) and a signified (what it is meant to mean to a reader)—privilege has always gone to the signified—or to what the signifier is meant to mean. So, what is translated is overwhelmingly the interpretation—not the simple materiality of the signifier—the mark on the page—but rather what is deemed to be the proper or correct meaning of those marks (182-3). This relation to the act or practice of translation sets up a hierarchy or a game of hide and seek in which the translation easily becomes regarded as inferior to "the original," because the translation is different, or "loses" (proper) meanings, or acquires new (improper) meanings, or does not convey the same, or the original or the correct meanings. So the translation is all too often regarded as a crossing over, a crossing out, and a "betrayal" of the original.

Chow critiques all of these value judgments (the *proper*, the *correct*, the *original*), and proposes that whether the translated text in question be literary or filmic—say, a translation of an ancient Chinese text, or the "translation" that is contemporary Chinese film (as we shall see in a moment)—the translation is frequently belittled by purists, nativists and other sorts of critics, because it is regarded as a "superficial" construction, which misses the "essence" of the "original." As Chow puts it in relation to her discussion of film:

> Given these deeply entrenched assumptions about translation, it is hardly surprising that the rendering of "China" into film, even at a time when the literary bases of

Chinese society are increasingly being transformed by the new media culture, is bedeviled by suspicion and replete with accusations of betrayal. While these suspicions and accusations may express themselves in myriad forms, they are always implicitly inscribed within the ideology of fidelity. For instance...is not the distrust of "surfaces"–the criticism of Zhang Yimou's lack of depth–a way of saying that surfaces are "traitors" to the historical depth that is "traditional China"? And yet the word *tradition* itself, linked in its roots to translation and betrayal, has to do with handing over. Tradition itself is nothing if it is not a transmission. How is tradition to be transmitted, to be passed on, if not through translation? (183)

Again, Chow's is a double-pronged approach, which intertwines a couple of critiques. The first is that translation is a problem of "tradition," and a matter of "handing over" (183). The second is that the terms we use to think about translation are already organized by a notion of origin as being primary and superior and translation as being secondary and inferior (183)–even though, both theoretically and practically, this should not be assumed to be the case. She continues:

Precisely because translation is an activity that immediately problematizes the ontological hierarchy of languages–"which is primary and which is secondary?"–it is also the place where the oldest prejudices about origins and derivations come into play most forcefully. For instance, what does it mean to make a translation sound "natural"? Must the translation sound more like the "original," which is not the language into which it is translated–meaning that it is by resemblance to the "original" that it becomes "natural"? Or, must it sound more like the language into which it is translated, in which case sounding "natural" would mean forgetting the "origin"? When we say, derogatorily, "This reads like a translation," what we mean is that even though we understand what the "original" meaning might be, we cannot but notice its translatedness–and yet is that not precisely what a translation is supposed to be–*translated* rather than "original"? As in all bifurcated processes of signification, translation is a process in which the notion of the "original," the relationship between the "original" and its "derivations," and the demand for what is "natural" must be thoroughly reexamined. (184)

To illustrate some of these points, Chow turns again to the criticisms of Zhang Yimou's films. She notes that the criticisms of his films seem to boil down to the idea that his films are unfaithful to an *essence*, "China," an essence that is presumed to exist somewhere, but that is equally never fully present. The criticisms always strongly imply that, because the film medium is "superficial," therefore it will always both fail and distort "China," and will never be able to *get to*–communicate or represent–its depth.

Of course, as all of the points made up to now have already anticipated, Chow could neither be satisfied with such a take on "film," nor on "representation," nor on "China," nor indeed on any other presumed or putative entity

(or essence). "China" is always and already only ever a discursive and textual construct—an idea, an argument, a set of associations, and so on. Even to the extent that it is a *thing*, specifically a nation state, this is at once also a textual matter (nations are written into existence by—and as—documents, as Chow has pointed out), and moreover something that is in no way divorced from the attending discursive textual constructs of ideology—the many different kinds of visual, sonic and narrative of celebration of the Chinese nation.

Accordingly, then, all texts are in some sense "translations," in that they are constructions which incorporate material and interpretations of other materials and interpretations. At the very least, all texts are constructions, which have been put together, in one place or context. So translation ought equally to be approached in terms of processes of putting together, and reworking, in another. This is why Chow recalls Walter Benjamin's argument in his essay "The Task of the Translator" (Chow 1995: 185), in which Benjamin argues that the task of the translator is to attend to the constructedness of the text and to reassemble it brick by brick, so to speak, or word by word (185). The original is already a construction. Therefore the translation must also be a construction—indeed a construction which demonstrates the constructedness of *every* text.

Nevertheless, this does not solve the conundrum of how to translate word for word. Even if we don't worry about what signified meaning our translations are constructing, the question remains one of which signifiers to use to translate which signifiers? For Benjamin, the task of the translator is therefore that of communicating the missing thing, the supplement to literality (186). This is to be located in what Benjamin calls the text's *mode of signification*. For Benjamin, what both original and translation should share is an exchange organized by a mode of signification. Translation is therefore regarded by Benjamin as a "liberation," both of the original and of the translation. This is because texts are now regarded as fragments of a larger "language" or mode of signification (188). What Benjamin takes this to mean is encapsulated in a passage that he quotes from Pannwitz, in which Pannwitz argues that the problem with translation is that translators always translate the original into the destination language without modifying the destination language in reverence for the original language. However, a good translation, Pannwitz suggests, should alter the destination language, too (189). Translation should be the transformation both of the text and of the context.

Chow actually regards this as an anti-ethnocentric theory of translation. For it implies an approach that doesn't demand that the other be reduced to

the same, but rather that the familiar language and culture reach out and be affected by the foreign.

That being said, Chow remains concerned to emphasize that we should not get (re)immersed in "logocentric" or language-centered understandings of translation. As she observes, the traditional academic focus on the *written* leaves unasked the question of translation from, for instance, literary to visual realms, registers and media, or literary to sonic, or aural to visual, and so on; as well as translation-transformations that may or may not be bound up in the legacy of Westernization. Moreover, she adds, those theorists of poststructuralism, for example, who produce ever-more dense and complicated readings of texts, and who have been inclined in the past to regard such work as "resistance" to cultural domination, and so on, should remember that the production of "dense readings" only makes sense in the context of institutions of close reading within the university (191).

Evoking approaches to cultural translation which advocate "transactional reading," Chow asks (rhetorically), must the emphasis always fall on "reading" and not simply on the idea of cultural translations as "transactional"? (191) She asks this because all manner of encounter and many different kinds of textual production or dissemination bespeak transactions across languages, mediums, and cultural forms, "transactions" that do not involve any close reading at all (192). Hence her questions: can we think translation that does not "valorize" or fetishize the idea—or investment in the idea—of an original? And can we think translation in terms that do not involve the idea of an "interpretation" towards depth? (192) In order to be able to do this, Chow proposes, we need to move from a focus on *interlingual questions* to focusing on *intersemiotic practices* (193).

Chow's move from a focus on language to a focus on non-linguistic cross-cultural encounter also signals the point at which she takes her distances from deconstruction. Specifically, she argues, deconstruction's "negative momentum"—its critical relation to language and texts—is incapable of thinking the specificity of the media into which the transformed text (e.g., literature) is translated (e.g., film) (193). Moreover, she notes, all too many people in translation studies and in poststructuralism still favor the original rather than the translation—something which is surely bizarre, especially in a field called *translation* studies. But, she asks: should we decide to champion the original because it was there first (even if it is a "necessary failure," in the sense argued by deconstructionists), or should we work with the translated text? Because of ingrained cultural and academic biases, she points out, many academics still choose the former. But the choice in this regard is one that Chow contends

will have profound significances and consequences—*for our own orientations and values*. As she puts it, "the choice of either path constitutes a major political decision" (193).

A similar decision that must be made, and that has similar ethical and political implications, is whether to focus attention on "high" cultural objects, texts and practices, or whether to focus on "mass" and "low" cultural objects, texts and practices (193). Chow gives numerous reasons why attention should be given to mass culture, including the ways in which mass culture registers, reworks and replays issues of the asymmetry of power relations between Eastern and Western cultures (193). Moreover, in a media saturated world, to proceed in any academic or intellectual endeavor in such a way as to try to block or blot out the profound, intense and relentless day-to-day crossovers and transactions between cultures—to ignore them or to try to pretend they aren't happening—is to remain obdurately blinkered and closed off to the extent to which global media transactions have transformed the world—for instance, in terms of a "weakening" of Western traditions and Western "metaphysics" (195), or, that is, the hold both of Western philosophical and epistemological views and of their "laws."

In other words, the vast traffic in global popular cultural encounters (for example, the transnationalism of film) means that, even if what the world has seen over the past centuries can be described as "Westernization," it is still the case that cultures, east and west, north and south, are more and more "coeval"—arising and developing together. So, although we may think of primitive cultures as having been eradicated and as having vanished because of Westernization, it is less hyperbolic to say that they have been "translated" (196). Obviously, some cultures have been more translated than others, and in ways determined by unequal directions of power. But this has not occurred without some reciprocal modifications. Chow adds to this the important point that our contemporary ideas about "lost" ancient and primitive cultures and peoples should be regarded as ideas that have arisen in modernity and postmodernity. In other words, they are *modern* ideas. The idea of the primitive and ancient that we mourn the loss of is in fact a contemporary idea, or a contemporary "affect." Chow calls such affects "primitive passions." She borrows the Nietzschean terms used by Gianni Vattimo to describe what he calls the "fabling" of the contemporary world, in order to assert that those other cultures have not gone; they have just changed and are still "authentic" even if translated. Moreover, she adds, even within the cultures that Westernizers "primitivize" and fetishize—by imagining them as being, for example, closer to nature, or

"timeless"—even such cultures themselves often trade in primitivist fantasies about parts of their own demographics (the poor, the rural, etc.) (196).

Rather than falling into primitivism or nativism, Chow seeks to attend to the implications of the fact that different media interact in different ways across national and international contexts (197). This means that not one mode of signification is dominant in the contemporary world, at the same time as—even if "technologization" might be regarded as "Westernization"—these self-same media have weakened Western "foundations" as much as having spread them. This is why Chow turns to Vattimo, who has argued that, accordingly, there has been a widespread *weakening of experience as such*. This has arisen by way of and thanks to the complexity of media, their multifarious interactions, and the cacophonic media saturation of everyday life. But ultimately, the turn here is to Nietzsche's prophetic argument that, more and more clearly it can be seen that there are no incontestable facts and only interpretations. According to Vattimo, this means that the world has more and more become a "fable" (198)—a story, a version among versions, something demanding interpretation rather than commanding experience.

Now, at such a point, many thinkers would take the turn most famously made by Jean Baudrillard—away from "the world" and into ideas and arguments about the primacy of simulacra and simulation. But Chow does not follow this hyperbolic line. To be a fable is not to be simply false simulation, she acknowledges; arguing that, for instance, contemporary Chinese films in this context ought to be understood as fables (198). This does not mean false or simply disconnected fiction. Rather,

> Contemporary Chinese films are cultural "translations" in...multiple senses of the term. By consciously exoticizing China and revealing China's "dirty secrets" to the outside world, contemporary Chinese directors are translators of the violence with which the Chinese culture is "originally" put together. (202)

That is, rather than regarding films as pure fantasy—or entirely excluded from the realms of ethnography or documentary—Chow suggests that certain Chinese films clearly show some of the ways in which Chinese culture is put together "in its cruelty" (198). Of course, this can be quite antagonistic or alienating for some viewers, and of course no representation will ever be free from the need for interpretation or contestation, but Chow argues that this shows the extent to which Chinese audiences can become not only inheritors of but also foreigners to their own tradition in the act of transmission (199). Indeed, Chow acknowledges, perhaps transmitting something or translating something so that it can me represented/communicated to a wider audience (translated), involves a kind of sacrifice (199). Kafka sacrificed truth for the sa-

ke of clinging to its transmissibility, she notes; arguing that perhaps it is the case that what is transmissible is what is accessible, and that this exacts a heavy toll. *Accessibility* is what enables transmission and translation between cultures (200), and this involves a cost. Thus, she writes, of Chinese film:

> In the dazzling colors of their screen, the primitive that is woman, who at once unveils the corrupt Chinese tradition and parodies the orientalism of the West, stands as the naïve symbol, the brilliant arcade, through which "China" travels across cultures to unfamiliar audiences. Meanwhile, the "original" that is film, the canonically Western medium, becomes destabilized and permanently infected with the unforgettable "ethnic" (*and* foreign) images imprinted on it by the Chinese translators. (202)

And this leads to her conclusion:

> Like Benjamin's collector, the Chinese filmmakers' relation to "China" is that of the heirs to a great collection of treasures, the most distinguished trait of which, writes Benjamin, "will always be its transmissibility." If translation is a form of betrayal, then the translators pay their debt by bringing fame to the ethnic culture, a fame that is evident in recent years from the major awards won by Chinese films at international film festivals in Manila, Tokyo, Nantes, Locarno, London, Honolulu, Montreal, Berlin, Venice, and Cannes. Another name for fame is afterlife. It is in translation's faithlessness that "China" survives and thrives. A faithlessness that gives the beloved life—is that not. . . faithfulness itself? (202)

Chow returns obliquely to this complex question some twelve years after the publication of "Film as Ethnography," in a paper called "China as Documentary: Some Basic Questions (Inspired by Michelangelo Antonioni and Jia Zhangke)" (forthcoming). In this work she considers directly the problems and pitfalls not of the "artistic" or "fictional" representation of the cinematic feature film, but rather of the "realistic" documentary itself. A fictional representation may offend for being incorrect or untrue, but surely not a documentary, right? Wrong. The stakes and problematics of representation are if anything amplified and intensified in the representation that seeks to be "objective" or "factual." This much we might anticipate. But in "China as Documentary," Chow as ever seeks to push our thinking further on this matter and related issues.

The first thing Chow notes is an ingrained but often unremarked difference between the ways that different constituencies of academics view images. She breaks it down into the difference between the ways that those she calls "natives" or "native informants" view images of their own culture and the ways that foreign observers view those same images. The first difference, she proposes, is the matter of *deference*: "foreign" (Western) academics are keen to defer to the opinions and interpretations of "natives." This is clearly the outcome

of a certain historical process—the increasing sensitivity of Western academics to the possibility that they may not have authority or access to the truth, that their readings may be "biased" or "Western," and that those immersed in the "deep textures" of a cultural context may have more claims to authority on matters pertaining to their own cultures than Western "foreign observers."

Perhaps the moment of the emergence of this self-reflexivity might be dated to the publication of Edward Said's book *Orientalism*, a book that firmly put on the agenda the idea that Western culture and scholarship had perpetrated and perpetuated a systematic representational distortion of "other" cultures. Anthropological and other cross-cultural scholarship has since been obliged to engage with the gauntlet thrown down by Said's study. Indeed, Chow's own remarks in this context are actually expressed in Said's terms: just as "foreign observers" are now keen to defer to the interpretations of "natives," so "natives" are keen to avoid being "orientalised."

To Chow's mind, the gap between these positions is where she would locate the future of visual research "in an age of hypermediality." Of course this is not a prediction of the predetermined or predestined future of the field(s) of visual analysis. Rather it is the space she feels to be most in need of further analysis and interrogation. Indeed, Chow's statement here is reminiscent of the opening of her 1998 essay "The Dream of a Butterfly," wherein she points out that, since Said's *Orientalism*, we have become increasingly adept at noticing the ways in which this or that text is "orientalist" or racist. But surely, therefore, shouldn't that now become the *starting point* of our analyses, and the observation from which we *begin*, rather than the conclusion to which we are still driving? This is because it is easy now to *see* orientalism. But it is difficult to engage with the fraught and complex matter of viewing positions and cultural relations that the incidence of biases, prejudices, simplifications, conflations, and so on attests to. As Chow puts it, the complexity of the relationship between natives and foreign observers is very old and of great complexity, and that complexity is increased by the complexity of the *entanglement* of the relationship. As she asserts both in "The Dream of a Butterfly" and "China as Documentary," East and West are both distinct *and* entangled, both in relationships and not in relationships. East is not simply East and West is not simply West: the twain do meet, and very often. Yet, in another sense, East is East and West is West and never the twain *fully*—or *simply*—meet. Or, as Chow puts it both in "The Dream of a Butterfly" and in "China as Documentary," perhaps the situation is akin to that described by Lacan of sexual relationships: that *there is no sexual relationship*. But, of course, there *are* sexual relationships. Perhaps, therefore, natives and foreign observers are thrown together and col-

laborate as if there were a relationship, when perhaps the nature of any possible relationship has never been and has yet to be established. In Derridean parlance, one might say that the relationship is permanently deferred. But in the Lacanian terms to which Chow frequently returns, the problem is couched as one of two different sets of fantasies (or phantasies) held by different parties, which never simply "meet." The phantasy about the other which, for example, sustains a sexual attraction or indeed a sexual relationship is always strictly speaking an onanistic phantasy and a projection. The other is as much "invented" and "projected" by the one as it is "performed" or "embodied" by the other.

Using this Lacanian insight as a point of reference, Chow has more than once constructed the "problem" or the "situation" of the East-West (ir)relation as a fantasy or phantasmatic relationship structuring relationships and encounters between China and the West. To Chow it is typical or exemplary of the long history of the relations between "the West" and "the Rest."

In this context, Chow argues that the gap between the visions and interpretations of "native informants" and "foreign observers" is amplified in the documentary form, despite its claims to factuality. And this raises the question, how are we to talk cross-culturally about seemingly straightforward images when often even the simplest of images become the most contentious. To illustrate this, Chow looks at a contentious documentary, made about China at a time when China was closed to the West, Michelangelo Antonioni's 1972 film *Chung Guo/Cina/China*. However, for the sake of this chapter, I would prefer to follow the implications and injunctions of Chow's orientation in order to explore, examine and assess a different filmic text in terms of Chow's arguments about cultural translation.

The film I have selected is one of Bruce Lee's early 1970s *kung fu* blockbusters. I have selected it deliberately—because Bruce Lee has always been construed as a figure who existed at various crossroads—a kind of chiasmatic figure, into which much was condensed, and displaced. His films, even though in a sense always being relatively juvenile action flicks, have also been regarded as spanning the borders and bridging the gaps between "trivial" popular culture and "politicized" cultural movements (Brown 1997; Morris 2001; Prashad 2001; Kato 2007). That is to say, although on the one hand, they are all little more than fantastic choreographies of aestheticized masculinist violence, on the other, they worked to produce politicized identifications and modes of subjectivization that supplemented many popular-cultural-political movements: his striking(ly) nonwhite face and unquestionable physical supremacy in the face of often white, always colonialist and imperialist bad-guys became a sym-

bol of and for multiple ethnic, diasporic, civil rights, anti-racist and postcolo-
nial cultural movements across the globe (Prashad 2001; Kato 2007). Both
within and "around" his films—that is, both in terms of their internal textual
features and in terms of the "effects" of his texts on certain viewing constitu-
encies—it is possible to trace a movement from ethnonationalism to a postna-
tional, decolonizing, multicultural imaginary (Hunt 2003). This is why his
films have been considered in terms of the interfaces and interplays of popular
culture, postcolonial, postmodern and multiculturalist issues that they have
been deemed to "reflect," engage, dramatize, explore or develop (Abbas 1997;
Hunt 2003; Teo 2008). Lee has been credited with transforming intra- and in-
ter-ethnic identification, cultural capital and cultural fantasies in global popu-
lar culture, and in particular as having been central to revising the discursive
constitutions and hierarchies of Eastern and Western models of masculinity
(Thomas 1994; Chan 2000; Miller 2000; Hunt 2003; Preston 2007; Bowman
2010).

In the wake of such well-known and well-worn approaches to Lee, I would
propose to take these types of arguments as read, and prefer to approach Bruce
Lee somewhat differently—maybe peculiarly, perhaps even queerly. Specifically,
I would like to propose that Bruce Lee's celluloid cinematic interventions—no
matter how fantastic and fabulous—ought to be approached as texts and con-
texts of *cultural translation* (Chow 1995). However, to say this, Chow's rather
twisted or indeed "queer" notion of translation needs to be emphasized. For,
as we have seen, to speak of *cultural* translation is not to simply refer to *transla-
tion* in a linguistic or hermeneutic sense. It is rather to be understood as some-
thing less "literal" (or logocentric); as what Rey Chow calls "an activity, a
transportation between two 'media,' two kinds of already-mediated data"
(Chow 1995: 193). Furthermore, cultural translation would also be under-
stood as a range of processes which mean that, for academics, "the 'translation'
is often what we must work with because, for one reason or another, the "orig-
inal" as such is unavailable—lost, cryptic, already heavily mediated, already
heavily translated" (193).

This is not a particularly unusual situation, as we have mentioned. It is, ra-
ther, says Chow, everyday: translated, mediated, commodified, technologized
exchanges between cultures happen every day. This is also the situation we are
in when encountering film, especially films that are dubbed or subtitled, of
course, as in the case of Bruce Lee's Hong Kong produced films. Such films
are translated, dubbed and subtitled. But, this is not the start or end of trans-
lation. For the notion of "cultural translation" demands that we extend our
attention beyond the scripts and into the matter of the very medium of film

itself, the relations between films, between film and other media, and so on. This is important to emphasize because, despite its everydayness, despite its reality, and despite the arguable primacy of the situation of cultural translation between "translations" with no (access to any) original, this situation of cultural translation is not often accorded the status it could be said to deserve. It is rather more likely to be disparaged by scholars, insofar as it occurs predominantly in the so-called "realms" of popular culture and does not conform to a model of translation organized by the binary of "primary/original" and "derived/copy" (Chow 1995: 182).

As Chow emphasizes, "the problems of cross-cultural exchange—especially in regard to the commodified, technologized image—in the postcolonial, postmodern age" (182) demand an approach that moves beyond many traditional approaches. For instance, she points out, as well as the "literal" matters of translation that arise within film, "there are at least two [other] types of translation at work in cinema" (182). The first involves translation understood "as inscription": any film is a kind of *writing into existence* of something which was not there as such or in anything like that way before its constitution in film. The second type of translation associated with film, proposes Chow, involves understanding translation "as transformation of tradition and change between media" (182). In this second sense, film is translation insofar as a putative entity (she suggests, "a generation, a nation, [or] a culture") are "translated or permuted into the medium of film." So, film as such can be regarded as a kind of epochal translation, in the sense that cultures "oriented around the written text" were and continue to be "in the process of transition and of being translated into one dominated by the image" (182). As such:

> the translation between cultures is never West translating East or East translating West in terms of verbal languages alone but rather a process that encompasses an entire range of activities, including the change from tradition to modernity, from literature to visuality, from elite scholastic culture to mass culture, from the native to the foreign and back, and so forth. (192)

It is here that Bruce Lee should be placed. However, given the complexity of this "place"—this relation or these relations—it seems likely that any translation or indeed any knowledge we hope might be attained cannot henceforth be understood as simple unity-to-unity transport. This is not least because the relations and connections between Bruce Lee and—well—*anything* else, will now come to seem always shifting, immanent, virtual, open-ended, ongoing and uncertain. This is so much so that the very notions of completeness, totality, or completion are what become unclear or incomplete in the wake of "cultural translation." In other words, this realization of the complexity of cultural rela-

tions, articulations and encounters jeopardizes traditional, established notions of translation and knowledge-establishment. Yet, it does not "reject" them or "retreat" from them. Rather, it transforms them.[1]

To elucidate this transformation, Chow retraces Foucault's analyses and argument in *The Order of Things* (1970) in order to argue that both translation and knowledge per se must henceforth be understood as "a matter of tracking the broken lines, shapes, and patterns that may have become occluded, gone underground, or taken flight" (Chow 2006: 81).[2] Referring to Foucault's genealogical work on the history of knowledge *epistemes* in *The Order of Things*, Chow notes his contention that "the premodern ways of knowledge production, with their key mechanism of cumulative (and inexhaustible) inclusion, came to an end in modern times." The consequence of this has been that "the spatial logic of the grid" has given way "to an archaeological network wherein the once assumed clear continuities (and unities) among differentiated knowledge items are displaced onto fissures, mutations, and subterranean genealogies, the totality of which can never again be mapped out in taxonomic certitude and coherence" (81). As such, any "comparison" must henceforth become "an act that, because it is inseparable from history, would have to remain speculative rather than conclusive, and ready to subject itself periodically to revamped semiotic relations." This is so because "the violent yoking together of disparate things has become inevitable in modern and postmodern times." As such, even an act of "comparison would also be an unfinalizable event because its meanings have to be repeatedly negotiated." This situation arises "not merely on the basis of the constantly increasing quantity of materials involved but more importantly on the basis of the partialities, anachronisms, and disappearances that have been inscribed over time on such materials" seemingly positivistic existences" (81).

We covered this to some degree in the previous chapter, but now is the time to apply it to our own analyses. Now is the time also to relate this to a perhaps unexpected problematic: that of the queer. To call this "queer" may seem to be stretching—or twisting, contorting—things a bit—or indeed, violently yoking unrelated things together. Clearly, such a notion of translation can only be said to be queer when "queer" is understood in an etymological or associative sense, rather than a sexual one. Nevertheless, it strikes me that the most important impulse of queer studies was its initial and initializing ethicopolitical investment in stretching, twisting and contorting—with the aim of transforming—contingent, biased and partial societal and cultural norms.[3] This is an element of queering that deserves to be reiterated, perhaps over and above queer studies' always-possibly socially "conservative" investment in sexu-

ality as such (Chambers and O'Rourke 2009). This is so *if* queering has an interest in transforming a terrain or a context rather than just establishing a local, individual enclave for new norms to be laid down. I believe that it does, which is one of the reasons that it seems worthwhile to draw a relation between cultural translation and queering, given their shared investments in "crossing over," change, twisting, turning and warping. Given the undisputed and ongoing importance of Bruce Lee within or across the circuits of global popular culture, crossing from East to West and back again, as well as from film to fantasy to physicality, and other such shifting circuits, it seems worthwhile to consider the status of "crossing over" in (and around) Bruce Lee films.

To bring such a complicated theoretical apparatus to bear on Bruce Lee films may seem excessive. This will be especially so because, as Kwai Cheung Lo argues, most dubbed and subtitled martial arts films from Hong Kong, China or Japan have traditionally been approached not with cultural theories to hand but rather with buckets of popcorn and crates of beer, as they have overwhelmingly been treated as a source of cheap laughs for Westerners (Lo 2005: 48-54). Indeed, as Leon Hunt has noted, what is "loved" in the "Asiaphilia" of kung fu film fans is mainly "mindlessness"—the mindless violence of martial arts. Like Lo, Hunt suggests that therefore even the Asiaphilia of Westerners interested in Eastern martial arts "subtly" amounts to yet another kind of orientalist "encounter marked by conquest and appropriation" (Hunt 2003: 12).

Lo's argument has an extra dimension, however, in that as well as focusing on the reception of these filmic texts in different linguistic and cultural contexts, he also draws attention to the realm of production. Yet even this, in Lo's terms, is far from theoretically complex: in Hong Kong film, he writes, "the process of subtitling often draws attention to itself, if only because of its tendency toward incompetence" (Lo 2005: 48). Nevertheless, he suggests, "as a specific form of making sense of things in cross-cultural and cross-linguistic encounters, subtitling reveals realities of cultural domination and subordination and serves as a site of ideological dissemination and its subversion" (46).[4] For Lo, then, despite a base level of material "simplicity" here, complex issues of translation do arise, and not simply with the Western reception of Eastern texts, but actually at the site of production itself, no matter how slapdash. As he sees it: "Unlike film industries that put a great deal of care into subtitles, Hong Kong cinema is famous for its slipshod English subtitling. The subtitlers of Hong Kong films, who are typically not well educated, are paid poorly and must translate an entire film in two or three days" (53).

At the point of reception or consumption, Lo claims, the "English subtitles in Hong Kong film often appear excessive and intrusive to the Western viewer." Drawing on a broad range of Žižeko-Lacanian cultural theory, Lo suggests that the subtitles are "stains" and that: "Just as stains on the screen affect the visual experience, subtitles undermine the primacy and immediacy of the voice and alienate the aural from the visual" (49). In this way, by using one of Žižek's favorite double-entendres—the crypto-smutty, connotatively "dirty" word "stain" (a word which, for Žižek, often signals the presence or workings of "the real" itself)—and by combining it with a broadly Derridean observation about the interruption of the self-presence of auto-affection in the frustration of cinematic identification caused by non-synchronized image-and-voice and image-and-written-word, Lo crafts an argument that is all about *excess*.

The subtitles are excess. Their meaning is excess: an excess of *sameness* for bilingual viewers, and an excess of *alterity* for monolingual viewers. For the bilingual, who both hear and read the words, they produce both excessive emphases and certain discordances of meaning, because of their spatial and temporal discordances and syncopations with the soundtrack. But, Lo claims, "To a presumptuous Western audience, the poor English subtitles make Hong Kong films more 'Chinese' by underscoring the linguistic difference" (51). Thus, for bilingual viewerships (such as many Hong Kong Chinese, who have historically been able to speak both English and Cantonese), the subtitles introduce an excess that simultaneously introduces alterity through their fracturing and alienating effects. For monolingual "foreign" viewerships, Lo argues, the subtitles also produce an "extra" dimension: a very particular, form of pleasure and enjoyment. This extra is not extra to a primary or proper. It is rather an excess generated from a lack. It is an excess—pleasure, amusement, finding the subtitles "funny." And Lo's primary contention is that, in this sense, the subtitles actually preclude the possibility of a proper "weight" or "gravity" for the films; that they are a supplement that preclude the establishment of a proper status, a proper meaning, a properly "non-excessive" non-"lite"/trite status.

Thus, the subtitles are a visual excess, Lo contends.[5] For monolingual or eurolingual viewers, the visual excess is the mark (or stain) which signifies a semantic lack. This might be a mark of viewers' own inability and lack of linguistic and cultural knowledge rather than any necessary semantic deficiency in the text itself; but the point is, argues Lo, "the words onscreen always consciously remind viewers of the other's existence" (48). In either case, this very lack generates an excess. As Lo puts it, "The fractured subtitles may puzzle the viewers who need them, and yet they also give rise to a peculiar kind of pleas-

ure" (54). That is, "The articulation of the loss of proper meaning offers a pleasure of its own to those who treasure alternative aesthetics and practice a radical connoisseurship that views mass culture's vulgarity as the equal of avant-garde high art" (54). Lo calls this the pleasure of "being adrift": "Drifting pleasure occurs when definite meaning can no longer be grasped. Bad English subtitles may kindle a kind of pleasure that was never meant to be there" (54), he proposes; going on to insist that:

> A subtitled Hong Kong film received in the West produces a residual irrationality that fascinates its hardcore fans. Apparently, a dubbed Hong Kong film would not offer the same sort of additional fun. The distorted meaning of the English subtitles is not to be overlooked. On the contrary, the distortion is written into the very essence of Hong Kong films and is one of the major appeals for Western fans. It is an unexpected boon that increases the viewer's already considerable enjoyment. (56)

Thus, he argues against the suggestions of commentators like Ascheid who have proposed that subtitled film fundamentally "contains a number of reflexive elements which hold a much larger potential to break cinematic identification, the suspension of disbelief and a continuous experience of unruptured pleasure" (Ascheid, quoted in Lo 2005: 56).[6] Against such arguments, Lo proposes that "In the case of subtitled Hong Kong films, these arguments are no longer valid." This is because, with these martial arts films, the "disruption of cinematic identification and the perception of difference might generate extra enjoyment but never a loss of pleasure." For, in martial arts films, suggests Lo, "rupture does not necessarily give rise to 'intellectual evaluation and analysis'; rather, it lends to a film's fetishistic appeal" (56).

So, the subtitles are constructed with "incompetence" by the undereducated and underpaid subtitlers. They are destined to be an *unnecessary* supplement for Chinese speakers and an *excessive* supplement for those who can also read Chinese. For Westerners, these supplements are destined to work to turn the movies into a joke. Indeed, apart from the thrills to be gained from watching the physical action of the martial choreography, the subtitles are destined to become the fetish which defines the nature of Western viewers' interest in Hong Kong films.[7]

Fun, off-center, camp, incompetent, uneducated, excessive, physical, intrusive: the way Lo constructs and represents Hong Kong cinema "in general" is not particularly far removed from the way that the Hollywood camera constructs the bumbling, bothersome Mr. Yunioshi in *Breakfast at Tiffany's* (see Morris 2001). Of course, Lo is putatively dealing with the "reception" and "interpretation" of Hong Kong films by *Western* viewers. Thus, according to Lo, it is the Western viewers, in their ignorance, who construct the dubbed Hong

Kong films as low-brow, "down-market amusements." But the likelihood or generality of such a reception is overdetermined by the conspiring factors of under-educated subtitlers who are, moreover, overworked and underpaid by an industry in a hurry to shift its product. Thus, even if the Hong Kong films *are* sophisticated, complex texts, this dimension is going to be forever foreclosed to the monolingual or eurolingual Western viewer. What is lost in the double translation from living speech to incompetent writing is *logos*. What remains is the nonsense of the body and gibberish, unintelligible baby-talk. As such, the only people could possibly be interested in such a spectacle, are, of course, *stupid people*.

Lo does not say this explicitly. But everything in his argument suggests the operation of a very familiar logic: the denigration of popular culture; the conviction that it is *stupid*. In his own words, the badly subtitled film entails "the loss of proper meaning [which] offers a pleasure of its own to those who treasure alternative aesthetics and practice a radical connoisseurship that views mass culture's vulgarity as the equal of avant-garde high art" (Lo 2005: 54). Thus, to Lo, "mass culture" is characterized by "vulgarity" and is not the equal of "avant-garde high art." Popular culture is stupid.

Lo's attendant argument, that the clunky subtitles are not really an "obstacle" to the smooth global circulation of commodities, but rather the condition of possibility for the success of the martial arts films, is similar. As he claims: "globalization is facilitated by the "hindrance" or the "symbolic resistance" inherent in the clumsy English subtitles—which represent a certain cultural specificity or designate certain ethnic characteristics of the port city" (54). Thus, Lo imagines the appeal of such films to be entirely fetishistic and ultimately racist. For, in Lo's conceptualization, what Western audiences want is a foreignness to laugh at. As such, it is the films' very palpable foreignness which helps them to succeed. Indeed, he concludes, "the subtitles as good and pleasing otherness are actually founded on the exclusion of the political dimension usually immanent in the encounter of the cultural other" (58). This is a core dimension of Lo's argument: "Hong Kong cinema is basically perceived as a 'good other' to the American viewer insofar as it is analogous to the old Hollywood" (57). Thus, for Lo, the matter of subtitles in Hong Kong film ultimately amounts to a process of depoliticization. Yet is this in fact the case?

The Queerness of Cultural Translation

The 1972 international blockbuster *Fist of Fury* (also known as *Jīng Wǔ Mén* [精武門] in Chinese and *The Chinese Connection* in America) begins with a burial. The founder of the Jīng Wǔ martial arts school in the Shanghai International Settlement (1854-1943)—the much-mythologized historical figure, Huo Yuanjia—has died (1910). Before the very first scene, a narrator tells us that the events surrounding Master Huo's death have always been shrouded in mystery, and that the film we are about to watch offers "one possible version" ("the most popular version") of what *may* have happened. What happens—or what could have happened, according to this fable—is that Huo's favorite pupil, Chen Zhen, played by Bruce Lee, returns to the Jīng Wǔ School and refuses to accept that his master died of natural causes.

At the official funeral the next day, an entourage from a Japanese Bushido School arrives, late. They bear a gift, as was traditional. But the gift turns out to be an insult and a provocation: a framed inscription of the words "Sick Man of Asia" (東亞病夫/dōng yà bìng fū). Upon delivering this, the Japanese throw down a challenge, via their intermediary, the creepy, effeminate and decidedly queer translator called Wu (or, sometimes, Hu): if any Chinese martial artist can beat them, the Japanese martial artists will "eat these words."

So begins what has become regarded as a martial arts classic. The film is organised by Bruce Lee's Chen Zhen's ultimately suicidal quest for revenge against what turns out to have been not merely a Japanese martial arts challenge (Lee of course picks up the gauntlet thrown down by the Japanese—besting the entire Japanese school single-handedly the next day, in a fight scene that made martial arts choreographic history and is still clearly referenced in myriad fight scenes of all action genres to this day) but also a murderous piece of treachery: Lee subsequently discovers that his master was poisoned by two imposters who had been posing as Chinese cooks, but who were really Japanese spies. Again, their intermediary, their contact, the communicator of the orders, was the translator, Mr. Wu. Thus, what begins with a crass and irreverent ethnonationalist slur at a Chinese master's funeral turns out to be part of a concerted plot to destroy the entire Chinese institution. As *Fist of Fury* makes clear, the assassination and the plot to destroy Jīng Wǔ arose precisely because the Japanese were deeply concerned that the Chinese were *far* from being "*sick men,*" were actually too healthy, and could become too strong and pose too much of a potential challenge to Japanese power, if left to their own devices. However, as the film also makes clear, in this colonial situation, the odds have

been stacked against the Chinese from the outset—no matter what they decide to do, they will not be left alone or allowed to prosper.

The translator is the first point of contact between the two cultures. The first face-to-face conscious contact follows the earlier behind-the-back, underhand and unequal contact of spying and assassination. To the Chinese, Wu is consistently belligerent, disrespectful and abusive. To the Japanese he is an obsequious crawler. On first face-to-face contact, at the funeral, Wu taunts the mourners, telling them that they are weak, pathetic and no better than cowardly dogs—simply because they are Chinese. A senior Chinese student (played by James Tien Chun) is evidently confused: he approaches Wu and demands an answer to one question. In the dubbed English version the question is: "Look here! Now, just what is the point of this?" And the answer is given: "Just that the Chinese are a race of weaklings, no comparison to us Japanese." So, here, Wu is Japanese. However, in the English subtitled version, the question and answer are somewhat different. Here, the Chinese student says: "One question, are you Chinese?" To this, the answer is: "Yes, but even though we are of the same kind, our paths in life are vastly different." So here, Wu is Chinese.

This disjunction between the subtitled version and the dubbed version may seem only to raise some fairly mundane questions of translation: namely, which version is correct, which version is faithful to the original? If by "original," we mean the Cantonese audio track, then, in this instance at least, it is the subtitles which follow it most closely.[8] But, as my act of distinguishing the audio tracks from the visual material implies, it seems valid to suggest, precisely because it is possible to separate out these various elements, that it is the very notion of the *original* here that should be engaged. For, the film was "shot postsynch," with the soundtrack added to the film only after the entire film was shot (Lo 2005: 50). As such, the visual and the aural are already technically divergent, distinct textual combinations, even in the putative "original." So, if we wish to refer to it, the question must be: *which original?*

It is of more than anecdotal interest to note at this point that the actor who plays the translator here—Paul Wei Ping-Ao—provided the voice over not only for the Cantonese audio but also for the English audio. This means that the actor who *plays* the translator is also *actually* an active part of the translation of the text. It also means that *the translated version of this film is also another/different "original" version*; a secondary, supplementary original, playing the part of a translation. It equally means that, given the overlapping production and translation processes involved in the technical construction of *not* "*this film*" but rather "*these films*," the quest to establish and separate the original from the copy or the original from the translation becomes vertiginous.

Certain binaries are blurred because of this fractured bilinguality. These are the very binaries which fundamentally structure and hierarchize many approaches to translation: fidelity/infidelity, primary/secondary, original/copy, authentic/construction, etc.[9] Here, the fractured bilinguality is itself symptomatic of what we might call (following Benjamin) a Chinese "intention" in a text produced in *British* Hong Kong about *Japanese* coloniality. This is a multiply-colonized text about a colonial situation produced in a different colonial context. In it, the supposedly stable binaries of text and translation are substantially unsettled. Indeed, this is so much so, I think, that what we are able to see here is what Rey Chow calls a "materialist though elusive fact about translation"; namely, to use Walter Benjamin's proposition, that "translation is primarily a process of *putting together*." As Chow explains, for Benjamin, translation is a process which "demonstrates that the "original," too, is something that has been put together"—and she, following Benjamin, adds: "in its violence" (Chow 1995: 185). What part does "violence" play, here?

There are several obvious forms of violence in the putting together of both the English and the Cantonese versions. Obviously there is the well-worn theme of the ethnonationalist violence of the film's primary drama: Bruce Lee's fantastic, phantasmatic, suicidal, symbolic victory (even in death) over the Japanese oppressors. But there is also the more subtle "violence" or "forcing" involved in constraining the English dubbing to synching with the lip movements of a different-language dialogue. This is "violent" in its semiotic consequences. For instance, as we have already seen, it violently simplifies the complexity of the translator, Mr. Wu. In the dubbed version, he becomes *simply* Japanese and therefore *simply* other. And this signals or exemplifies a further dimension. The dubbed version seems consistently to drastically simplify the *situation* of the film. That is, it dislodges the visibility of the themes of the politics of coloniality that are central to the subtitled (and presumably also to the Cantonese) versions, and empties out the socio-political complexity of the film, transforming it into a rather childish tale of bullies and bullying: in the dubbed version, the Japanese simply bully the innocent and consistently confused Chinese, simply because they are bullies. More complex issues are often elided. This is nowhere more clear than in the difference between the question "nǐ shì Zhōng guó rén ma?" ("are you Chinese?") and the alternative question, "just what is the point of this?"

However, although "are you Chinese?" is *literally* faithful to the Cantonese, and although "what is the point of this?" is not, and is more simplistic, I do not want to discount, discard or disparage this literally inadequate translation. This is not least because the question "just what is the point of this?" is surely

one of the most challenging and important questions to which academics really ought to respond. It is also because the unfaithful translation is the one which perhaps most enables the film to be *transmissible*—that is, to *make sense* elsewhere, in the non-Chinese contexts of the film's own transnational diasporic dissemination. This is to recall Benjamin's proposal that a work's "transmissibility" actually arises "in opposition to its 'truth'" (Chow 1995: 199). This contention arises in Benjamin's discussion of Kafka, in which he asserts that: "Kafka's work presents a *sickness of tradition*" in which the "consistency of truth...has been lost." Thus, suggests Benjamin, Kafka "sacrificed truth for the sake of *clinging to its transmissibility*" (Benjamin quoted in Chow 1995: 199). Picking up on this, Chow adds Vattimo's Nietzschean proposal that this "sickness" is constitutive of transmissibility and is what enables and drives the "turning and twisting of tradition away from its metaphysical foundations, a movement that makes way for the hybrid cultures of contemporary society" (195).[10]

This issue of transmissibility might be taken to suggest one of two things: *either*, "just what is the point of this?" is the more primary or more "universal" question, because it is more transmissible; *or* this translation/transformation *loses* the essential stakes of the local specificity of the ethnonationalist question "Are you Chinese?"

Rather than adjudicating on the question of transmissibility *and* (or *versus*) truth in "direct" terms, it strikes me as more responsible to expose each of these questions to each other. Thus, in the face of the question "Are you Chinese?" we might ask: "Just what is the point of *this?*" and vice versa. In doing so, we ought to be able to perceive a certain ethnonationalist "violence" lurking in the construction of the former question. For instance, "Are you Chinese?" is *regularly* leveled—accusingly—at translated or globally successful "Chinese" films (as Chow often discusses). It is often asked aggressively, pejoratively, dismissively—as if simultaneously demanding fidelity and essence, *and* suggesting treachery.

The accusative question leveled at Hu the translator strongly implies that if Hu/Wu *is* Chinese, then he, in being a translator, is a traitor. Translator, traitor: "*Traduttore, traditore*," runs the Italian expression, as Rey Chow reminds us. But in *Fist of Fury* there is more. The translator is a pervertor: a pervertor of tradition, first of all. And also: a very queer character. The film draws a relation between the translator and queerness. It makes the translator queer. Because he crosses over.

In *Fist of Fury* the translator adopts Western sartorial norms and works for the powerful Japanese presence that exerts such a considerable force in the in-

ternational settlement in Shanghai. He enables communication between the Chinese and the Japanese institutions, and also sabotages one institution's development at a particularly fraught moment—the funeral, the moment of transition/translation/passing over from one generation to the next, from the stability of the founding master's presence and protection to the uncertain leadership of his multiple senior students. The translator in fact *precipitated* this unnatural crisis in the first place—installing spies and transmitting assassination orders. The translator is a pervertor. So, it is unsurprising that he has been constructed as certainly "queer" and probably gay.

In this largely erotically-neutered film, Mr. Hu's sexuality is unclear. All that is clear is that he is creepy and effeminate. But if we are in any doubt about his sexuality, this same character, played by the same actor, was to return in Lee's next film, *Way of the Dragon* (1972). *Way of the Dragon* is a film that Lee himself directed and in which he plays Tang Lung, a mainland/New Territories Hong Kong martial artist who flies to Rome to help his friend's niece when her restaurant business is threatened by a veritably multicultural, interracial "mafia" gang. The Chinese title of *Way of the Dragon* (*Měng Lóng Guò Jiāng* / 猛龍過江) is rendered literally as something like "the fierce dragon crosses the river," which refers to travel and migration, and hence to the diasporic Chinese crossing over to Europe.

In both *Fist of Fury* and *Way of the Dragon*, the same actor plays virtually the same character. However, in the European location of *Way of the Dragon*, we have crossed over from "traditional" China to "modern" Europe. So the translator becomes *blatantly* gay: wearing flamboyant clothing and behaving flirtatiously with Lee's character, Tang Lung (Chan 2000). In the later film, the translator is "queerness unleashed." But the point to be emphasized here is that the same reiterated rendering of the translator as creepy and queer is central to both films—in much the same way that Judas is central to the story of Jesus. If it weren't for him, none of this would be possible, but as a contact zone or agency of communication and movement, he is responsible for warping and perverting things. In both films, the translator enters at a moment or situation of crossing over, and signals the break, the end of stability, the severance from paternal protection, from tradition. "And yet," notes Chow, "the word *tradition* itself, linked in its roots to translation and betrayal, has to do with handing over. Tradition itself is nothing if it is not a transmission. How is tradition to be transmitted, to be passed on, if not through translation?" (1995: 183)

Chow's championing of such translation notwithstanding, the answer to her rhetorical question ("how is tradition to be transmitted, to be passed on, if

not through translation?") as (if) it is given by both films is *not* that "tradition ought to be transmitted through translation," but rather that "tradition *ought* to be transmitted through monolingualism and monoculturalism." The *problem*—and it is presented *as a problem* in the films—is that culture does not stay "mono." Its authorities *want* it to be; its institutions try to *make* it stay so; but it cannot. Even the most pure repetition is never *pure*, but is rather *impure*—a *reiteration* which differs and alters, introducing alterity, however slightly: re-*itera*, as Derrida alerted us. Basically, that is, one does not "need" an insidious translator to pervert things. The unstoppable flow of transnational popular cultural products, commodities and practices, mass media sounds and images, and filmic texts does the job of the pervertor quite well enough. And surely far more cross-cultural encounters, exchanges and transactions are enacted by way of mass commodities than by way of dry hermeneutic or linguistic translation.

Given this plague of contact zones, Chow argues: "cultural translation can no longer be thought of simply in linguistic terms, as the translation between Western and Eastern verbal languages alone" (196-7). Rather, she proposes, "cultural translation needs to be rethought as the co-temporal exchange and contention between different social groups deploying different sign systems that may not be synthesizable to one particular model of language or representation" (197). As such:

> Considerations of the translation of or between cultures...have to move beyond verbal and literary languages to include events of the media such as radio, film, television, video, pop music, and so forth, without writing such events off as mere examples of mass indoctrination. Conversely, the media, as the loci of cultural translation, can now be seen as what helps to weaken the (literary, philosophical, and epistemological) foundations of Western domination and what makes the encounter between cultures a fluid and open-ended experience. (197)

Once again, it strikes me as important to reiterate at this point that although the *encounters* of cultural translation *may* be fluid and open-ended, the *treatment* of such encounters by academics and cultural commentators is far from fluid and open-ended. On the contrary, such treatment seems rigid; overdetermined, even. Translatory encounters of or between cultures are, in fact, regularly treated by academics and cultural commentators in a manner akin to the way the translator is treated in these films: ridiculed, reviled, rejected and killed—but too late. Such films, whether putatively lowbrow like these or supposedly highbrow like those of Zhang Yimou or Ang Lee are often regarded with disdain: as not "real," not "true" or not "faithful" translations of that fantastic phantasmatic essentialized entity known as "China."[11] Such texts are regularly written off as trivial and trivializing, commodified, orientalist, un-

faithful, secondary, derived, warped, warping, and so on. But as the works of thinkers like Chow have proposed, such responses to migrant texts like these might be (essentialized as) *essentialist*. Nevertheless, asks Chow: "can we theorize translation between cultures without somehow valorizing some 'original'?" Moreover, "can we theorize translation between cultures in a manner that does not implicitly turn translation into an *interpretation* toward depth, toward 'profound meaning'?" (192)[12] Her answer urges us to rethink translation by way of mass commodities, whose "transmissibility" arguably arises "in opposition to ... 'truth'" (Chow 1995: 199) in the context of a *"sickness of tradition."* Recall that this "sickness" is actually constitutive of transmissibility, suggests Chow (Chow 1995: 195).

To this I would add: this sickness is queer. In constructing the translator as a traitor and *"therefore"* as queer, both of these films cling to tradition—a tradition that seems universal and seems to need no translating. If we ask of this tradition, "Are you Chinese?" the answer must be: yes, but no; yes and no.[13] And if we ask "Just what is the point of this?" one answer must be that it points to a queer relation—but a clear relation—between translation and queering. About which much could be said. The point I want to emphasize here is that the primary field of "translation between cultures," through their twisting, turning, concatenation, warping and "queering" is, of course, that supposed "realm" (which could perhaps be rather better understood as the condition) called mass or popular culture.

As we have seen, Chow's contention is that "There are multiple reasons why a consideration of mass culture is crucial to cultural translation." To her mind, "the predominant one" is to examine "that asymmetry of power relations between the 'first' and the 'third' worlds." However, she continues immediately, "Critiquing the great disparity between Europe and the rest of the world means not simply a deconstruction of Europe as origin or simply a restitution of the origin that is Europe's others but a thorough dismantling of *both* the notion of origin and the notion of alterity as we know them today" (193-4). In Bruce Lee films, of course—in a manner akin to the arguments of the critics who regard popular filmic representations as betrayals of "China"—the "origin" is avowedly not Europe, but "China"—the spectral, haunting, "absent presence," the evocation (or illusion-allusion) of "China."

From this perspective, there are two alterities: the "simple" alterity of the enemy, and the "double" alterity of the translator. In *Fist of Fury*, alterity seems unequivocal: an enemy (the colonizers—Japan in particular). When the Hong Kong films cross over to Europe, for *Way of the Dragon*, however, origin and alterity become more complicated.

In Lee's first martial arts film, *The Big Boss* (1971), he plays a migrant Chinese worker in Thailand—a country boy *cum* migrant proletarian whose enemy is a foreign capitalist/criminal. In *Fist of Fury*, when hiding from the authorities, Chen Zhen's peers emphasize that even though they can't find him he surely cannot be far away because he is a country boy who does not know Shanghai. In *Way of the Dragon*, in Italy, Lee's character rejoices in the fact that he comes not from *urban* Hong Kong Island but from the rural *mainland* New Territories. Dragged grudgingly on a tour of the sites of Rome, he is evidently rather under-whelmed. In the sole scene of *Fist of Fury* that was filmed outdoors, at the entrance to a segregated public park, Lee's character evidently *only* wants to go into the park because, being Chinese, he is not allowed—because China has been *provincialized*: a turban-wearing, English-speaking Indian official at the gate directs Lee's attention to a sign which says "No Chinese and Dogs Allowed."

In other words, all of the injustices in Lee's Hong Kong films are organized along ethnonationalist and class lines, and the notion of the origin in these films is the *idea* of mainland China. This idea in itself provincializes the various locations of each of the films. All of the places that are "not China" are just vaguely "somewhere else," and that elsewhere is "bad" (or at least not very good) because, wherever it is, it is "not China"—not the free, proud, strong, independent "imagined community" China "to come."

Of course, in sharing this tendency, these films construct a Chinese identity that is also based on actively celebrating or enjoying *being* what Chow calls "the West's 'primitive others'" (1995: 194).[14] To this extent these films may easily seem, in Chow's words, to be "equally caught up in the generalized atmosphere of unequal power distribution and [to be] actively (re)producing *within themselves* the structures of domination and hierarchy that are as typical of non-European cultural histories as they are of European imperialism" (194). Yet, at the same time, they are also and nevertheless (to use Dipesh Chakrabarty's term) actively involved in "provincializing Europe," albeit without any reciprocal (self-reflexive) problematization of "China" (see Chow 1995: 195).

However, it strikes me that such a problematization was palpably embryonic and growing in many of Lee's other works: in his TV roles, personal writings and interviews, Lee increasingly gestured to a postnationalist, liberal multiculturalist ideology; and it was perhaps "in the post" at the time of his death in the form of his declared intentions for his unfinished film *Game of Death*. But even in his "early" film, *Way of the Dragon*, even though it is certainly caught up in a degree of masochistic enjoyment of Chinese victimhood, the film ar-

guably enacts what Chow's proposed approach to film ("as ethnography") could construe as a significant discursive move. So it is with a brief–summary–consideration of this embryonic impulse that I would like to conclude this chapter.

The very first scenes of *Way of the Dragon* place Lee in the arrivals area of an airport in Rome. Lee is surrounded by white Westerners and is being stared at, implacably, unremittingly, and *inscrutably* by a middle-aged white woman. This lengthy, awkward and tense scene goes nowhere. The woman is eventually dragged away by a man who comes to meet her. It is followed immediately by an excruciatingly long scene in which Lee's character goes in search of food, around the airport. First he approaches a child and asks (in Chinese) "food?," "eat?" and then, pointing to his mouth, "eggs?" whereupon the camera changes to the child's point of view, showing a huge towering man looming over the child, pointing at his own mouth and making horrendous gurgling sounds. The child screams, and Lee's Tang Lung hurries away. He soon stumbles across a restaurant, which he enters. Unable to make sense of the (supposedly) Italian menu, he points confidently to more than half a dozen dishes—all of which turn out to be different kinds of Campbell's soup. So Lee is presented with a ludicrous dinner of multiple bowls of soup, which he brazenly pretends he knew he had ordered.

These slow, clumsy and somewhat bizarre scenes could easily strike viewers, especially white Western viewers, as a peculiar way to begin a martial arts film—a film, it should be noted, that very soon opens out into extreme violence, murder, mortal treachery, and even a gladiatorial fight to the death in the Roman Coliseum. Beginning such a film with these rather tortuous efforts at comedy seems to be a peculiar directorial decision.

However, there is something significant in the way that these opening scenes dramatize ethnic experience. The film shows us an ethnic "viewed object," of course. But it does so from a crucial point of view; one in which "'viewed object' is now looking at 'viewing subject' looking" (Chow 1995: 180-1). Thus, over 20 years before Chow proposed precisely such a twisting (or queering) of specular relations away from a simple subject-object dieresis as the way to escape the deadlock of Western anthropology, "simple" popular cultural artifacts like this film were already actively engaged in this deconstruction, in which Europe is not the viewing subject and Europe is not "the gaze," and in which—as *Way of the Dragon* seems to be at pains to make plain—Europe is *just some place* in an increasingly fluid globality.

Europe never becomes origin or destination in the film. In fact Italy itself never really becomes much more than an airport lounge—a zone of indetermi-

nacy, a contact zone; just some place or other, between origin-A and destina-tion-B, C, D, or X, Y, Z. Lee leaves Hong Kong to help a diasporic working community. He flies to Europe. The Europeans cannot defeat him. Frustrated, they arrange to fly in "America's best." America's best takes the form of "Colt," a martial artist played by Chuck Norris. Colt flies in. His arrival is filmed from a low angle. He walks down from a jet plane, and towards the camera. A drum beat marks his every powerful step. As he approaches, what is more and more foregrounded is his crotch. When he reaches the camera, it is his crotch that comes to fill the entire screen and close the scene. And so it continues: as has been much remarked, Colt is all crotch; Lee is all lithe, stri-ated torso. Their pre-fight warm-ups are more like foreplay; their fighting is more like love-making (Chan 2000; Hunt 2003). But the film plays the stand-ard semiotics of powerful masculinity; in other words, treading a fine line be-tween emphasizing heteronormativity and crossing over into outright homoeroticism. Hating the queer element is important in order to assert that this text itself is not of or for the queer; whilst all the time exemplifying the polymorphously perverse recombination, intermingling and reconstitution of cultures, provincializing and queering Europe.

Rey Chow's Alter-Native Conclusions

At a symposium in September 2012 focusing on the work of Rey Chow, an event organized by Patrizia Calefato at the University of Bari, I was asked two questions by my interlocutor, Floriana Bernardi. First, she asked me: in the context of all I have ever said and written about Rey Chow's early arguments that "China" is in more than one sense at the heart and at the foundations of cultural studies, did I think that there is or will be a "Chinese turn" in cultural studies. Second, given the use that I regularly make of Stuart Hall's essay "Cultural Studies and Its Theoretical Legacies" (1992) whenever I articulate my understanding of cultural studies, she asked me this: if cultural studies is conceived as a *political* project, as it is in Stuart Hall's account, what is the place, position or importance of Rey Chow's *academic* work?

These are both significant and challenging questions. Moreover, they are provocative and productive. Both of them look backwards and ask us to take stock of the present in its light, and yet—importantly—they ask about the present in terms of our orientation, asking about directions, hopes, intentions and aspirations. Accordingly, I would like to engage with Bernardi's questions as a way to conclude this present study.

Cultural Studies after China

However preposterous it may seem to some to put it like this, I would propose that the "question of China" in this context is simpler to answer than the question of Rey Chow's relation to a certain conception of cultural studies. It is simpler not because China is a simple matter. Of course it isn't—whatever referent the word "China" is deemed to designate (and it might refer to any number of "things"). Rather, the question of China and cultural studies is simpler because, in the context of its relation to cultural studies, I think that the status of "China"—whatever the term is taken to represent—has changed. As I have argued throughout this book, whether looked at historically, politi-

cally, economically, discursively or *textually* (whether in the terms of semiotics and signification or in the terms of deconstruction—that is, in terms of constitutive antagonisms (Laclau and Mouffe 1985), hauntings, specters, impossibilities, mourning (Derrida 1994), or otherwise), "China" is not the same thing now as it was in the mid-20th century, when cultural studies was forming. Through the 1960s, and peaking with the popularity of the Cultural Revolution at the time of uprisings and protests in France and Europe (as well as North America, and indeed much of the world more widely) in 1968, "China" was the very symbol of alterity and difference. As Rey Chow has demonstrated many times (in her readings of Julia Kristeva, Roland Barthes and Jacques Derrida, for instance), the poststructuralists, as much as the hippies and all involved in the countercultural movements in the West, were deeply interested in the enigmatic alterity of China. Both Barthes and Kristeva travelled in and wrote about China. The cover image of Spivak's translation of Derrida's *Of Grammatology* is a fragment of a Chinese character. And so on. This has all been covered and re-covered many times, not least by Chow herself, but also by a range of people responding to her provocative analyses in the pages of such journals as the *PMLA*, *Critical Inquiry*, and elsewhere (Meighoo 2008).

To reiterate: in relation to the formation of cultural studies, Chow's argument is essentially that both poststructuralism and cultural studies (not unlike various kinds of Marxism and countercultural movements at that time) always entailed critiques of the social order, critiques that either theorized, conjectured, or fantasized alternatives to the existing societies of Europe and America. Whilst in one sense, a clear alternative to "Westernization" could not be completely envisaged, in another sense the *most* "alternative" difference (in a world offering a range of alternatives to the existing state of affairs in Europe) was China. So ideas about "China" functioned in a range of ways to diversely "inform," organize and orientate European, American, and indeed even Chinese discourses—and doubtless others besides.

However, whilst the important (albeit always problematic) function of fantasies and fears about different sorts of alterity will always remain active and functional within discourses, China is no longer the best candidate to stand for the figure of alterity within Western discourses. Or, if it is, it is no longer the figure of the abject, impoverished, enigmatic and much-fetishized other that it once was. It is still perhaps equally representative of a kind of "specter haunting Europe," although it is now no longer synonymous with Marx's "specter of Communism." Rather, it is now more likely to be the specter of a militarized, undemocratic and economically growing world superpower. So, in a sense, for many Western discourses, China now occupies a discursive posi-

tion closer to that which was once occupied by the Soviet Union. Close, but not quite. For things are very different...

But this is not a book about geopolitics, or the vast tectonic movements of modern history. My point is simply this: that China is not the same thing, nor does it signify the same things, nor in the same discourses. The discursive status of "China" has changed in any number of discourses—economic, historical, ideological, even popular cultural. As Chow herself observed in the run up to and the immediate aftermath of the handover of control of Hong Kong from the UK to China in 1997, the discursive status of China had long been shifting in Hong Kong popular culture, in the years preceding 1997 (Chow 1998b). Hong Kongers—for so long "between colonizers" (Chow 1993)—could no longer easily sustain the long-running discourse of "China as longed-for motherland," when the reality of the impending handover to the often-repressive and vociferously anti-capitalist nation was rapidly approaching. Since 1997, the cultural relations between Hong Kongers and mainlanders have if anything only gotten worse, with the millions of mainlander tourists in Hong Kong sometimes being represented in Hong Kong contexts as *locusts*, and with a reciprocal cultural chauvinism on the part of some Chinese commentators, calling Hong Kongers lapdogs of Britain and of capitalism, and so on.

At the same time, cultural studies is not the same thing as once it was. If it ever was "one" thing, it too has changed. It is certainly now a widely institutionalized and intellectually established disciplinary space and field or set of fields of contestation, with shared points of reference and shared problematics (with its work organized by issues of race, class, gender, and other identity issues, along with technology, disability, media, communication, translation, migration, legislation, environment, emotion, and so on and so forth). Indeed, *so* well established is cultural studies, that it is possible to argue that its status as a "project" in Stuart Hall's 1992 sense is now perhaps fully elaborated, if not exhausted. As has been argued more than once, perhaps the things deemed to signal the success and the things deemed to signal the failure of cultural studies as a project are two sides of the same coin. As John Mowitt once argued, perhaps it is the case that cultural studies has been the victim of its own paradigm—its own institutional success amounts to its own undoing (Mowitt 2003). For, if cultural studies has taken off to such an extent that everyone in the arts, humanities and social sciences can be said to be "doing" race, gender, ethnicity, class, identity, disability, technology and other such "studies" (organised by a focus on their "politics"), then who needs to be doing cultural studies in order to do such things (Bowman 2008)?

But, despite this talk of "everyone," such a view is perhaps very Eurocentric. This "everyone" and "everywhere" view is surely rather parochial. For instance, with the dissemination of cultural studies, there has been the emergence of such different innovations as the Inter-Asia Cultural Studies Society (as spearheaded in the work and collaborative projects of Kuan-Hsing Chen since the mid-1990s, at least), a society with a very different "project" to that of 1960s and 1970s British cultural studies, which itself was evidently somewhat different to that of 1970s and 1980s US cultural studies, or Canadian cultural studies, or Australian cultural studies (given the different demographics and socio-political situations and problems in each of these and other contexts), or the emergence of cultural studies in Italy and other countries; and different even to the very recent emergence of "cultural studies" as a named entity in such august French institutions as The Sorbonne in Paris. This is so even though Paris is really not very far from London. All of this is as much as to say: even a "Eurocentric" view easily occludes differences between European countries and contexts. Europe (and Eurocentrism) should not be flattened and homogenized: it has its own internal differences and "internal frontiers" (Arditi 2007).

Hopefully, such a response to Floriana Bernardi's important enquiry might recast the question of whether there is a "Chinese turn" in cultural studies in such a way as to *provincialize* Anglo-American cultural studies without "throwing out the baby with the bathwater." Certainly, Anglo-American cultural studies must now engage more and more with the empirical geopolitical facticity—the multiple forces and presences—of China, rather than fantasizing around a more or less content-free or content-lite idea of China, using the word "China" as a Laclauian "empty signifier," or as some kind of promissory messianic (or terrifying) future "to come." This is not to say that China will not henceforth continue to be demonized and fetishized by turns. It is simply to say that the status or statuses of China has changed within (or in relation to) something(s) called cultural studies—when "cultural studies" is *clearly* now plural and multiple.

So, given the inevitability of discursive change, what has become of the type of cultural studies that I persist in both evoking (or conjuring) and advocating? And then, what specifically is the value or virtue of Rey Chow's work in this regard? This is the "baby" that I would not want to see "thrown out with the bathwater" of relativizing, historicizing or contextualizing everything: even if the international institutional elaboration of cultural studies means that "cultural studies" cannot possibly have remained the same, still, there is an important dimension to the cultural studies with which I identify (Bowman

2007; 2008), and with which Floriana Bernardi requested I engage *vis-à-vis* the work of Rey Chow.

Rey Chow after Cultural Studies

In the exact words of her question, Bernardi put it like this: "What is Rey Chow's contribution to cultural studies as a 'political project' aimed at making some difference in the real world?" I would argue that this formulation is heavily reliant on the words of Stuart Hall (1992: 279). However, it also directs back at me my own frequent arguments about cultural studies—arguments that I have constructed from various readings of Hall's arguments in such texts as this famous 1992 essay—specifically, in terms of the contention that it has long seen itself as a "politicized" project whose primary objective has been "intervention" (Bowman 2007; 2008). How, asked Bernardi, does Chow's work relate to all of this?

To the extent that the words chosen in the formulation of the question were a conscious citation of some key elements of Stuart Hall's injunctions about cultural studies (elements that I have used and reused myself), it is worthwhile to turn, for the last time in this book, to the most salient passage in Hall, the passage from which Bernardi is more or less explicitly drawing here. This is a rich passage, in an essay of rich passages, and it is one that deserves (even demands) to be quoted in full—not least because a paraphrase or summary would surely take up at least as much and quite possibly more space, and would be highly unlikely to improve upon Hall's precise formulations. So permit me to quote at some length. Hall writes:

> The question is what happens when a field, which I've been trying to describe in a very punctuated, dispersed, and interrupted way, as constantly changing directions, and which is defined as a political project, tries to develop itself as some kind of coherent theoretical intervention? Or, to put the same question in reverse, what happens when an academic and theoretical enterprise tries to engage in pedagogies which enlist the active engagement of individuals and groups, tries to make a difference in the institutional world in which it is located? These are extremely difficult issues to resolve, because what is asked of us is to say "yes" and "no" at one and the same time. It asks us to assume that culture will always work through its textualities—and at the same time that textuality is never enough. But never enough of what? Never enough for what? That is an extremely difficult question to answer because, philosophically, it has always been impossible in the theoretical field of cultural studies—whether it is conceived either in terms of texts and contexts, of intertextuality, or of the historical formations in which cultural practices are lodged—to get anything like an adequate theoretical account of culture's relations and its effects. Nevertheless I want to insist

that until and unless cultural studies learns to live with this tension, a tension that all textual practices must assume—a tension which Said describes as the study of the text in its affiliations with "institutions, offices, agencies, classes, academies, corporations, groups, ideologically defined parties and professions, nations, races, and genders"—it will have renounced its "worldly" vocation. That is to say, unless and until one respects the necessary displacement of culture, and yet is always irritated by its failure to reconcile itself with other questions that matter, with other questions that cannot and can never be fully covered by critical textuality in its elaborations, cultural studies as a project, an intervention, remains incomplete. If you lose hold of the tension, you can do extremely fine intellectual work, but you will have lost intellectual practice as a politics. I offer this to you, not because that's what cultural studies ought to be, or because that's what the Centre [for Contemporary Cultural Studies at Birmingham University] managed to do well, but simply because I think that, overall, is what defines cultural studies as a project. Both in the British and the American context, cultural studies has drawn the attention itself, not just because of its sometimes dazzling internal theoretical development, but because it holds theoretical and political questions in an ever irresolvable but permanent tension. It constantly allows the one to irritate, bother, and disturb the other, without insisting on some final theoretical closure. (Hall 1992: 285)

Now, I would not propose that anyone should work through this passage as if it provided a "tick list" of things that one should "do" in order to "do" cultural studies "properly." Indeed—just as I tried in chapter one both use and to problematize the matter of how well Derridean deconstruction could be said to measure up to its own exacting terms and standards when elaborating itself—one might wonder how well *anyone*, including Stuart Hall, might score were such an audit carried out in terms of his own activities and achievements. But who would be the judge? And what would be the criteria? And so on. No. Rather than anything like this, I would prefer to point out a slight but crucial conceptual drift in Bernardi's question. This is a slight drift away from Stuart Hall's own terms and concepts, but it is a drift which opens up a space that demands clarification; which will allow us to perceive and to assess the difference between one perspective and another which looks like it but which is not the same.

Bernardi's question ultimately asks about Chow's intervention into the "real world." However, it should be noted that in Stuart Hall's essay, despite the noticeable frequency of words like "real," "world," "make," "difference," "vocation," "commitment," and so on, he never actually uses the expression "real world." The closest he comes to it is in his use of the term "institutional world." And this is an important distinction, which is eclipsed in Bernardi's paraphrase. Yet I would propose that precisely such a distinction—between the evocation of a "real world" and the evocation of an "institutional world"— needs to be maintained because, in itself, if makes a difference—both to

thought and to "action" (however that comes to be defined). This is because, if we introduce an understanding of culture and society as either "things" or "processes" that are effectively constituted in and through their "institutions," then this third term effectively deconstructs the implicit binary that all too easily arises whenever we evoke such entities as "academia" and "the real world" (or, alternatively—ultimately—indeed, "mere words" versus "real things"). If we understand both academia and very many other aspects of culture and society as "institutions," then we can construct an understanding of cultural and social practices and contexts that does not collapse *difference* into *opposition*, and opposition into hierarchy. In other words, if we introduce the important (third) term, "institution," we can see that academic work is not the opposite of real life. Academic work is not the opposite of politics—even if the energetic and polemical tone of Hall's essay may make it seem so. Indeed, it is true, academic work may often seem disarticulated or unconnected, cut off from anything else. But, as a practice within an institution in a complex network of institutions, academic work is not essentially or necessarily disconnected. It is just that the connections between things are often obscure, occluded, or perhaps even unpredictable and constitutively unknowable. As Hall has just argued, it has *always* been *impossible* to *know* cultural relations and effects.

Certainly, one of Hall's points here is that the politicized academic will most likely need to forge the connection to other sites and scenes in order to try to achieve some kind of intervention. The implication certainly seems to be that the cultural studies academic should not just write "about things," but should rather try to intervene into situations in order to try to alter things. Yet this is still not to say that "normal" academic work does not already have one or more type or route of connection with other social institutions. Roland Barthes gives what is surely one of the most striking illustrations of what this may mean when, in the short essay "Dominici, or the Triumph of Literature" (Barthes 1972: 43-6), he gives a shocking interpretation of how it could come to pass that a man could have been found guilty of murder on entirely circumstantial evidence: Barthes reads the transcripts of the court case in question and argues that a strong factor in the collective interpretation of the events on the part of the prosecution, the jury and the judge was determined by the way the prosecution constructed a narrative of events that exploited their shared *literary* education. In other words, in the absence of other information, those involved in the case fell back upon the interpretive (and value) frameworks provided by their "normal" literary education: the accused was represented according to the model of a certain literary *type* (incidentally, a kind of savage, barbarian *native*): a psychology was attributed to him accordingly; and a chain

of events was constructed that followed the structure of the dramatic literary fiction well known at the time. In other words, according to Barthes, a shared cultural education had a kind of decisive agency.

Among the many implications of this, one is that knowledge production itself *always* has a political charge, a political value and a political effect—even if that political consequence is nothing more nor less than aiding in the maintenance of values and states of affairs. (In Rancière's terms, such work could be said to be part of the *police*.) Therefore there is a strong case to be made for attending to the processes and procedures by which knowledge is constructed and elaborated, or in other words, with the modes of reading and writing as they are practiced in the university. For, the *way* knowledge is constructed is always contingent. And—crucially—no matter what the discipline—indeed, no matter what the realm, register or context—what *all* processes of knowledge production or knowledge establishment entail is a moment of *reading*, of *interpretation*.

At this point, it is vital to recall the ways that Jacques Derrida engaged with and interpreted the relationships between "interpretation" and "institution." (Indeed, the relationship between institution and interpretation has been regarded as so strong within poststructuralist thought that Sam Weber even wrote a book with the title *Institution and Interpretation* (Weber 1987).) In one of his reflections, Derrida points out:

> An institution—this is not merely a few walls or some outer structures surrounding, protecting, guaranteeing or restricting the freedom of our work; it is also and already the structure of our interpretation. If, then, it lays claim to any consequence, what is hastily called deconstruction *as such* is never a technical set of discursive procedures, still less a new hermeneutic method operating on archives or utterances in the shelter of a given and stable institution; it is also, and at the least, the taking of a position, in work itself, toward the politico-institutional structures that constitute and regulate our practice, our competences, and our performances. Precisely because deconstruction has never been concerned with the contents alone of meaning, it must not be separable from this politico-institutional problematic, and has to require a new questioning about responsibility, an inquiry that should no longer necessarily rely on codes inherited from politics or ethics. Which is why, though too political in the eyes of some, deconstruction can seem demobilizing in the eyes of those who recognize the political only with the help of prewar road signs. Deconstruction is limited neither to a methodological reform that would reassure the given organization, nor, inversely, to a parade of irresponsible or irresponsibilizing destruction, whose surest effect would be to leave everything as it is, consolidating the most immobile forces of the university. (Derrida 1992: 23)

In itself this deconstructs the idea that to be doing work that is political or consequential one needs to focus entirely on the "outside" (or "real") "world."

Indeed, to pick up Derrida's term here, such approaches arguably only recognize politics and the political when they are signaled by "road signs"—or when the "political" character of this or that thing is either agreed, telegraphed, announced, declared, or indeed shouted (as if from a soap box). Rather than this, Derrida proposes that there are real stakes and consequences attending *disciplinary* choices, *disciplinary* languages, paradigms and procedures. These decisions may only obviously appear to have ramifications for the institutional world of this or that academic field, in the first instance. But if the notion of an articulated and reticulated "institutional world" holds any water whatsoever, such "entirely academic" or "merely academic" decisions and orientations might be expected to have significant ramifications otherwise and elsewhere, however unclear, immanent and unforeseeable that may be.

In this light, hopefully both the immediate and the immanent or potential value of Rey Chow's close focus on (and sensitivity to) the matters of exactly *what* different disciplinary, theoretical and methodological paradigms enable us to *see*, to *think*, to *hear*, to *perceive*, to *countenance* or *comprehend*—let alone to *conclude*—should start to become clearer. To recall just a few examples: her exploration of the paradigm of area studies in the context of its emergence in the USA in the new world order after World War II, which enabled her to reveal its debt (and usefulness) to militarism; her reading of texts such as those of Fanon dealing with postcolonial community and "belonging," texts that elaborate themselves in terms of race (or color) but that Chow explores in terms of their treatment of gender so as to reveal the ways in which patriarchal thought seeks to police female agency; her exploration of the antagonisms defining the differences between different schools of feminism, each of which deems the other "less political" because of its different relation to language; her observation that diagnoses of orientalism in texts can lead to a kind of moralism that thereby misses salient matters of identity, desire, pleasure, and so on; or her deconstruction of very many things, including Derridean and de Manian deconstruction themselves, along with other forms of poststructuralism, often in their own terms and often in terms of their relationship with other critical and intellectual movements, such as cultural studies and postcolonialism, movements with which some poststructuralists might prefer to believe they are not in a relationship at all (and vice versa).

The point of carrying out such revelatory readings is neither that of point-scoring, pleasure or ridicule, nor is it for sport, nor is it merely a demonstration of academic dexterity. Rather, Chow's readings serve to reveal the ways that the insights of one paradigm or perspective imply blind spots or blindness to other issues—to use Paul de Man's terms. Or, put differently, they demon-

strate the ways that "regimes of visibility" (Foucault/Deleuze) or "partitions of the sensible" and perceptible (Rancière) always entail their own "internal frontiers."

By "internal frontiers" I mean to evoke Freud's oxymoronic term "foreign internal territory." As Benjamin Arditi appropriates the term, Freud used it to "describe the relation between the repressed and the ego" (Arditi 2007: 3). Arditi takes the impetus behind this idea into the sphere of political theory, in order to develop a concept of what he calls the "internal periphery." Internal peripheries are paradoxical "edges" that are "inside." As Arditi argues, with a focus on macro-politics, the "edges" of liberalism, indeed the "edges" of politics, in other words, are not to be thought of as residing at some distance, a long way away from a "center." On the contrary, argues Arditi, the "edge," the "limit," the "periphery," in this sense, is "a region where the distinction between inside and outside is a matter of dispute and cannot be thought outside a polemic. To speak of politics on the edges of liberalism is to speak of the internal periphery of liberalism" (Arditi 2007: 3-4).

This concept of the internal periphery, or of the internal foreign territory, helps to express the reasons why Chow's "position" is difficult to summarize. It is certainly not "one." However, it is consistent. As I have tried to demonstrate throughout this book, her work can be related to a number of politicized intellectual movements, impulses and fields, although without being comfortably reducible to any one in particular. Her work is clearly connected to the work of many others invested in exploring the ongoing histories and consequences of imperialism, colonialism and nationalism in terms of cultural value and the complexities of identity in relation to national and transnational power, in different ways. But Chow's writings typically explore these areas by *reading* the ways they are played out in literary and filmic texts in the "contexts"—or against the backdrop—of the flows of global popular culture, and they simultaneously interrogate the antagonisms which structure academic approaches, styles and positions themselves.

This is why, without laying out or ascribing to her some singular position—her work is always far too creative and unexpected for that—this perspective on her work should help us to tie up some loose ends, especially in terms of ideas of "position." This should also clarify why Chow's work is always essentially *comparative, juxtapositional*, or indeed—to use Rifkin's preferred terms—*anahistorical* and *parataxic*.

Of course, the expression I have just used—"to tie up loose ends"—carries the sense of tidying up, tying off and sealing—specifically, so as to prevent stitches from coming loose, coming out and unraveling. This is not exactly the

image I want to conjure up. Rather, what I want to do here is to make more explicit some more of the connections between Rey Chow's work and some of the wider debates from and into which her work feeds, or into which it should be regarded as being tied. As we have seen repeatedly throughout this study, Chow's work ties itself into other discourses and their texts in such a way as to *pull them out of shape* and to *reconfigure* them. Her work stitches itself into relations with other texts not in order to construct a clear or stable position for her own work, but rather to reconfigure the texture, biases and orientations of the fabric of the field(s) into which her work is an intervention.

A large part of the main movements to which much of Chow's work can be related are called—or have at certain times travelled under the names of—postcolonialism and poststructuralism. Postcolonialism, as we know, is a field defined by the examination of the legacies and effects of colonialism and globalization on specific cultures and societies; and, as we have seen, Rey Chow's work uses poststructuralist perspectives to offer us new ways to formulate and to look at the significance and effects of various types of identities, migrations, border crossings and the flows, exchanges and encounters of ideas, beliefs, practices and powers in a range of contexts. She rarely broaches any of this "directly," of course, but rather approaches social, cultural and academic problems, problematics and issues in terms of the quite subtle or subterranean (not always easily visible) power structures and processes at play within such phenomena as the orientations of academic disciplines through their critical responses to global films or works of literature. It is in this way that one can situate Rey Chow's subtle and complex work in relation to that of others who work on questions of the contexts and discourses of the ongoing histories and consequences of imperialism, colonialism and globalisation on the development and features of cultures.

This is clear right from the beginning and through all of the "leading questions" of Rey Chow's work, as elaborated most fully first of all in her 1993 book, *Writing Diaspora*. As we have seen, Chow's insights enable us to look again at many of the forces, processes and consequences of various types of cultural movement and mobility, which characterize the contemporary globalized world, and to see them anew, in often remarkably unexpected ways. Her work often obliges us to reconsider many of the significant effects of transnational, cross-border and cross-cultural importation, exportation, consumption and encounters. It is especially helpful in considering the effects of the global circulation of different cultures' products—or, indeed, the global circulation of different cultures as such, as takes place in many ways and by many means, including the production and circulation of texts like Hollywood, Hong Kong,

Japanese or any other nation's films, songs, music videos, television programs and popular cultural products and practices; the emergence of a global Chinese film industry, or the Chinese film designed for international markets; and other forms of face to face or mediated cultural encounter or crossover.

Of course, any emphasis on the "trans" and the "global" needs to be supplemented by a consideration of the "place" that the trans and the global so problematize. This is why Chow's work very often reflects on the continuing importance of ideas and images of *place*—specifically landscape and cityscape—as they function dynamically in culture. In Rey Chow's readings of filmic texts especially, the modern city, the postmodern city and the tropes of national landscapes are often prominent. Her readings elucidate some of the ways in which these images or repositories of imagery have and continue to function both culturally and politically, as markers of identity (or shared identification), for instance.

A closely related question is that of community. Community is often thought through figures of blood and soil, or kinship and place. But, Chow's work asks, in various ways: what does it mean to speak of community? Through what concepts, metaphors, figures and tropes do we conjure it up and deploy it, and for what reasons? To what ends? Chow reads cultural texts in terms of these questions in order to elucidate the different—and loaded—ways in which texts negotiate issues such as the complex demands of competing positions and voices—ethnic, class-based, gendered, and so on—in relation to ideas of community. Her work prompts us to think about interactions between or across communities and different academic and national approaches (cultural studies, area studies, international relations, etc.), as well as looking at the politics and ethics of "communities."

In the orbit of this discussion, one current concern in this context is the popular notion of cultural hybridity. This notion has had a lively existence: it has been proposed or entertained by a wide range of academics and cultural agencies. But what does cultural hybridity mean or entail? It has a range of implications, ramifications, possibilities and—as Chow has suggested—even impossibilities. Indeed, it has been theorized and also put into practice or circulation by activists and policies in different ways. Chow's readings of the notion of cultural hybridity always reveal the extent to which it attempts to stabilize an essential instability, one which often fractures and fragments around the problems of ethnicity. Ethnicity "itself," Chow reiterates, is a variable cultural marker, a political designation, a mode of stereotyping, ordering, hierarchizing and arranging contexts, discourses, institutions and struggles. It is not simply a matter of "identity politics" divorced from macro-social or mac-

ro-political contexts and processes. It is a key part of the ways in which culture and society are structured. So it is important to interrogate the ways in which different ethnicities become "fixed" in different contexts; with various ethnic "types" defined, for example, as studious, as model minority, as protesting or agitating, as motivated or lazy, etc., and to explore the social and cultural ramifications of these modes of inscription—modes of inscription that Chow often reveals to be unexpectedly tied to discourses of the nation.

Reiter(n)ation

Chow regularly reiterates the extent to which identity is inextricably ensnared within discourses of the nation. Often discourses of the nation are played out in condensed and displaced form as (or as if) they are not about the nation but are about some essential ethnicity. However, Chow's work frequently draws out the subtle ways in which discourses of nation and ethnicity are strongly interimplicated and intertwined.

Discourses of nation are complicated by the addition of the idea of Westernization. "Westernization," as Chow has argued at least since *Writing Diaspora* (1993) is a global idea, inasmuch as there is a kind of *trans*-national consensus that there is a *supra*-national force called Westernization that jeopardizes the integrity or "authenticity" of this or that nation. "Westernization" in this sense may therefore be a polite euphemism—a term of criticism that is perhaps conveniently imprecise, so as not to pin the blame for "Westernization" on one or another particular nation. Of course, the reasons for the success—the globality—of this particular term may relate less to the politeness of many commentators, as if they do not wish to offend by pointing an accusing finger at one particular nation (America—the USA—would have to be the most likely candidate as being the driving force of "Westernization" aka "Americanization"), and may relate more to the power that this very nation holds over critical discourse. In other words, the fact that Westernization is so widely called Westernization and not, say, Americanization, may attest to the power of American discourse to subtly deflect attention from itself as the referent. "Westernization" may be the preferred term of "American" (or "Americanized") academics and intellectuals, for obvious reasons.

On the other hand, "Westernization," like "Europeanization," may be in more widespread use than the perhaps older term "Americanization" simply because the powers and effects identified as "Westernization" seem to transcend and exceed one particular nation, and seem connected to wider national

or post-national constellations (to use Habermas' term) or groupings, such as the cultural and geopolitical amalgam that is "Europe" or even the loose linguistic, cultural, economic, political, migratory and military connections that could be termed "Euro-America."

In any case, the idea of "Westernization" both complicates and intensifies the often-overlooked place of *nation* in considerations of culture, ethnicity and identity. It complicates it because it displaces focus from specific nations, but it intensifies it because the concept (or the forces grouped and conceptualized as those) of Westernization is almost always deployed in relation to some particular nation that is in one way or another being challenged or modified by it.

In this sense, "Westernization" is a global idea. And as Rey Chow points out, one of its consequences is *nostalgia*. Specifically, this takes the form of a dreamlike idea of an essential—and essentially *lost*—cultural difference. In other words, one correlate of the globality of the *idea* of "Westernization" is the appearance of the idea of a lost "authenticity" to certain cultures. Chow calls this phenomenon "primitive passions," and argues that various forms of investment in "primitivism" emerge in times of cultural crisis and dislocation, in which the perceived loss of origins produces fantasies of origins, in which various things, like landscape and cityscape, etc., play a key role in the elaboration of the discourse (along with the animal, the savage, the primitive and the land).

According to Chow, this discourse of the primitive is to some degree a discourse about the *unthinkable*—about that which is both basic and universal, transparent and yet conceived as being outside time and language (Chow 1995: 22-3). As she puts it, the discourse of the primitive is about *a common place* and *a commonplace*. This is always invented retroactively. As such, the primitive is *phantasmagoric*. This is so even though it often characterizes not only popular cultural discourses such as film but also the history writing within a culture as well. This is precisely why Chow gives the example of Chinese "primitive passions": the sense of China and Chinese culture's primary-ness, in China—the affirmation of China as being the oldest culture—is what leads to a certain active and dynamic paradox in Chinese discourse. On the one hand, China is regarded, in Chinese discourse itself, as both a *victim* and as the *oldest empire*. As the self-professed oldest empire, possessing a sense of having been victimized for centuries, it is only a short step to the conclusion that its destiny is to become a great empire, once it frees itself from the shackles of its past. This, Chow suggests, is what leads to Chinese intellectuals' "obsession" with China (1995: 24; 1998b).

This "structure of feeling," she argues, finds its best expression in film. And elucidating and elaborating on this sort of observation accounts for a large part of Chow's film analyses. However, in the context of this discussion, the important point is to note the way in which Westernization and globalization seem to make "authenticity" evaporate. Nonetheless, asks Chow, what is authenticity? Her answer is that it is tied to an idea of the nation. Yet the nation is a complex geopolitical construct that neither happens "naturally" nor in isolation from the rest of the world. Indeed, in many respects, she points out, many "indigenous" or "native" ideas of authenticity are palpably connected to—informed by or even constructed by—such "Western" discourses as orientalism. Moreover, ideas of "national difference" are all too easily and frequently conflated with ideas of ethnic or racial difference and vice versa. So, although it may be dissymmetrical, "orientalism" is often a two-way street. The orientalism of the West is not simply one-sided. There is often active orientalism in Eastern nationalism.

In *Writing Diaspora* Chow cites the case of Japan. Japan has never simply existed outside of a relationship with the nations of the West. Therefore, she points out, any critique of *the West* from Japan logically requires a reciprocal critique of *Japan*. This is because ideas such as that of a "Japanese character" are all intimately bound up with nationalism and the history of a nation whose existence has never been independent of global geopolitics. Moreover, national and nationalistic discourses are not simply spontaneously occurring phenomena of the world, either. Chow repeatedly draws attention to the role that academics and intellectuals play in producing and circulating nationalist ideas.

In other words, academia is not innocent in the face of the production of nationalist and orientalist discourse. In fact, academic approaches are often organized by orientalist ideas, such as those based on propositions such as that culture x is essentially different from culture y. This is why Chow points out, time and again, in book after book, the extent to which academic approaches can be seen to construct and elaborate themselves in terms of "borders" that (re)iterate, (re)play, (re)produce and (re)confirm the geographical borders of what they take—or construct—as their objects. Historically, anthropology has been guilty of characterizing peoples in terms of nations and constructing "national characters," whilst at the same time Western anthropologists have refused to take their own cultural field into consideration when studying the other. Rather than repeating such a mode of production of academic discourse, Chow has always argued that instead of scholars formulating social, cultural and political matters as "internal" issues (an optic that is geographically determinist and culturally essentialist), academics and intellectuals should

always be attentive to the *shared* history of East and West in order to avoid needlessly reproducing ideas of essentialist differences.

So, Chow reminds us that "orientalism" is not a one-way street. Nor does it *necessarily* relate to a particular geographical location (such as the countries that Said focused on in his groundbreaking work). Orientalism is rather, says Chow, more like a *language*. Anyone can speak it. It is a relational term, concept, or field. One culture can refer to another in its terms, and can just as easily (reciprocally) construct its own self-perception through its frames. This is why Chow insists that orientalism applies to discourses of East Asia (and elsewhere) even though much of Asia was not literally colonized by the West. So, on the one hand, orientalism is an ideological phenomenon and discursive process associated with Western imperialism and colonialism. But on the other hand, China's dealings with the rest of the world, for example, have always been organized in terms of trying to construct itself as a nation that is as strong as—but different to—those of the West. So "orientalism" can be seen to be at work in this kind of nation-building invention and insistence of difference.

AlterNatives

Chow is not a critic of the nation state as such, nor of nationalism per se. Her studies are not organized as works of international relations or of macropolitics. Rather, her concerns lie with the products, circuits, relays, referral systems and feedback loops of transnational popular culture. It is in terms of such a shifting perspective that Chow keeps showing the ways in which the nation arises and returns, unexpectedly, often where you would least expect it.

For instance, for diasporic ethnic Chinese, "China" comes back in words—haunting words, emotional words, nostalgic words, or teleological, eschatological words. Because of phenomena such as this, in many respects it is with the power of words over people that Chow is most consistently concerned. For instance, *ethnic* Chinese subjects the world over are often interpellated as if they are *national* Chinese subjects—even when they may be second or third generation emigrants. Accordingly, the notion of "China" among Chinese diaspora is problematic. Primarily, it functions emotionally. In Chow's interpretation, it activates a myth of consanguinity that demands absolute submission even though it is empty. Indeed, she suggests that the idea of "Chineseness" lies at the root of a kind of violence, one that works by producing and exploiting the most deeply ingrained feelings of "bonding." However, this is a force that she insists diasporic intellectuals must collectively resist. As she expresses it

throughout *Writing Diaspora*, there is a need for "ethnic subjects" to *unlearn* submission to their ethnicity.

Unfortunately, things are not so simple. This is because of the way that ethnic difference is so often viewed and treated by this or that dominant culture. Chapter two explored some of the ways in which Chow provides insights into the micro-politics of ethnicity by way of the concept of "coercive mimeticism." That discussion and that concept do not cover all of her contributions. The idea of "coercive mimeticism" was elaborated by Chow in her 2002 book, *The Protestant Ethnic and the Spirit of Capitalism*. However, almost ten years before, Chow had already set out some important elements of this field of study, in *Writing Diaspora*. As we have seen reiterated throughout her works, Chow keeps returning the way that, all over culture and academia, we constantly re-encounter the peculiarity—actually, the inevitability—of someone finding the native to be *disappointingly inauthentic*.

What is it about this native and this encounter that is disappointing for certain people? In other words: for whom is the encounter disappointing? And why? What expectations were held that led to the disappointment? Chow's answer is this: disappointment occurs among those who are in some way under the sway of nativism or primitivism—or, in other words, perhaps, what a thinker like Jacques Rancière would term a certain type of "police logic" (Rancière 1999).

I mention Rancière's notion of "police logic" here because it complements Chow's thought. This is because one of Rancière's central arguments is that the vast majority of political and philosophical thinkers in European traditions have held what he calls a *geometrical* view of society—as if society is structured according to a hierarchy of place, position and rank, wherein certain types of subject are conceived of and treated as if they should be in certain types of place (and not others). As we have already seen, Chow's thought is relatively in accordance with Rancière's view; for instance, when she evokes Etienne Balibar's argument that the cultural pressure for ethnic subjects to know their genealogy is problematic at least inasmuch as it makes them "know their place" and thereby works to keep them in "their place" more effectively. In *Writing Diaspora*, one of Chow's examples is the way that certain assumptions about the other raise their head in the most unexpected ways—for example the assumption on the part of a member of a job interviewing panel at a US university that a "native" of Communist China ought to be faithful to her nation's official political ideology. This is a case of a migrant or diasporic ethnic Chinese person being conflated with and understood in terms of a nation—as if the identity of the one should necessarily be matched and mirrored in the

identity of the other. This is a kind of "police logic," in which coercive mimeticism is at play. It is a way of placing and positioning and hence limiting and interpellating.

Chow notes the way that even anthropologists have been under the spell of a police logic: she recalls the story of Lévi-Strauss being troubled by "natives" who are "out of place"—such as sitting in a university research library in a metropolitan city rather than being "out there," "in the field." Chow regards this as a regularly recurring desire to "archaize" the "ethnic specimen," which is on the one hand a valorizing of the native via the ideology we attribute to them, but a valorizing which by the same token constrains them to a category. The negative implication of such a view is that whenever a "native" or an "ethnic specimen" roams into other territory—whether literally or metaphorically—he or she will be regarded as something of a corrupt and impure ethnic.

In other words, argues Chow, the native is constructed in terms of an image; an image set up by, for instance, the form of a people's appearance on first encounter. For example, "newly" discovered tribes in the Amazon *remain* frozen in the moment of their first captured images, and the idea of them *remains* overwhelmingly tied to that image, as if it captures their essential *and timeless* truth. But Chow asks, *why*: why this strong and enduring tie between the native and timelessness?

> As an issue of postcoloniality, the problem of the native is also the problem of modernity and modernity's relation to endangered authenticities. The question to ask is not whether we can return the native to her authentic origin, but what our fascination with the native means in terms of the irreversibility of modernity. (Chow 1993: 36)

As we learn in her subsequent books, this discursive predicament or "plight" of the (phantasy category) native is a kind of symptomal effect of the trauma of modernity, a symptom that she thinks in terms of the emergence of "primitive passions." But things are still not so simple: as she notes in *Writing Diaspora*, natives are treated by Western academia as if they are either timeless or entirely historically specific. And both of these treatments are equally problematic:

> As we challenge a dominant discourse by "resurrecting" the victimized voice/self of the native with our readings—and such is the impulse behind many "new historical" accounts—we step, far too quickly, into the otherwise silent and invisible place of the native and turn ourselves into living agents/witnesses for her. This process, in which *we* become visible, also neutralizes the untranslatability of the native's experience and the history of that untranslatability. The hasty supply of original "contexts" and "specificities" easily becomes complicitous with the dominant discourse, which achieves he-

gemony precisely by its capacity to convert, recode, make transparent, and thus represent even those experiences that resist it with a stubborn opacity. (1993: 37-8)

In this dense passage, Chow seeks to draw attention to the tendency of scholars to *speak for* this or that "subaltern" or "other" identity. This remains at least as problematic as representing "them" as "all the same" (in other words, as a univocal and frozen *image*). She gives the case of one scholar's reading of a book of Western photographs of Algerian women—a reading in which the male scholar, Malek Alloula, seeks to address (or even redress) the historical wrong of the representation of these women as objects for a pornographic male gaze. However, the problem, as Chow sets it out, with this male academic who wishes to right this wrong of the representational abuse of the women, is that, on the one hand, he to some extent proceeds as if he sees himself as being in the women's/the victims' *position*, whilst on the other hand, he desires to take a certain kind of *revenge* over the white Westerners who did this. So, some of what Alloula denounces about the Western treatment of the Algerian women, he inevitably repeats: "The Algerian women are exhibited as objects not only by the French but also by Alloula's discourse" (39), notes Chow. Moreover, she adds, "the anti-imperialist charge of Alloula's discourse would have us believe that the French gaze at these women is pornographic while his is not" (39). In the end:

What emerges finally is not an identification between the critic and the images of the women, as he wishes, but an identification between the critic and the gaze of the colonialist-photographer *over the images of the women*, which become bearers of multiple exploitations. (Chow 1993: 40)

Chow reveals the politics of representation here to have more dimensions than a certain type of postcolonialist discourse might want to countenance. In this and other cases, Chow interrogates the postcolonialist engagement with this "gender issue" and finds multiple antagonisms and ambivalences. How different is Alloula's desire to be in control of these "objects" from that of the colonialists and imperialists that he is against? Chow suggests, it is not very different. It reflects a patriarchal impulse, and also a kind of aggression, which does not seem to be culture-specific at all. So here it is through a self-consciously gendered approach to reading (and to reading a matter that is ostensibly about gender as much as it is about colonialism) that Chow comes to be able to see this otherwise occluded or foreclosed dimension.

However, this still has not addressed the question of why modern, postmodern, colonial and postcolonial discourses and subjects still seem to be so fascinated with the image of the native. Chow's suggestion is that this fascina-

tion arises because–like some kind of "Midas touch"–the characteristics of modernity seem always to mean that whenever modern cultures encounter something *other*, something *alterior* or indeed *prior*, that encounter also effectively *destroys* that thing, at least in some sense. Hence the emergence of "primitive passions," and hence also the spread of a relation to the world which is at once fascinated if not obsessed with "history" and "natives," and which is at the same time sad, melancholic and nostalgic for the inexorable demise of former historical conditions, peoples, identities and situations. Many accounts of modernity, writes Chow, view the world *retrospectively*, and with sadness. Moreover, she continues:

> whenever the oppressed, the native, the subaltern, and so forth are used to represent the point of "authenticity" for our critical discourse, they become at the same time the place of myth-making and an escape from the impure nature of political realities. (1993: 44)

The myths of an idealized alterity that is desired but constantly (constitutively) out of reach–like a pot of gold at the end of a rainbow–are the inverted expression of a commodified, virtualized and mediatized modernity. Hence, she concludes:

> Our fascination with the native, the oppressed, the savage, and all such figures is therefore a desire to hold on to an unchanging certainty somewhere outside our own "fake" experience. It is a desire for being "non-duped"; which is a not-too-innocent desire to seize control. (53)

Yet, again, the desire for control is not something that should simply be attributed to certain groups but not others. It is not the case that the postmodern, media-saturated world produces an entirely unique fantasy structure, which fantasizes a state of control through the figure of the native. Arguably all forms of society hold ideas of an ideal community. One need not be an expert etymologist to sense that the very word *community* itself carries resonances of *commune, common, unity, united,* via a French-sounding "comme un" or "comme une" ("as one"), or "comme-unity": "as a unity," "united."

Unfortunately, however, Chow's readings–whether of cross-cultural desire and inter-cultural relationships, as in "The Dream of a Butterfly," or of the gender politics entailed by Frantz Fanon's post-colonial community-building politics–regularly reconfirm the constitutive impossibility of simple unicity, univocity, or oneness. In this respect, Chow's readings regularly reconfirm a primary "tenet" of Derridean deconstruction. For, although Derrida was always loath to make many ontological pronouncements (other than those about textuality), he did once–as if reluctantly–state the following: "If, in an absurd

hypothesis, there were one and only one deconstruction, a sole *thesis* of 'Deconstruction,' it would pose divisibility: différance as divisibility' (Derrida 1998: 33). Which is to say: things are not simple, things are not unified, not univocal, not unities. They can and will pull apart and unbind, because they are not essentially, necessarily or permanently bound. But, Derrida adds: "The possibility of unbinding is also, of course, the only condition of possibility for binding in general" (33).

Rey Chow's work focuses on the forces and logics at play in all kinds of bonds, in order to reveal the ways that they not only bind but can also blind. Communities of different sorts form and transform, through the establishment of common bonds, ways of reading, knowing, being, doing, relating, and so on. These bonds are never simple, univocal or transparent. They have "internal peripheries" and internal limits and limitations as much as external peripheries and limits. Chow's interventions are therefore best regarded as carefully focused demonstrations of the internal foreign territories attendant to—and silently or invisibly structuring—this or that implicit or explicit community (whether nationalist, ethnic, academic, critical, aesthetic or political). As I have argued throughout this work, it is in this way—among others—that her work always carries with it a double-demand, at one and the same time, of and for academic and intellectual rigor, on the one hand, and ethical and political responsibility, on the other—a double-edged demand of which more students and academics should be made aware and to which we should all be challenged to respond.

Notes

Chapter One

1 Slavoj Žižek provides a gloss on two key dimensions of a deconstructive strategy. On the one hand, argues Žižek, "power can reproduce itself only through some form of self-distance, by relying on the obscene disavowed rules and practices that are in conflict with its public norms." He calls this an "inherent transgression" (Butler, Laclau, and Žižek 2000: 218) and claims that any discourse, any institution or power edifice must inherently transgress its own central claims in order to "work." Examples abound of situations in which this could be said to be the case, from the arguments and claims of Western philosophy to those of the Catholic Church to the actions of Imperial powers past and present—and, in fact, across the board throughout any and every situation in which power shouts "Do as I say" and mutters to itself "not as I do." Accordingly, deconstructive reading amounts to the revelation of the inherent transgression of texts and the institutions founded upon or supplemented by them. The second moment in Žižek's account comes, as he puts it, with the possibility that "in so far as power relies on its 'inherent transgression,'" then—sometimes, at least—overidentifying with the explicit power discourse—ignoring this inherent obscene underside and simply taking the power discourse at its (public) word, acting as if it really means what it explicitly says (and promises)—can be the most effective way of disturbing its smooth functioning" (220).

2 Heidegger formulated the difference between Europe and East Asia, it deserves to be noted, in essentially linguistic terms, in the form of a declared fundamental untranslatability between Japanese and European languages, which for Heidegger signalled an essential uncrossable border and an absolute difference.

3 Robert J. C. Young problematizes this widely held assumption of Said's Foucauldian character. Young argues that Said's notion of discourse is somewhat different to Foucault's, in that for Said the West invents an oriental other as a kind of timeless fictional form, whereas for Foucault "discourse" is always the working over of material in institutional encounters. In any case, Young's book *Postcolonialism: An Historical Introduction* (2001) includes excellent introductions and analyses to the relations between key figures of poststructuralism and the fields of postcolonialism.

Chapter Three

1 See, for instance, Rey Chow, "The Postcolonial Difference: Lessons in Cultural Legitimation" (Chow 1998: 161–169).

2 Gayatri Spivak uses the term in her "Translator's Preface" to *Of Grammatology* (Derrida 1976: lxxxii). The meaning of this is discussed more fully below.

3 For example, Chow's "Brushes with the-Other-as-Face: Stereotyping and Cross-Ethnic Representation," in *The Protestant Ethnic and the Spirit of Capitalism* (2002), especially pp. 54–60.

4 But there are others. See for instance, Mowitt (1992) or Bowman (2007).

5 See for instance Chow's chapter "The Dream of a Butterfly" in *Ethics After Idealism* (Chow 1998: 74–97).

6 Chow quotes from Gilles Deleuze (1988: 52, 58, and 59). See *Sentimental Fabulations* (Chow 2007: 11).

7 For Jacques Rancière, the political moment is a certain "kind of speech situation"–which he calls one of "disagreement." It is "one in which one of the interlocutors at once understands and does not understand what the other is saying. Disagreement is not the conflict between one who says white and another who says black. It is the conflict between one who says white and another who also says white but does not understand the same thing by it." (Rancière 1999: x). See also Benjamin Arditi (2007: 115).

8 As Chow writes of the ethnic academic subject: "Her only viable option seems to be that of reproducing a specific version of herself–and her ethnicity–that has, somehow, already been endorsed and approved by the specialists of her culture" (Chow 2002: 117).

9 Yet, one might ask, what could be clearer to an academic or intellectual than the following act of "undeciding": "whatever choice I might make, I cannot say with good conscience that I have made a good choice or that I have assumed my responsibilities. Every time that I hear someone say that 'I have taken a decision,' or 'I have assumed my responsibilities,' I am suspicious because if there is responsibility or decision one cannot determine them as such or have certainty or good conscience with regard to them. If I conduct myself particularly well with regard to someone, I know that it is to the detriment of an other; of one nation to the detriment of another nation, of one family to the detriment of another family, of my friends to the detriment of other friends or none friends, etc." (Derrida 1996: 86).

Chapter Four

1 This paper is online both at the journal website, of course, and (open access) here: http://cardiff.academia.edu/PaulBowman/Papers/9926/Alterdisciplinarity

2 As Young explains: "The difficulty for literary theorists, when faced with a new 'technologico-Thatcherite' assault on the humanities, was that the terms by which their subject was established historically, and the only effective terms with which it could still be defended, were those of cultural conservatism and humanist belief in literature and

philosophy that 'literary theory' has, broadly speaking, been attacking since the 1970s. When theorists found themselves wanting to defend their discipline against successive government cuts they discovered that the only view with which they could vindicate themselves was the very one which, in intellectual terms, they wanted to attack. One might say that the problem was that the oppositional literary or theoretical mode was not the oppositional institutional one—a situation that in itself illustrates the limitations of oppositional politics. In short, for theorists the problem has been that in attacking humanism they have found themselves actually in consort with government policy. This has meant, effectively, that it has often been left to those on the right to defend the study of the humanities as such: symbolized, perhaps, when the University of Oxford, traditionally, as we have seen, the main object of utilitarian hostility, refused to award Margaret Thatcher the customary honorary degree given to British prime ministers" (Young 1992: 113).

3 The whole paper is online at the open access resource of academia.edu, here: http://goldsmiths.academia.edu/AdrianRifkin/Papers/323032/Inventing_Recollection

4 In this context, another noteworthy connection is, as Rifkin discusses, the fact that he has long had a close intellectual relationship with Jacques Rancière. This is noteworthy because, despite Rancière's lengthy and prestigious writing career in philosophy, ethics, theory and history, he is only now definitively coming to the forefront of theoretical debates within Anglophone academia. Given the recent widespread explosion of interest in the significance of the work of Jacques Rancière for a very wide range of disciplines, the extent to which Rifkin has for a very long time been influenced and orientated by the work of Rancière (albeit tangentially, much more in the manner of inspiration and mutual affiliation than anything like discipleship) ought to be acknowledged and deserves to be engaged. For if Rancière is a figure whose significance in the context of educational philosophy, theory and practice is still now continuing to emerge, internationally and cross-disciplinarily, then consideration of this case of one of the longest sustained Rancièrean relationships in Anglophone academia clearly has a unique currency. Given the extent to which Anglophone scholarship of many persuasions is currently trying to establish what a Rancièrean history, a Rancièrean cultural studies, a Rancièrean art history, a Rancièrean political theory, etc. will or should look like, therefore a consideration of what Rifkin's long-standing Rancièreanism, not just in art history but also in cultural studies, does look like, should also recast this problematic—moving it from the speculative and futural by demonstrating that it already has several long histories, of which Rifkin's is but one. Specifically, here, I hope to illustrate the actual and potential alterdisciplinarity inscribed in the convergence of Rancièrean insights and Rifkin's approach to research, to the archive, and to the autodidactics of that encounter and that relation.

5 Simon During (2011) has recently proposed that the new phenomenon of the borderless free flow of academic fashions—in which people working in all manner of nominally different fields all over the university and all over the world will all of a sudden start taking seriously the work of this or that theorist—indicates the extent to which academic disciplines are in fact post-disciplinary. "Disciplinary" knowledge is less and less bordered and bounded; scholars are less and less disciplinarily hidebound, less and less invested in their own putative fields.

6 Although, since drafting this sentence, an external examiner at an exam board for the BA in Journalism, Media and Cultural Studies on which I teach at Cardiff University raised a

range of "criticisms," among which was the fact that many modules did not demonstrably test or assess each and every one of the stated learning aims and outcomes on certain modules. And this was not the least of his criticisms and suggestions for "improvement." All of them amounted to suggestions for increasing panopticism, standardization, regularity, disciplining and policing within, across and between every module. ... Despite this, I have decided to let the sentence stand. The reader can decide whether my argument could or should perhaps have gone the other way instead.

Chapter Five

1 For a related discussion of the implications of this and of the discussion of Foucault in the paragraph which follows, see also Weber (1987: xii).

2 Similarly, Weber reminds us of Bachelard's reflections on the implications that contemporary science has for our understanding of knowledge: "All the basic notions can in a certain manner be doubled; they can be bordered by complementary notions. Henceforth, every intuition will proceed from a choice; there will thus be a kind of essential ambiguity at the basis of scientific description and the immediacy of the Cartesian notion of evidence will be perturbed" (Bachelard in Weber 1987: xii).

3 See Chambers and O'Rourke (2009: 2) for a recent discussion of the etymological, conceptual and cultural connections between torsion and queering, and between queer studies and ethico-political torsions.

4 Elsewhere, he argues: "When the concept of modernity still implies 'progress' and 'westernization,' any translation or introduction of modern texts is by no means free from cultural imperialism" (Lo quoted in Chow 1995: 176). This claim by Lo is the very first quotation that Rey Chow makes in the essay "Film as Ethnography" from which I am been drawing here.

5 "The subtitles become a kind of verbal "stain" that partially obscures the field of vision. It is like living in a world of comics, where one would continuously see one's own speech and the speech of others" (Lo 2005: 50).

6 Ascheid argues that subtitled films construct a ruptured space "for intellectual evaluation and analysis" insofar as this confluence of features "destroys the usual unity between the spectator and the cinematic world he or she experiences" and "results in the perception of 'difference' rather than the confirmation of 'sameness' and identity" which "potentially leads to a considerable loss of pleasure during the experience" (Ascheid, quoted in Lo 2005: 56).

7 As Lo puts it: "It has been well-documented in Western film guides and critical studies of Hong Kong films that the English subtitles are not viewed simply as troublesome but also as great fun for Western viewers. In the West, Hong Kong cinema enjoys great popularity among nonconformist subcultures—festival circuits, college film clubs, Internet fanzines, and fan groups—in which cult followers and lovers of camp celebrate the exploitation and peculiarities on display.... [I]ts wild and weird subtitles further elevate the cinema's fetishistic status and exotic flavor. The tainted object that obscures part of the screen and confuses the signification has been sublimated into a cult element by hardcore fans who look for off-center culture and down-market amusements" (Lo 2005: 54).

8 As mentioned, there are other possible renderings of the Chinese, such as "our ancestors are the same, but our destinies are completely different," which, in referring to a shared *ancestry* rather than a shared *present*, could be taken to mean one of several different things and hence change the implications.

9 These several senses of translation, treachery and tradition all coalesce in the early scene in *Fist of Fury*. As we have seen, this scene—which initiates and initializes the action of the film—is dominated by an accusation: The Japanese declare that an unnamed addressee is the "Sick Man of Asia." This is a brilliantly efficient insult, as it operates on all salient levels at once: This is the funeral of a Chinese martial arts master who apparently died of a sickness, so he was the sick man; but it is also directed at all Chinese, and equally to the nation of China, whose independence and powers had been drastically compromised by a wide range of foreign onslaughts. Reciprocally, of course, as Chan emphasizes, this is all organised through the other element of this copula: masculinity. Thus, the vocalisation of the accusation of sickness on all levels comes at a moment of profound cultural crisis. China is in a weakened state—hence the presence of such powerful Japanese in Shanghai. The funeral is that of the traditional Chinese master. Moreover, the deceased master was also the actual founder.

10 The primary field of such twisting, turning, concatenation and warping is, of course, that supposed "realm" (which could perhaps be rather better understood as the condition) called mass or popular culture. Thus, argues Chow: "There are multiple reasons why a consideration of mass culture is crucial to cultural translation, but the predominant one, for me, is precisely that asymmetry of power relations between the 'first' and the 'third' worlds.... Critiquing the great disparity between Europe and the rest of the world means not simply a deconstruction of Europe as origin or simply a restitution of the origin that is Europe's others but a thorough dismantling of *both* the notion of origin and the notion of alterity as we know them today" (193-4).

11 See Chow: "Using contemporary Chinese cinema as a case in point, I think the criticism (by some Chinese audiences) that Zhang and his contemporaries 'pander to the tastes of the foreign devil' can itself be recast by way of our conventional assumptions about translation. The 'original' here is not a language in the strict linguistic sense but rather 'China'—'China' as the sum total of the history and culture of a people; 'China' as a content, a core meaning that exists 'prior to' film. When critics say that Zhang's films lack depth, what they mean is that the language/vehicle in which he renders 'China' is a poor translation, a translation that does not give the truth about 'China.' For such critics, the film medium, precisely because it is so 'superficial'—that is, organized around surfaces— mystifies and thus distorts China's authenticity. What is implicitly assumed in their judgment is not simply the untranslatability of the 'original' but that translation is a unidirectional, one-way process. It is assumed that translation means a movement from the 'original' to the language of 'translation' but not vice versa; it is assumed that the value of translation is derived solely from the 'original,' which is the authenticator of itself and of its subsequent versions. Of the 'translation,' a tyrannical demand is made: the translation must perform its task of conveying the 'original' without leaving its own traces; the 'originality of translation' must lie 'in self-effacement, a vanishing act'" (Chow 1995: 184).

12 She asks these questions not simply in the spirit of the post-structuralist, deconstructive or anti-essentialist problematization of "essences" and fixed/stable identities; but rather because of the extent to which many theories of translation focus exclusively on the

"intralingual and interlingual dimensions of translation" (192) and hence miss the cultural significance "of intersemiotic practices, of translating from one sign system to another" (193).

13 This tradition, it should be noted, is not an exclusively Chinese tradition. It is of course always and already transnational—some might even say universal. It is *transmissible*, communicable. This is not the case with the question "Are you Chinese?" Such a question only means something barbed and precise within certain contexts. So, the switch, the non-translation transformation of the question "Are you Chinese?" into "Just what is the point of this?" is an act which clings to transmissibility rather than to truth.

14 In other words, actively involved in a complex dialectical identification akin to Hegel's much (re)theorized dialectic of Lord and Bondsman, within which each identity depends on (is constituted and compromised by) the other's (mis)recognition.

Bibliography

Abbas, Ackbar (1997), *Hong Kong: Culture and the Politics of Disappearance*, Minneapolis and London: University of Minnesota Press.

Adorno, Theodor W. and Max Horkheimer (1986), *Dialectic of Enlightenment*, London and New York: Verso.

Arditi, Benjamin (2007), *Politics on the Edges of Liberalism: Difference, Populism, Revolution, Agitation*, Edinburgh: Edinburgh University Press.

Arditi, Benjamin, and Jeremy Valentine (1999), *Polemicization: The Contingency of the Commonplace*, Edinburgh: Edinburgh University Press.

Attridge, Derek and Thomas Baldwin (2004), "Obituary," *The Guardian*, Monday October 11.

Bahti, Timothy (1992), "The Injured University," *Logomachia: The Conflict of the Faculties*, ed. Richard Rand, Lincoln and London, University of Nebraska Press.

Barthes, Roland (1972), *Mythologies*, London: Paladin.

Barthes, Roland (1977), *Image–Music–Text*, Fontana: London.

Benjamin, Walter (1999), *Illuminations*, London: Pimlico.

Bennington, Geoffrey and Jacques Derrida, (1993), *Jacques Derrida*, Chicago and London: University of Chicago Press.

Bernardi, Floriana (2010), "Gazes, Targets, (En)Visions: Reading Fatima Mernissi through Rey Chow," *Social Semiotics*, 20:4 (September), pp. 411-423.

Bewes, Timothy (2001), "Vulgar Marxism, The Spectre Haunting *Spectres of Marx*," ed. Martin McQuillan, *parallax 20*, "the new international," 7:3, July-September.

Bowman, Paul (2007), *Post-Marxism Versus Cultural Studies: Theory, Politics and Intervention*, Edinburgh: Edinburgh University Press.

Bowman, Paul (2008), "Alterdisciplinarity," *Culture, Theory and Critique*, 49:1, pp. 93-110.

Bowman, Paul (2010), *Theorizing Bruce Lee: Film–Fantasy–Fighting–Philosophy*, Amsterdam and New York: Rodopi.

Brown, Bill (1997), "Global Bodies/Postnationalities: Charles Johnson's Consumer Culture," *Representations*, No. 58, Spring, pp. 24-48.

Butler, Judith, Ernesto Laclau, and Slavoj Žižek (2000), *Contingency, Hegemony, Universality: Contemporary Dialogues on the Left*, London: Verso.

Calefato, Patrizia (2010), "Fashion as Cultural Translation: Knowledge, constrictions and transgressions on/of the female body," *Social Semiotics*, 20:4 (September), pp. 343-355.

Chambers, Iain (2010), "Theory, Thresholds and Beyond," *Postcolonial Studies*, 13:3: pp. 255-

264.

Chambers, Sam, and O'Rourke, Michael (2009), "Jacques Rancière on the Shores of Queer Theory," *Borderlands*, 8:2, pp. 1-19.

Chan, Jachinson W. (2000), "Bruce Lee's Fictional Models of Masculinity," *Men and Masculinities*, 2:4, April, pp. 371-387.

Chaudhary, Zahid R. (2010), "The Labor of Mimesis," *Social Semiotics*, 20:4 (September), pp. 357-365.

Chow, Rey (1991), *Woman and Chinese Modernity: the politics of reading between West and East*, Minneapolis: University of Minnesota Press.

Chow, Rey (1993), *Writing Diaspora: tactics of intervention in contemporary cultural studies*, Bloomington: Indiana University Press.

Chow, Rey (1995), *Primitive Passions: Visuality, Sexuality, Ethnography, and Contemporary Chinese Cinema*, New York: Columbia University Press.

Chow, Rey (1998), *Ethics after Idealism*, Bloomington: Indiana University Press.

Chow, Rey (1998a) "The Postcolonial Difference: Lessons in Cultural Legitimation," *Postcolonial Studies*, 1:2, pp. 161-169.

Chow, Rey (1998b), "King Kong in Hong Kong: Watching the 'Handover' from the U.S.A.," *Social Text*, No. 55, *Intellectual Politics in Post-Tiananmen China*, Summer, pp. 93-108.

Chow, Rey (2002), *The Protestant Ethnic and the Spirit of Capitalism*, New York: Columbia University Press.

Chow, Rey (2006), *The Age of the World Target: Self-Referentiality in War, Theory and Comparative Work*, Durham, NC: Duke University Press.

Chow, Rey (2007), *Sentimental Fabulations, Contemporary Chinese Films*, New York: Columbia University Press.

Chow, Rey (2012), *Entanglements, or: Transmedial Thinking about Capture*, Durham NC and London: Duke University Press.

Chow, Rey (forthcoming), "China as Documentary: Some Basic Questions (Inspired by Michelangelo Antonioni and Jia Zhangke)."

Dagostino, Maria Rosaria (2010), "With Great Affection: Translating Rey Chow: listening and emotion," *Social Semiotics*, 20:4 (September), pp. 367-376.

Debord, Guy (1994), *The Society of the Spectacle*, New York: Zone Books.

Deleuze, Gilles (1988), *Foucault*, trans. Sean Hand, foreword by Paul Bové, Minneapolis: University of Minnesota Press.

Derrida, Jacques (1974/1976), *Of Grammatology*, Baltimore MD and London: Johns Hopkins University Press.

Derrida, Jacques (1981), *Dissemination*, trans. B. Johnson, Chicago and London: University of Chicago Press.

Derrida, Jacques (1982), *Margins of Philosophy*, London: Harvester Wheatsheaf.

Derrida, Jacques (1987). *The Truth in Painting*, Chicago: Chicago University Press.

Derrida, Jacques (1994), *Specters of Marx: The State of the Debt, the Work of Mourning, & the New International*, London: Routledge.

Derrida, Jacques (1995a), *The Gift of Death*, trans. David Wills, Chicago and London: University

of Chicago Press.

Derrida, Jacques (1995b), "*Honoris Causa*: This is *also* extremely funny," *Points... Interviews, 1974-1994*, Stanford, CA.: Stanford.

Derrida, Jacques (1996), *Monolingualism of the Other; or, The Prosthesis of Origin*, Stanford, CA.: Stanford University Press.

Derrida, Jacques (1997), *Politics of Friendship*, London: Verso.

Derrida, Jacques (1998), *Resistances of Psychoanalysis*, Stanford, CA.: Stanford University Press.

Derrida, Jacques, and Alan Bass (2001), *Writing and Difference*, London: Routledge.

Derrida, Jacques (2003), "I Have a Taste for the Secret," in Jacques Derrida and Maurizio Ferraris, *A Taste for the Secret*, Cambridge, UK: Polity.

Docherty, Thomas (2003), "Responses: An Interview," *Interrogating Cultural Studies*, ed. Paul Bowman, London: Pluto.

During, Simon (2011), "Postdisciplinarity: A Talk Given at the Humanities Research Centre at the ANU. May 2011," Unpublished paper.

Fabian, Johannes (1983), *Time and the Other: how anthropology makes its object*, New York: Columbia University Press.

Fanon, Frantz (1952/1967), *Black Skins, White Masks*, trans. Charles Lam Markmann, New York: Grove Press.

Fanon, Frantz (1961/1963), *The Wretched of the Earth*, trans, Constance Farrington, New York: Grove Weidenfeld.

Foucault, Michel (1970), *The Order of Things: an archaeology of the human sciences*, London: Tavistock Publications.

Foucault, Michel (1977), *Discipline and Punish: the birth of the prison*, New York: Pantheon Books.

Foucault, Michel (1978), *The History of Sexuality, Volume 1*, London: Penguin.

Frow, John (2010), "Hybrid Disciplinarity: Rey Chow and Comparative Studies," *Postcolonial Studies*, 13:3, pp. 265-274.

Gilbert, Jeremy and Ewan Pearson (1999), *Discographies: dance music, culture, and the politics of sound*, London: Routledge.

Hall, Gary (2002), *Culture in Bits: The Monstrous Future of Theory*, London: Continuum.

Hall, Gary, and Clare Birchall, eds. (2008), *New Cultural Studies: Adventures in Theory*, Edinburgh: Edinburgh University Press.

Hall, Stuart (1990), "The Emergence of Cultural Studies and the Crisis of the Humanities," *October*, 53.

Hall, Stuart (1992), "Cultural Studies and Its Theoretical Legacies," in Lawrence Grossberg, Cary Nelson, and Paula Treichler, eds., *Cultural Studies*, New York and London: Routledge.

Hall, Stuart (1996), "On Postmodernism and Articulation: an interview with Stuart Hall," in David Morley and Kuan-Hsing Chen, eds, *Stuart Hall: critical dialogues in cultural studies*, London: Routledge.

Hardt, Michael and Negri, Antonio (2000), *Empire*, Cambridge, MA. and London: Harvard University Press.

Heidegger, Martin (1971), "A Dialogue on Language: between a Japanese and an inquirer," *On The Way to Language*, New York: Harper Collins.

Hristov, Todor (2010), "Making Difference Work: post-socialist biopolitics through the lens of Rey Chow," *Social Semiotics*, 20:4 (September), pp. 425-439.

Hunt, Leon (2003), *Kung Fu Cult Masters: From Bruce Lee to Crouching Tiger*, London: Wallflower.

Kato, T. M. (2007), *From Kung Fu to Hip Pop: globalization, revolution and popular culture*, New York: SUNY.

Kilroy, P., R. Bailey and N. Chare, eds. (2004), *parallax*, "Auditing Culture," 10:2.

Kloet, Jeroen de (2010), "Created in China and Tozer Pak's Tactics of the Mundane," *Social Semiotics*, 20:4 (September), pp. 441-455.

Laclau, Ernesto (1977), *Politics and Ideology in Marxist Theory*, New Left Books: London.

Laclau, Ernesto, and Chantal Mouffe (1985), *Hegemony and Socialist Strategy: towards a radical democratic politics*, London: Verso.

Lo, Kwai-Cheung (2005), *Chinese Face/Off: The Transnational Popular Culture of Hong Kong*, Chicago: University of Illinois Press.

Lyotard, Jean-François (1984), *The Postmodern Condition: a report on knowledge*, Minneapolis, MN: University of Minnesota Press.

Marchart, Oliver (2007), *Post-Foundational Political Thought: political difference in Nancy, Lefort, Badiou and Laclau*, Edinburgh: Edinburgh University Press.

Meighoo, Sean (2008), "Derrida's Chinese Prejudice," *Cultural Critique*, Winter, pp. 163-209.

Morley, David, and Chen, Kuan-Hsing, eds. (1996), "Introduction," *Stuart Hall: critical dialogues in cultural studies*, London: Routledge.

Morris, Meaghan (2001), "Learning from Bruce Lee," in Matthew Tinkcom and Amy Villarejo, eds. *Keyframes: popular cinema and cultural studies*, London: Routledge.

Mowitt, John (1992), *Text: the genealogy of an antidisciplinary object*, Durham and London: Duke University Press.

Mouffe, Chantal (2005), *On the Political*, London: Routledge.

Mulvey, Laura (1975). "Visual Pleasure and Narrative Cinema," *Screen*, 16:3: 6-18.

Nitta, Keiko (2010), "An Equivocal Space for the Protestant Ethnic: U.S. popular culture and martial arts fantasia," *Social Semiotics*, 20:4 (September), pp. 377-392.

Park, Jane Chi Hyun (2010), *Yellow Future: oriental style in Hollywood cinema*, Minneapolis: University of Minnesota Press.

Pourgouris, Marinos (2010), "Rey Chow and the Hauntological Specters of Poststructuralism," *Postcolonial Studies*, 13:3, pp. 275-288.

Prashad, Vijay (2001), *Everybody Was Kung Fu Fighting: Afro-Asian connections and the myth of cultural purity*, Boston: Beacon Press.

Protevi, John (2001), *Political Physics: Deleuze, Derrida and the body politic*, London: Athlone.

Rancière, Jacques (1987/1991), *The Ignorant Schoolmaster: five lessons in intellectual emancipation*, Stanford, CA.: Stanford University Press.

Rancière, Jacques (1999), *Dis-agreement: politics and philosophy*, Minneapolis: University of Minnesota.

Rifkin, Adrian (2003), "Inventing Recollection," *Interrogating Cultural Studies*, ed. Paul Bowman, London: Pluto. This text is also online here:

http://goldsmiths.academia.edu/AdrianRifkin/Papers/323032/Inventing_Recollection

Said, Edward W. (1978/1995), *Orientalism: Western conceptions of the Orient*, London: Penguin.

Sandford, Stella (2003), "Going Back: Heidegger, East Asia and 'The West'," *Radical Philosophy*, 120, July/August, pp. 11-22.

Shaviro, Steven (2010), *Post-Cinematic Affect*, Winchester, UK and Washington, DC: Zero Books.

Slack, Jennifer (1996), "The Theory and Method of Articulation in Cultural Studies," in David Morley and Kuan-Hsing Chen, eds., *Stuart Hall: critical dialogues in cultural studies*, London: Routledge.

Spivak, Gayatri Chakravorty (1988), "Can the Subaltern Speak?" In Lawrence Grossberg and Cary Nelson, eds., *Marxism and the Interpretation of Culture*, Urbana-Champaign: University of Illinois Press.

Steintrager, James (2010), "Hermeneutic Heresy: Rey Chow on translation in theory and the 'fable' of culture," *Postcolonial Studies*, 13:3, pp. 289-302.

Teo, Stephen (2008), *Hong Kong Cinema: the extra dimension*, London: British Film Institute.

Valentine, Jeremy (2006), "Denial, Anger and Resentment," in Paul Bowman and Richard Stamp, eds., *The Truth of Žižek*, London: Continuum.

Weber, Samuel (1987), *Institution and Interpretation*, Minneapolis: University of Minnesota Press.

Young, R. J. C. (1992), "The Idea of a Chrestomathic University," *Logomachia: the conflict of the faculties*, Lincoln and London: University of Nebraska Press.

Young, Robert J. C. (2001), *Postcolonialism: an historical introduction*, London: Blackwell.

Žižek, Slavoj (2004), *Organs without Bodies: On Deleuze and consequences*, London and New York: Routledge.

Filmography

Big Boss, The (1971), Dir: Lo Wei, HK

Blade Runner (1982), Dir: Ridley Scott, USA

Bourne Identity, The (2002), Dir: Doug Liman, USA

Bourne Supremacy, The (2004), Dir: Paul Greengrass, USA

Bourne Ultimatum, The (2007), Dir: Paul Greengrass, USA

Breakfast at Tiffany's (1961), Dir: Blake Edwards, USA

Chung Guo/Cina/China (1972), Dir: Michelangelo Antonioni, Italy

Fist of Fury (1972), Dir: Lo Wei, HK

Game of Death (1973/1978), Dir: Bruce Lee, HK

Joy Luck Club (1993), Dir: Wayne Wang, USA

M. Butterfly (1993), Dir: David Cronenberg, USA

Matrix, The (1999), Dir: Wachowski Brothers, USA

Minority Report (2002), Dir: Steven Spielberg, USA

Old Boy (2003), Dir: Park Chan-wook, South Korea

Rouge (1988), Dir: Stanley Kwan, HK

S1m0ne (2002), Dir: Andrew Niccol, USA

To Live (1994), Dir: Zhang Yimou, China
Way of the Dragon (1972), Dir: Bruce Lee, HK

Index